P9-CDE-428

—— THE ——

ILLUSTRATORS
BIBLE

THE
ILLUSTRATORS
BIBLE

The Complete Sourcebook of Tips, Tricks,
and Time-Saving Techniques in Oil, Alkyd,
Acrylic, Gouache, Casein, Watercolor,
Dyes, Inks, Airbrush, Scratchboard, Pastel,
Colored Pencil, and Mixed Media

ROB HOWARD

WATSON-GUPTILL PUBLICATIONS / NEW YORK

TO MY PARENTS, WHO TAUGHT ME TO READ
AND THUS GAVE ME THE WORLD

—————————————— ACKNOWLEDGMENTS ——————————————

This book results from the collaboration of many people. Regarding art supplies, a large number of manufacturers graciously provided me with many of the products discussed herein. The technical and material involvement of many of these manufacturers went far beyond the bounds of enlightened self-interest—they were downright courageous. Knowing that I would report on the their products' weaknesses, as well as their strengths, they nonetheless welcomed the opportunity to have their products evaluated in direct comparisons. If there is one lesson to be learned from the product evaluations, is must be that the majority of people making artist's materials are motivated by more than mere profit. They have a deep pride in their work—and it shows.

Producing a book cannot be done without the help of others who share in the author's vision.

Foremost among these people must be Candace Raney, Senior Editor at Watson-Guptill, whose enthusiasm breathed a spark of life into this project.

Thanks are also due to some deserving colleagues: Several of the techniques demonstrated in this book were developed by Clif Lundberg when he was associated with the Studio for Illustration. And Laurie Johnson of Cordella Design is responsible for ensuring that the information on scanners and print production is accurate and up to date.

Very special thanks must go to my son, Maximillian, without whose assistance this book could never have taken form. Max pointed out problems with continuity , took most of the photos, organized and edited thousands of slides, and wrought harmony from chaos. His intelligence and humor are stamped on every page. This book is as much his as it is mine.

Copyright © 1992 by Rob Howard

First published in 1992 by Watson-Guptill Publications, a division of BPI Communications, Inc., 1515 Broadway, New York, NY 10036

Library of Congress Cataloging-in-Publication Data

Howard, Rob.
 The illustrators bible : the complete sourcebook of tips, tricks, and time-saving techniques in oil, alkyd, acrylic, gouache, casein, watercolor, dyes, inks, airbrush, scratchboard, pastel, colored pencil, and mixed media / Rob Howard
 p. cm.
 Includes index.
 ISBN 0-8230-2532-2
 1. Art—Technique. I. Title
N7430.H78 1992
741.6—dc20 92-11206
 CIP

All rights reserved. No part of this publication may be reproduced or used in any form or by any means—graphic, electronic, or mechanical, including photocopying, recording, taping or information storage or retrieval systems—without written permission of the publisher.

Manufactured in Malaysia

First printing, 1992

5 6 7 8 9 / 99 98 .97

Edited by Paul Lukas
Designed by Areta Buk
Senior Editor: Candace Raney
Graphic Production: Hector Campbell

CONTENTS

Introduction 7

CHAPTER 1.
WHAT TO DO WITH YOUR
HANDS 9

CHAPTER 2.
THE REPRODUCTION
PROCESS 13

CHAPTER 3.
THE EFFICIENT STUDIO 17

CHAPTER 4.
TRANSFERRING THE
DRAWING 35

CHAPTER 5.
SUPPORTS 41

CHAPTER 6.
MASKS AND FRISKETS 49

CHAPTER 7.
LINE TECHNIQUES 59

CHAPTER 8.
PASTEL AND COLORED
PENCIL 91

CHAPTER 9.
OIL AND ALKYD PAINTING 103

CHAPTER 10.
ACRYLICS 125

CHAPTER 11.
GOUACHE AND CASEIN 135

CHAPTER 12.
INKS, DYES, AND
WATERCOLOR 147

CHAPTER 13.
THE AIRBRUSH 153

CHAPTER 14.
THE BUSINESS OF
ILLUSTRATING 169

Appendix: Resources 174
Index 175

INTRODUCTION

I love being an illustrator. Looking back to my youth, I can't remember a time when I wasn't drawing—often at the expense of study time that should have been devoted to Latin or algebra. These days, fortunately, I seldom use Latin and never use algebra; instead, I'm paid to make pictures and have fun. I've spent three decades developing my craft and learning the tricks of the trade. Every one of these techniques—including those that have never before appeared in any book and have been closely guarded professional secrets until now—will be passed on to you in this book. Nothing will be kept from you.

A good illustration is like a magic trick: It leaves you wondering how it was done. What was the medium? How was it applied? A good illustration resists such analysis—its surface is so well finished, there is no hint of what went into making it. Like a magic trick, its secrets appear impenetrable. The guiding thought behind this book is to take you backstage to see how the magic is done. Every trick will be shown and explained.

While I've tried to vary the illustration styles in order to demonstrate the range and capabilities of each technique, the book is not a portfolio of my illustration style. The illustrations are just demonstrations, designed to take the mystery out of illustration technique. Remember, even the most mystifying trick is easy, once you've seen it from backstage.

This book is not written for the rank beginner or Sunday painter—it is a tool for students of illustration and professionals. As such, the assumption here is that you know how to draw convincingly, and that you understand the rudiments of painting. Moreover, the book is not meant as course of study—this is a reference book. Each illustration technique is presented with step-by-step demonstrations. To show the versatility of the techniques, the illustration styles for a given technique are varied between demonstrations. The demonstrations are not meant to function as examples of finished illustration—the idea is for you to apply these techniques to your own personal style. Because of wide variations between various brands of artist's materials, the specific brand names of the products used will be mentioned. This ensures that your results will be as consistent as possible with those shown in the demonstrations.

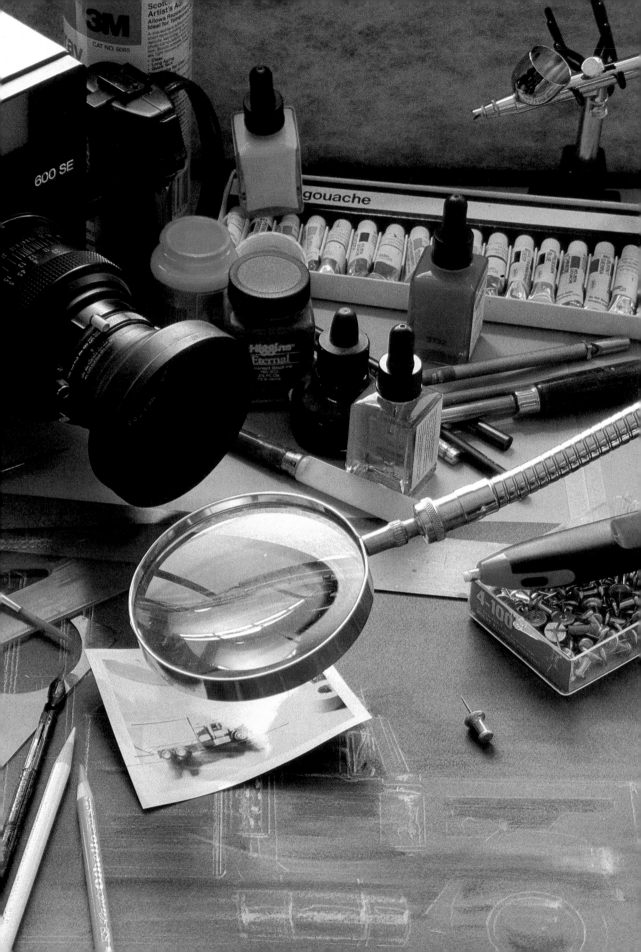

WHAT TO DO WITH YOUR HANDS

Learning to perfect and expand the use of your hands will make a big difference in the quality of your illustration. There's as great a variety in hands as in any other part of the anatomy—some are thin and supple, and others, like mine, are large and not so nimble.

Some artists grasp a brush, pencil, pen, or airbrush the same way they first held a pencil when they were children learning to write. Do you still hold your pencil close down to the point? Are your fingers in the same crabbed and gnarled clutch that you adopted as a child? It's normal to resist relearning something when you feel you're already doing it well, but there's a big difference between the hand positions and movements needed for writing and those for drawing or painting.

Because the smallest bones are in the fingers, the typical writing position has a very narrow arc, which results in repetitive strokes. By learning to rest the back of the pencil at the base of the thumb and relying on arm motion, you will draw fluid but accurate strokes. Try it: Hold a pencil as you normally would when writing and make a series of close strokes. Do them in a normal and comfortable manner. Now, holding the pencil much farther back from the tip, make the same strokes, and compare them with the first set. You'll notice that the second group is longer and straighter—you've lengthened the arc. In keeping with this principle, many artists working at the easel keep their arms stiff and swing their strokes from the shoulder, giving their work a free, painterly quality. Learning the different ways to hold your tools, whether to achieve broad strokes or tight details, is the sign of a master. Repetitive strokes are…well, dull and repetitive.

Other techniques are suited to specific effects: The detail position (see page 11) affords you the greatest accuracy, because your hand stays braced; a variation of the detail position enables you to draw straight lines with a brush by running it along a straightedge; to draw accurate curves with a brush, use a signpainter's technique of making a fist with your weak hand and resting your brush hand on top of it. This is worth a few hours of practice.

Intelligent use of your hands can help you achieve better results with certain tools and equipment, too. When cutting friskets, for instance, it is important to maintain a consistent depth of cut. Once your knife is set at the correct depth, lock your fingers on the knife. Position your fingers to form a depth guide to prevent the blade from cutting through the frisket and into the surface of the support. And when operating a double-action airbrush, an unsupported forefinger on the trigger can slip and cause the paint to feed erratically—instead, operate the trigger with a braced thumb and forefinger.

No discussion of artists' hands would be complete without some mention of the problems caused by the natural oils our hands produce. For the artist, this is no small concern—placing your hand on a watercolor or gouache painting is sure to result in a noticeable slick spot, and drawing with pencil or ink on acetate and Denril requires a pristine surface. Take a cue from animators and retouch artists, who buy the thin cotton gloves used in photo labs and cut off all the fingers except the little finger. This gives them complete control without forcing them to put pieces of paper under their hands, or to elevate their hands with bridges. The gloves are comfortable, cheap, and disposable, and are surprisingly easy to adjust to.

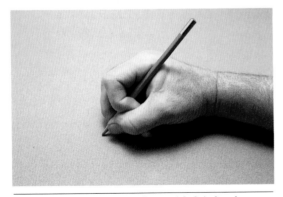

Some people actually try to draw with their hands crabbed up like this. The resulting drawings are always clumsy, and even maintaining the position for a few minutes is tiring.

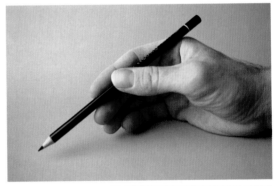

A much better approach. Note the relaxed position of the hand as it lightly holds the pencil far back from the tip. This posture results in long, smooth lines.

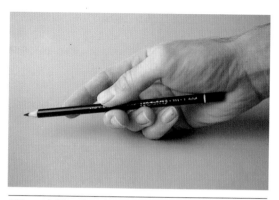

This useful hand position for working at the easel or an elevated board allows you to swing your shoulder, elbow, and wrist to create long, bravura brushstrokes.

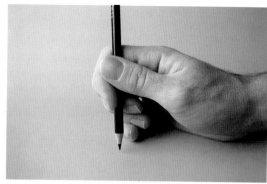

The detail position. Note how well-braced the hand is in this position. This position is ideal for (and is actually limited to) vertical strokes—your lines can't wobble off to the horizontal.

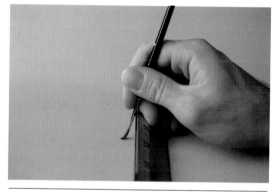

Running the ferrule of a brush along a metal-edged ruler yields a crisp, straight line. The edge of the ruler is elevated slightly and the hand is held in a modified detail position.

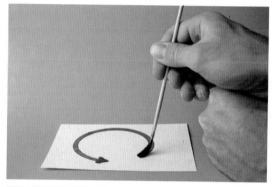

This hand position is favored by signpainters. The top hand rests on the bottom hand, which is cupped into a fist. The bottom hand is used to rock horizontally while the top hand makes the vertical strokes. Try it yourself— while it may look a bit awkward, it's actually quite easy and comfortable.

When cutting friskets and Amberliths, brace your hand to prevent the blade from cutting too deeply into the substrate.

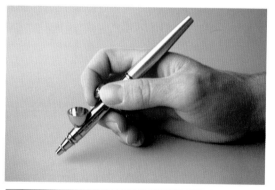

Both the thumb and the forefinger control the main lever of the double-action airbrush. The thumb acts as a brake to allow gradual changes in paint or air flow.

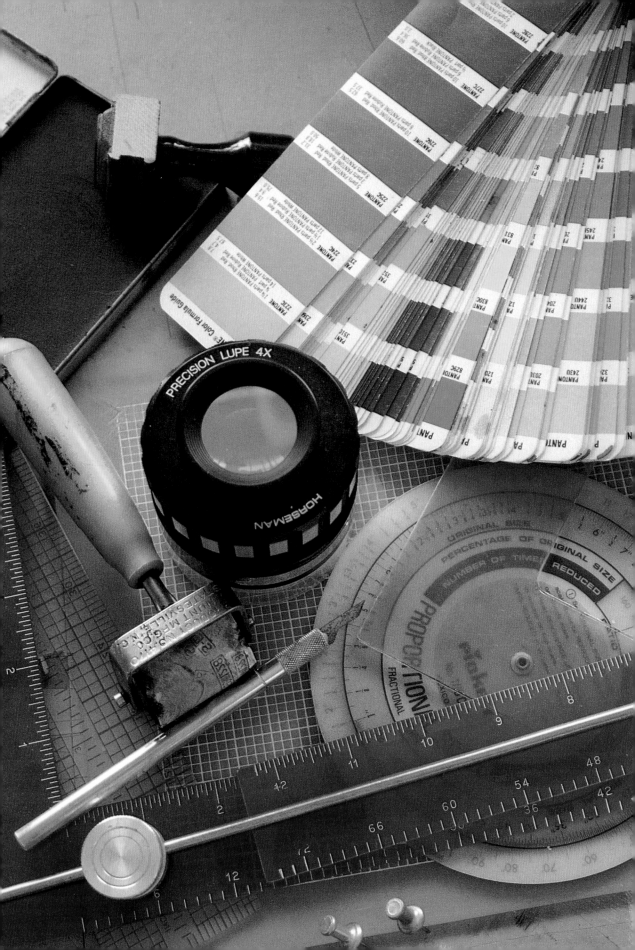

CHAPTER 2

THE REPRODUCTION PROCESS

No, this chapter is not devoted to biology. Its purpose is to help you to prepare your artwork for the print reproduction. Unlike the fine artist, whose work is displayed on a gallery's walls, the illustrator's work is displayed on a printed page. A viewer visiting the gallery usually spends some time savoring the painter's work, but the same viewer flipping through a book or magazine will stop to cast a lingering gaze on only the most stunning illustration.

While a memorable illustration may owe a lot to the illustrator's mastery of paints, brushes, or similar tools and equipment, it usually owes just as much to the illustrator's understanding of the reproduction processes—how certain colors reproduce, which colors will be distorted if photographed, which surfaces are best for reproduction, and so on. Don't fall into the trap of thinking that a piece is done when you finally put away your airbrush, markers, or whatever else you were using—an illustration is not finished until it rolls off the press. So the complete illustrator must work with the printing press in mind.

Printers now reproduce color work with electronic scanners capable of pinpoint accuracy, which have replaced the old-time process cameras. While scanner technicians are not as romantic as the highly skilled cameramen who worked the process cameras, today's methods can produce better results if the technician brings a degree of taste and craft to the job.

The art analyzed by the scanners can be either *transparent* (slides or other transparencies) or *reflective* (the original art or photographic prints). Either way, the art to be scanned must be sufficiently flexible to be wrapped around the scanner's rotary drum. For transparent art or reflective prints, this is no problem, but original illustrations on board or other inflexible surfaces can create problems, so always try to work on a flexible surface. If you

are preparing a large illustration, check with the printer or the project's production contact to find out how large a piece the printer's scanner can accommodate. If your illustration is too large, or if it is too rigid to be scanned, you or the printer will have to make a *copy transparency* of the piece to be used for reproduction.

Because of the limitations of photography, many things can go wrong when making a "simple" copy transparency. Color film does not have anything resembling the color and tonal range of paint, and it cannot produce dense, solid blacks or clean, open whites. Within film's limited range, large-format transparencies (4×5s or 8×10s) generally give the best color fidelity. If you hire someone to photograph a large or inflexible piece, don't accept the transparency until it accurately represents your original art.

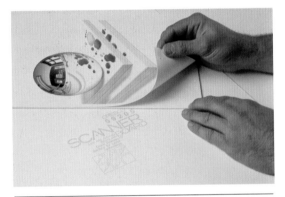

Specially made scanner boards have a drawing surface that is easily peeled away from the adhesive backing board. (Courtesy of Crescent Cardboard)

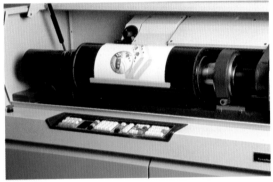

An illustration attached to the scanner drum, ready to be separated. (Courtesy of Crescent Cardboard)

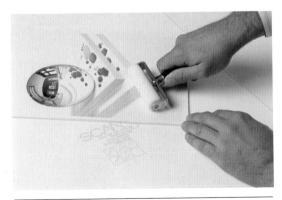

In order to protect and strengthen the illustration after it has been scanned, the drawing surface is readhered to the backing board with pressure from a hard roller. (Courtesy of Crescent Cardboard)

A moderately heavy coat of casein on Strathmore Two-Ply Bristol board. When this piece was rolled around a scanner drum, the casein chipped and flaked off. The same chipping can occur with heavy coats of tradtional gum-based gouache.

Unfortunately, original artwork is seldom sent to the printer along with a copy transparency. The scanner technician, not having the original artwork to refer to, treats the transparency as the first-generation art. This can be disastrous, as the technician may "helpfully" amplify or sharpen colors that were inaccurate to begin with. The best option in these situations is to send the original art and let the printer's staff make the copy transparency themselves.

Of course, all this can be avoided if you do your illustrations on flexible supports. Paper, bristol board, and canvas (removed from the stretcher bars) work well. But when considering flexibility, don't just think about the art surface—since the illustration will be wrapped on the scanner drum, the paint must be able to bend without cracking. Watercolor, acrylics, and oils are all fine, but thick layers of casein and gouache (except Acryla Gouache) can crack, so be careful with your paint choices.

If you are mounting paper or bristol board to illustration board, apply adhesive to the board only. When the illustration is peeled from the support board and scanned, adhesive applied to the paper can leave a residue on the sensitive surface of the drum and cause problems for the technician. This is no small problem—an annoyed technician can be an illustrator's worst nightmare. The best route toward a successful illustration is for illustrators, photographers, printer staff, and production managers to make each other's jobs easier.

With this in mind, the adhesive least likely to leave a residue is 3M Spray Mount repositionable adhesive. No matter what adhesive you use, the best way to avoid residue problems is to allow the glue to dry for 10 to 15 minutes before attaching the paper or bristol board.

Illustration board manufacturers have recently invented a new product and a new word, "strippable." The idea here is to provide a high-quality, illustration surface that can be peeled from its rigid backing for scanning. Letramax calls theirs Strippable Board; Crescent calls theirs Scanner Board. Both feature superb cold-press and hot-press surfaces that readily accept all painting and drawing media, and both strip smoothly from their backing boards. But the Letramax Strippable Board has adhesive on the paper, which could cause scanner problems. Go with the Crescent board instead.

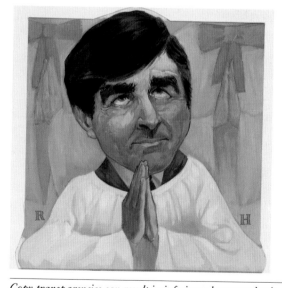 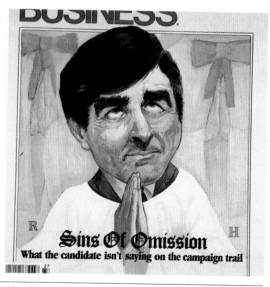

Copy transparencies can result in inferior color reproduction. On this project, for instance, the original illustration (left), painted in thin coats of oil on gessoed Masonite, was photographed with too much contrast. The unsatisfactory transparency was nonetheless sent to the separator, but without the original illustration. The separation was made with even more contrast than the transparency, and the art director was on vacation. The printed result looks as though an entire layer of paint was skinned from the surface of the illustration.

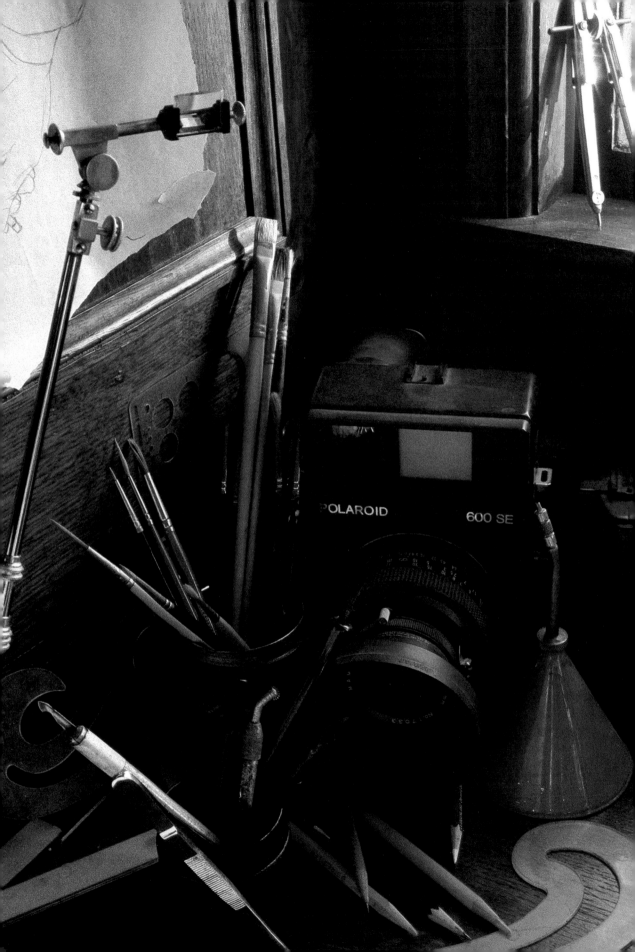

—— CHAPTER 3 ——

THE EFFICIENT STUDIO

Through more than a quarter-century of illustrating, I've worked in all sorts of studios—large studios with huge northern exposures, small studios with nothing but artificial light, antiseptic modern studios, and charming old studios. All had one thing in common: They were set up and equipped for the rapid and efficient production of high-quality artwork.

My present studio faces north and looks out on a rolling valley and an old stone castle perched high up on a hill. But while the view is idyllic, it doesn't improve my ability to draw, paint, or meet deadlines. Proper equipment is what helps me produce the artwork, and that's what this chapter is about—choosing and using the right equipment.

VISUALIZING DEVICES

There are still some artists who try to impose arbitrary rules on the creative process. They say you can't use photographs for visual reference, that tracing is cheating, that the artist should be able to draw solely from imagination. This is nonsense. Aside from genuine plagiarism, there is no such thing as "cheating" at drawing.

In fact, although some artists may be loath to admit it, a rational analysis of the old masters' working methods shows that they were preoccupied with efficiency. Their goal was *to produce the highest quality artwork in the least amount of time.* They enthusiastically embraced any useful method, tool, or new device that would simplify the creative process. Today, we have an astounding array of such aids—photography, projectors, copy machines, computer-generated graphics, and transfer type, to name just a few. And make no mistake—if these new tools had been available centuries ago to the old masters, they would have had absolutely no qualms about using them.

The truth is, the better you can draw without visualizing aids, the better you can draw *with* them. They are tools to simplify the use of talent—not a substitute for it. Many unskilled people, having seen me use a visualizing device, have asked to try it themselves, only to be shocked and disappointed by their results. They draw as badly with the tool as without it. Assuming you *do* have some talent, here are some tools that can help you.

Slide Projectors
The 35mm slide projector is the most common visualizing device. You can use it to project an image onto your illustration surface for tracing, preliminary sketching, or just close study. I use Kodak's Carousel model. It features a zoom lens, which allows me to enlarge or reduce an image on the easel, and remote focusing, which can save time when the projector is 20 feet away from the easel. I always leave some lights on in the room when drawing from a projected image—it's more important to see how the drawing is

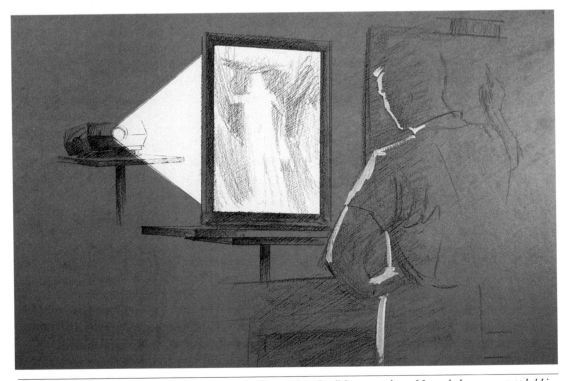

If you want to view your reference image while you draw, project the slide onto a sheet of frosted glass or acetate held in a frame. The projected image will be bright enough to allow you to view the slide even in fully lit conditions.

progressing than to see the nuances of the projected slide.

After the drawing is blocked in, you will want to be able to refer to the slide. Hand-held slide viewers are inadequate—they require you to stop, lay down your brushes, pick up the viewer, look away from the canvas, refocus your eyes, and peer through an eyepiece. Instead, make a rear-projection screen: Get a sheet of glass frosted on one side and have it mounted in a cheap but sturdy metal frame. Add wooden legs to the sides of the frame, and position it on a table convenient to your easel. Reverse the slide in the projector and project the image from behind the glass. The image will be sharp and detailed. If your studio is brightly lit, the image may be difficult to see; a shield made of black matte board will prevent the ambient light from washing out your projected image.

Another way to use a slide projector is with the Artograph SL 35M Slide Projector Platform, which features a sturdy, adjustable

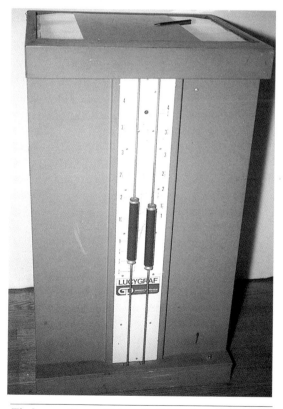

The Lucygraf is an efficient, flexible tool, and about half the price of its competitors.

column that attaches to your drawing board. The SL 35M mounts on the top of the column and holds a highly reflective front-surface mirror, while the projector sits on the platform aimed at the mirror. The mirror reflects a sharp image directly onto the work surface. The lens can enlarge up to 18 times. The stand also doubles as a projector stand for horizontal projection.

The Lucy
The stand-alone visualizer, the lucy, looks like a stat camera (which, of course, would make a fine visualizing device in its own right): It has a copyboard, a lensboard with attached lights, and a glass plate for viewing. By adjusting the distances between these three elements, you can enlarge or reduce any reflective image onto the reverse side of a sheet of tracing paper. Small three-dimensional objects can be accurately drawn as well.

A number of manufacturers produce their own version of the lucy. The most common are expensive, complex, chain-driven affairs that frequently slip out of focus, but the best is the Lucygraf, which features a generous 18-by-22-inch work surface and sells for about half the cost of its competitors. The model in my studio is still going strong after 20 years, and has never slipped out of focus.

Opaque Projectors
Unlike the lucy, which projects an image through a thin sheet of tracing paper, the opaque projector is designed to project images *onto* illustration board, canvas, and other opaque supports. High-quality models range in size from the 8-foot-tall Artograph 1000K to the Astrascope 5000, which is not much bigger than a toaster. Obviously, your preferences may vary depending on the circumstances of your studio, but the features to look for when buying any opaque projector are a high-quality, color-corrected lens (to prevent colors from "levitating"), a front-surfaced mirror, high output lights, and an internal fan (to keep from burning your reference photos). Don't be penny-wise and pound-foolish when considering the price—nobody ever got rich by saving money on an opaque projector, and a good one will quickly repay its cost.

Some opaque projectors project horizontally onto an easel, others project vertically onto a desk, and some can do both. The lowest-priced model I'd recommend is the horizontal-projecting Artograph Super AG100. The lens is serviceable, the two 200-watt lamps provide adequate illumination, and an optional stand and reduction lens allow you to convert the device for vertical projection onto a drawing table.

The Astrascope 5000 and Artograph MC 250 have superior lenses, powerful halogen lamps, 6-by-6-inch glass copyboards, and similar capabilities, but the German-made Astrascope model is somewhat more expensive. At the top of the line is the Artograph TH 500, which has an 8-by-8-inch copyboard, a 500-watt tungsten halogen lamp,

and a tack-sharp color-corrected lens, and is designed to accommodate books and three-dimensional objects.

If the horizontal opaque projector and easel are not aligned, the resulting image will be distorted. Our eyes naturally compensate for this, so the image might look correct when it's being projected, but once the projector is turned off, distortions in the drawing become apparent. The solution is simple: Just put a grid on the copyboard. First, project the reference onto the drawing surface, getting it properly scaled and in focus. Then, replace the reference with a quarter-inch grid—this should make any misalignment apparent. If you're projecting onto an easel, shift the easel until it is perfectly aligned with the projector. Once they are aligned, remove

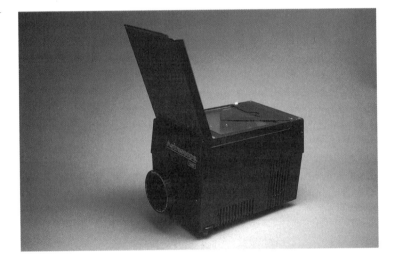

For large easel paintings, the Astrascope 5000 has a powerful quartz lamp that easily projects images at enlargements up to 1,800 percent. This type of opaque projector cannot reduce images, however.

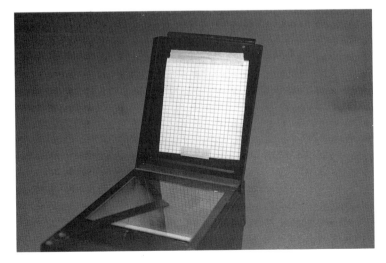

A grid mounted in the top cover of the Astrascope 5000 is an important aid for preventing photographic distortion.

the grid and replace the reference. The grid can also reveal any distortion inherent in the lens, so bring a grid when shopping for an opaque projector.

Overhead Projectors

Overhead projectors, which are designed for illustrators who prefer to work at a drawing table rather than at an easel, do not require frequent alignment—the best models are properly aligned at the factory. Artograph dominates the market. Their top-line model is the giant 1000K Vertical Arto Projector, which stands 8 feet tall. It features two powerful 500-watt tungsten halogen lamps, two fans, a 12-by-12-inch copyboard, and a color-corrected lens. As you might expect, it carries a sizable price tag.

My favorite is the drawing table–mounted Artograph DB 400, one of Artograph's best-selling models, which can enlarge up to 300 percent (or 800 percent when projected onto the floor) and reduce down to 33 percent, and has a 10 $\frac{1}{2}$-by-11-inch copyboard, two 200-watt lamps, a fan, a five-element lens and a viewing light. The hinged copyboard allows you to project opaque artwork, transparencies, and three-dimensional objects, and the projected images never slip out of focus, even during long drawing sessions. Since I started using this tool, I've pretty much abandoned other opaque projectors—it's that good.

Camera Lucida

The camera lucida consists of a prism mounted on an adjustable arm. Looking down through the prism splits your line of vision: The subject, which is positioned to your front, appears to be projected onto the paper. It's an optical illusion, since the image isn't *really* projected onto the drawing surface. It takes a bit of practice to master.

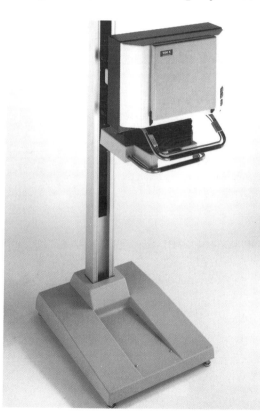

The freestanding Artograph 1000K is the undisputed leader of overhead projectors. It is almost 8 feet tall and, unlike previous models, does not have to be mounted on a wall. (Photo courtesy of Artograph)

The Artograph DB 400 overhead projector is lightweight, mounts onto a drawing table, and projects sharp images at a wide range of reduction and enlargement percentages.

The camera lucida boasts one unique feature: It allows you to draw directly from large subjects without interim photographs. In addition, you can reverse images, create anamorphic distortions, and, with some practice, enlarge and reduce photographic reference images. Camera lucidas are distributed through HK Holbein.

ADDITIONAL EQUIPMENT

Aside from the usual studio tools—drawing tables, easels, tabourets, and so on—a variety of other equipment should be included in an efficient studio. In my studio, for instance, the *electric pencil sharpener* ranks right up there with the invention of the wheel. There's one next to each drawing table, another one next to the lucy, and several battery-powered portable models for use on location or at client meetings. These humble devices are essential: Colored pencils need to be sharpened after every two or three strokes; pastel pencils, which are too delicate to be sharpened in a manual sharpener, present no problem to an electric sharpener; I even sharpen vine charcoal with an electric sharpener. Of the many models available, the Panasonic KP-33 has an auto-stop feature that prevents oversharpening, thus conserving those costly pencils.

Until recently, I had always thought of an *electric eraser* as a tool for architects and engineers—most models are cumbersome affairs that more closely resemble an industrial grinder than an artist's tool. This situation was remedied with the introduction of the Sakura Electric SE-2000 eraser, a small, battery-powered tool that fits in your hand. As we shall see later, it is an essential tool for the new methods of airbrush rendering.

A *lightbox* is essential, too. While uniform illumination is nice, a lightbox must be powerful enough to enable you to see your preliminary drawing through a sheet of three-ply bristol board in a fully lit studio. This standard effectively eliminates any of the lightboxes made for viewing slides.

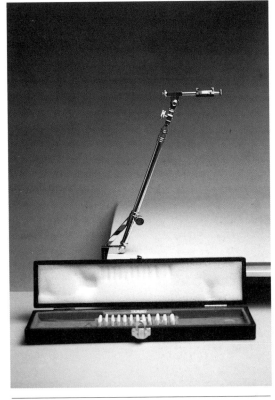

The camera lucida, such as this Holbein model, shown with its selection of lenses, is lightweight and portable.

The camera lucida creates an optical illusion, making the subject appear to be projected onto the drawing surface.

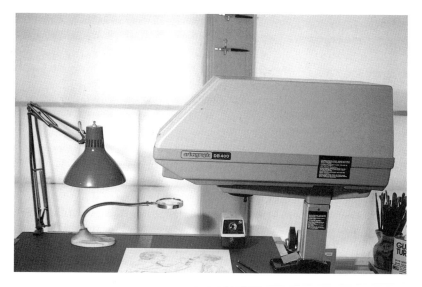

An efficient drawing table for a right-handed artist. The desk lamp has a powerful reading bulb. A magnifying lens mounted on a gooseneck and an electric pencil sharpener are close at hand. The Artograph DB 400 overhead projector takes up little desk space and can be raised out of the way.

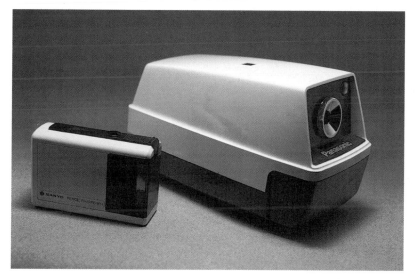

Two good pencil sharpeners: The Panasonic electric model (right) has a built-in auto-stop feature to prevent oversharpening; the Sanyo portable sharpener is powered with AA batteries.

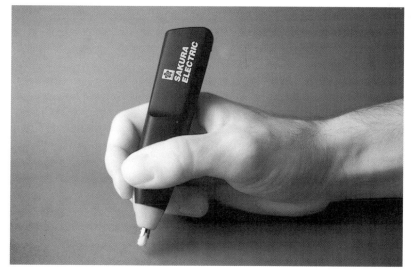

Unlike electric erasers designed for engineers and architects, the Sakura electric eraser is lightweight and small enough to be used as a drawing tool.

The Rabbit lightbox is no better—it has raised edges, which will dent and crease your drawing. Also to be avoided are lightboxes with acrylic surfaces, which create a static charge that attracts dirt and dust particles. Insist on a glass work surface—glass is easy to clean, and it allows you to cut mortises without scratching the surface.

Glass also makes a perfect *palette*. I use a quarter-inch sheet of glass with rounded corners, and position it over a sheet of neutral gray paper and a gray scale, which makes it easy to compare the values of my color mixtures. Don't underestimate the gray scale's importance—poorly chosen values comprise most of the mistakes made in painting.

Templates are important studio aids. My studio has a large collection of special-purpose templates, along with stacks of ellipse and circle templates; I can't imagine running an efficient studio without them. Badger, the airbrush company, makes a series of plastic laser-cut templates with extremely smooth edges. Because of the precision of laser cutting, these templates include both the positive and negative shapes of the various circles and ellipses they represent.

A *magnifying lens* is useful, and not just for artists with failing eyesight. Painting under a magnifying lens can improve detail quality—you will find that your hand is capable of much more than your unaided eye can see. The amazing control demonstrated in many

A lightbox lets you to see your working drawing through all but the thickest papers. Color-correct illumination is not as important as a powerful lamp.

A thick piece of glass placed over a neutral gray, with a gray scale mounted in the corner, makes a perfect palette.

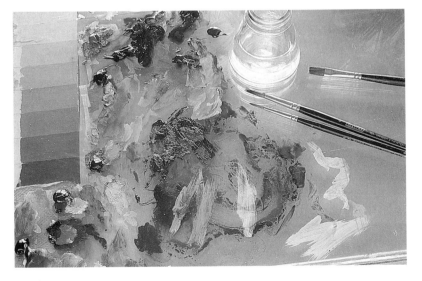

modern illustrations is achieved with the aid of this tool. There are several types of magnifying lenses available. The most common is the desktop model—a lens mounted to a flexible gooseneck, which is fixed to a heavy base. Another type features the lens mounted in a visor worn by the illustrator; a variation of this is the set of lenses that clips to a pair of eyeglasses. Most people find a working distance of 8 to 10 inches to be comfortable with the visor or clip-ons; the desktop model has a working distance of 4 to 5 inches. (One small caveat: Painting a red area on a blue area under a magnifying lens can be disconcerting. Because the lens is not color-corrected, the red appears to "levitate" a quarter-inch or so above the blue. This phenomenon, known as *chromatic aberration*, is easy to adjust to after a bit of time.)

As for drawing tools, aside from the usual collection of French curves and irregular curves, a set of *ship's curves* comes in handy. I'm particularly fond of using a slightly curved ship's curve for adding a bit of life to *straight* lines. Straight lines in an illustration are deadly dull, adding a stark mechanical look; a slight curve appears to be straight, but doesn't have the sterile feeling of a mechanically drawn line.

A useful tool for drawing long, irregular curves is the *flexible curve*. There are a couple of different styles: The traditional model is a plastic-coated metal spine held

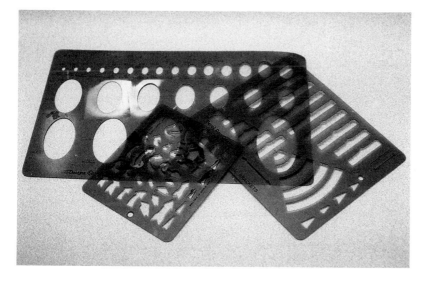

Every studio needs a complete selection of ellipse and circle templates, as well as special-purpose templates.

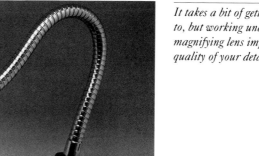

It takes a bit of getting used to, but working under a magnifying lens improves the quality of your details.

down with metal weights called ducks; a newer design features interlocking plastic strips, and is less cumbersome than the traditional style.

Most illustrators regard perspective drawings the same way they regard bookkeeping: a necessary evil, to be done quickly but accurately. We've all done drawings with figures that appear to float above the ground, or interiors that look as if the walls are oddly folded—an inaccurate perspective drawing, like inaccurate bookkeeping, is immediately apparent. What the pocket calculator has done for bookkeeper, printed *perspective charts* have done for the illustrator. The grids are drawn in normal, telephoto, and wide-angle views. In addition, there are charts for high, medium, and low viewpoints. I use the large (22-by-28-inch) charts from Graphicart, although similar products are made by Lawson and Skapa.

How many hours per year do we waste waiting for ink, paint and gesso to dry? A common *electric hair dryer* can take a big bite out of that time. In addition, the hair dryer can be used to warm masking tape and friskets that have been left on too long, thereby softening the adhesive bond and allowing them to be removed without tearing the surface.

REFERENCE PHOTOS

Working directly from a model is the ideal way to gather visual information. It allows you to do what an artist does best—interpret a three-dimensional object on a two-dimensional surface. A one-eyed camera will never translate a solid form as convincingly as a two-eyed artist, because the camera cannot accurately perceive space. But when it comes to recording texture and detail, the camera is extraordinary.

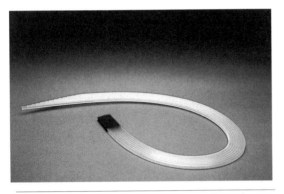

Complex curves are usually drawn section-by-section with French curves, but this multisectioned curve allows you to draw it as one continuous line.

Printed perspective charts make perspective drawings a snap.

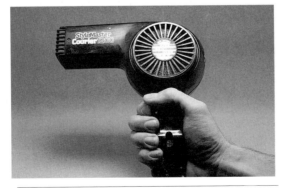

For drying paint, or removing friskets or masking tape without harming the surface, keep a hair dryer handy.

When used properly and not relied upon instead of artistic skill, reference photos can help you to create a more convincing illustration. There are several ways to go about this, the most direct of which is to take your own photos. With this in mind, every studio needs a Polaroid camera. The overwhelming choice of illustrators is Polaroid's 600SE, often referred to as the *Goose*, because the *6* looks like a *G.* It has a high-quality lens, a split-image rangefinder, and interchangeable film backs, and it handles ultra-high-speed film. Unlike most Polaroid cameras, it can use black-and-white film, which is better than color for reference purposes. To get a better understanding of this, turn up the color controls on your television set—although the resulting image is vibrant, it lacks solid form. If you then turn the colors off, you are left with a solidly rendered image. This is because a two-dimensional image's illusion of space and solidity does not come about through the hue and chroma of color, but through carefully selected values of those colors. This is why black and white is better than color for reference photography.

Unfortunately, the Goose is no longer manufactured, but there are plenty available on the used-camera market. Check your local camera shop or get a copy of *Shutterbug.*

It appears that Ilford had the illustrator in mind with the development of 35mm XP2 film. Although Ilford rates the film's speed at ISO 400, it has a wide latitude of correct exposure—it's nearly impossible to take an improperly exposed picture. Better still, XP2 black-and-white prints can be developed by your local one-hour photo processor.

Given the advantages of XP2 film, a 35mm single-lens-reflex (SLR) camera with XP2 film has far greater capabilities than any Polaroid camera, including the Goose, and the market abounds with excellent SLRs. Nikon equipment is particularly good, sturdy enough to withstand life in an illustration studio, and the auto-focus and auto-exposure capabilities of the Nikon N8008 practically guarantee a sharply focused shot.

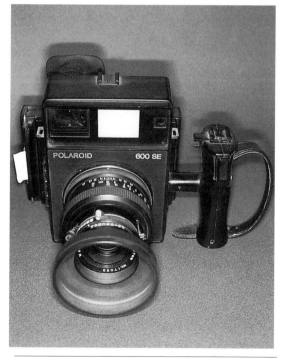

The "Goose"—the Polaroid 600SE camera—with its interchangeable film packs and high-quality lenses, delivers the most professional-quality photos of any Polaroid camera.

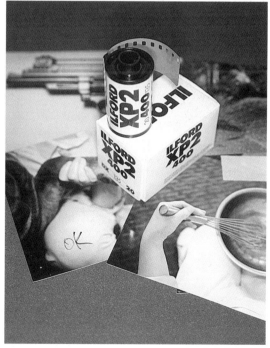

Ilford XP2 film allows you to take high-quality black-and-white photos with your 35mm camera, and can be processed at any one-hour processing lab.

Using the Correct Lens

There is a huge difference between a good photograph and a good *reference* photograph. While a good photograph can have streaks, blurs, featureless shadows and burned-out highlights, a good reference photo must be sharp and show detail in the shadows as well as in the highlights.

Knowing how to achieve your desired photographic results begins with understanding how a camera "sees" things. We don't perceive any distortion when we stand 6 feet away from a person, but the person appears distorted if we take a photo from that distance. Why? Our eyes scan a subject from head to toe and relay the visual information to the brain, which then constructs an undistorted composite image from the scanned information. This composite image that we see is really an optical illusion. To test it, try standing 6 feet away from your model, and use a pencil to visually measure the model's head. Hold

that mark on the pencil, and then look down and measure the model's foot—it should measure the same as the head, because those two body parts are about the same size, but it doesn't. Instead, the foot appears to be half the size of the head. That's a *wide-angle distortion*. If your illustration calls for an unrealistic and distorted drawing as its base, you can duplicate this effect by standing close to your model and using a 24mm lens on your camera.

Change your station point to 18 feet away from your model and measure the head-to-foot relationship again. Now it will be correct. You can duplicate this view by using a *moderate telephoto lens* (105mm to 135mm). The most important change here did not involve the lenses—it was the change of the station point. If you had used the 24mm lens from 18 feet, the resulting proportions would have been identical. However, the image on the film would have been minuscule, requiring extensive enlargement. The short

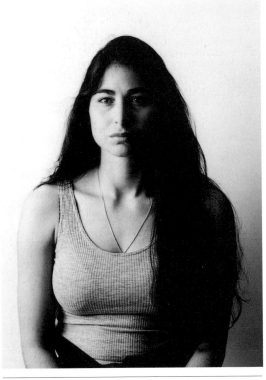

This shot, taken with Ilford XP2 film and processed in a one-hour lab, is an example of form light. The shadows are dark and dramatic.

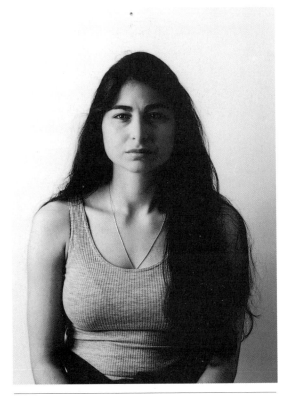

The same form light setup, with the addition of a piece of white illustration board placed on the shadow side of the subject, produced this shot. The shadows show much more detail and the subject loses little, if any, drama.

telephoto lens is merely a convenience. You can take undistorted pictures with a shorter lens, as long as you remember to maintain your distance.

Positioning your camera at the vertical center of your subject yields the least distortion. For a standing figure, position the camera at the height of the subject's hips. A lower camera position will create an imposing or monumental appearance; a slightly elevated camera position can make your subject look vulnerable.

Lighting

More than anything else, lighting creates the mood and emotional impact of an illustration. Again, don't lose sight of the ultimate goal of these photos—lighting techniques that may be entirely appropriate for advertising or fine arts photography convey more illusion than information, and can be all wrong for reference photography. Take a look at an atmospheric cosmetic advertisement, for instance—the soft lighting effect would be useless for reference purposes.

The following types of lighting produce differing emotional effects that are useful to the illustrator, and are worth keeping in mind as you set up your shots:

- *Overhead light*, a variation of form light, makes the subject look as if it's on a stage. Moving the light directly overhead creates a greater feeling of mystery.
- *Rim light* is created by placing the light behind and slightly to the side of the model. The result is a silhouette with a few features delineated by the light. The effect can be either mysterious or menacing.
- *Form light*, the type of lighting most frequently used by illustrators, is created by placing the light to the front and side of the model. As the name implies, form light creates a feeling of solidity and form. It doesn't create strong emotional impact.

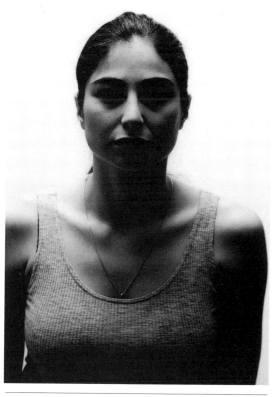

Overhead lighting: The light source is placed directly overhead to create a dramatic, and mysterious feeling to the subject.

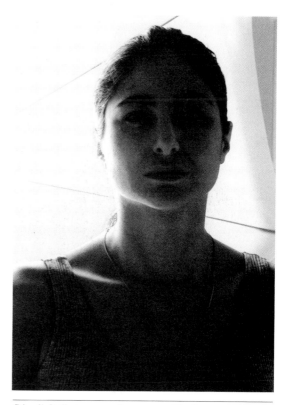

Rim light flattens out the contrast. Moving your subject at various angles to the light can show more or less visual information.

- *Back light* compresses the values and contrast in the subject, which can be helpful in creating a lyrical or romantic feeling. It's best when combined with some judiciously softened edges. Because there is so little apparent solidity when using back light, try to use shapes and contours that are easily recognized.

- *Front light* is useful for factual renderings and product illustration. It doesn't impart any emotion to the subject.
- *Underlighting* can be used to create unexpected effects, because we are used to our light sources, whether artificial or the Sun, coming from above. The typical result is a spooky, ethereal effect.

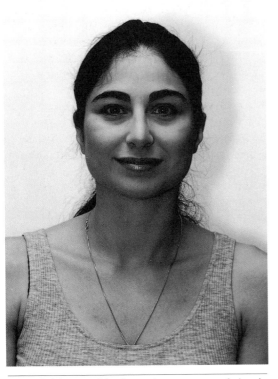

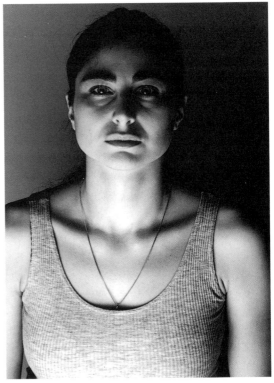

Front lighting provides the maximum amount of visual information but very little emotional content. It is therefore useful for product or factual illustration.

Underlighting is usually used to create a spooky feeling.

PRO'S TIP: LIGHTING

- If the light is too harsh and contrasty, soften it by putting a sheet of tracing paper between the light and the subject.
- If the shadows are too deep, place a reflective sheet of illustration board on the shadow side of the subject.
- If you want deeper shadows, place a sheet of black matte board on the shadow side of the subject.

Action and Mood

Draw from live models every chance you get—it will develop your powers of observation. Of course, you will still photograph your models for reference, but these well-developed powers of observation will help you to produce convincing poses. Once you understand the elements of a convincing pose, you'll be able to guide your models in striking such poses for you. Norman Rockwell used to act out his desired poses for his models. He knew that all poses must be exaggerated, because they become watered down as the illustration progresses. Similarly, the master illustrator Robert Fawcett favored starting out with a sketch of almost savage intensity, because he knew its emotional power would become diluted in the later stages of the illustration.

Individual character was the quality most important to Rockwell when choosing a model. As a result, he selected many of his models from among his neighbors. For commercial and advertising illustration, actors recruited from local playhouses make ideal models for reference photos—they have no difficulty in exaggerating expressions for the camera.

Synthesis

The illustrator often brings together reference photos from a variety of different sources to put into one illustration. Every element should be selected with an eye toward creating the proper emotion in the viewer. In selecting backgrounds for these compositions, remember that the figures should be photographed to fit into the perspective of the background photo, and that the light source on the figures should be similar to that of the background. Personally, when I shoot reference photos for an illustration, I prefer to locate the background reference first, and then fit my figures to it.

Don't underestimate the value of costumes and props to help create the mood—they add authenticity. I've done a lot of military illustrations, and as a result I've amassed quite a collection of uniforms and weapons. Using just the right costume and prop adds authenticity to your illustrations, and can save you the embarrassment of having a reader point out that you used the wrong clothing, or that you omitted something. Elements that are not in your reference should not be faked in the illustration—proper preparatory work at the photo stage will save you hours of drudgery later on.

The Morgue

Yes, you've now entered the morgue. Don't worry, it sounds much worse than it is—the morgue is just the illustrator's term for a picture file (or a clip file or swipe file, or whatever else you may choose to call it). It contains pictorial reference clipped from magazines. The pictures are arranged and

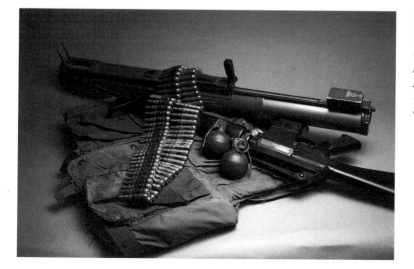

The requirements of a project often require the illustrator to be a good historian. Costumes and props must be as authentic as possible, like these props from my collection of military equipment.

filed into various categories and subcategories, so that the illustrator can refer to them later if an appropriate assignment comes along.

To start a morgue, you'll need a file cabinet, file folders, and stacks of magazines. Working on the morgue is something to do when you are between assignments, or when the stack of magazines starts looking like a fire hazard. Some large studios have such extensive morgues, they require a full-time librarian; most illustrator's morgues are on a far more modest scale—a couple of file drawers.

The category list for the morgue in my studio is shown below. Obviously, there are no specific rules to compiling this sort of resource listing, and different illustrators may have requirements that suggest different arrangements and category groupings.

The Fairburn System of Visual References
The Fairburn System, which consists of three series of books published by Mitchell Press in 1979, represents a landmark in photo-reference. Virtually any pose or expression a human being can strike is documented in these books, providing invaluable reference for illustrators. The *Figures and Hands* series is comprised of three books of photographs, each showing a variety of poses. For each given pose, shots were simultaneously taken from slightly above the model, at waist level, and slightly below the model. Moreover,

CATEGORY LISTING

I. People
 A. Children
 1. Babies-
 Boys-Girls-
 Teenage-
 Playgrounds-
 Toys
 B. Men
 1. Angle-
 Full Face-
 Profile-
 Mature-Old-
 Expressions
 C. Women
 1. Angle-
 Full Face-
 Profile-
 Mature-Old-
 Expressions
 D. Miscellaneous
 1. Embraces-
 Crowds-
 Famous People
II. Costume
 A. Women's
 Fashions
 B. Men's Fashions
 C. Period Costumes
 D. Miscellaneous

III. Animals
 A. Domestic
 B. Wild
 C. Dogs
 D. Horses
 E. Miscellaneous
IV. Nature
 A. Gardens and
 Flowers
 B. Trees
 C. Snow and Water
 D. Miscellaneous
V. Housing
 A. Exterior
 B. Interior
 C. Furnishings
VI. Transportation
 A. Aircraft
 B. Space
 C. Automobiles
 D. Boats
 E. Public
 F. Miscellaneous
VII. Industry
 A. Stores and Offices
 B. Computers
 C. Farming
 D. Manufacturing
VIII. Art

IX. Science
X. Entertainment
 A. Music
 B. Dance
 C. Theater
 D. Miscellaneous
XI. Sports
 A. Events
 B. Individual
XII. Geography
 A. Europe
 B. Asia
 C. Africa
 D. Islands
 E. Australia
 F. North America
 G. South America
 H. Miscellaneous
XIII. Miscellaneous
 A. Church
 B. School
 C. Government
 D. Street Scenes
 E. Disaster
 F. Fabric Folds
 G. Flags
 H. Food
 I. Holidays
 J. War

each pose is shown from the front, the back, and all sides. The three books are devoted to, respectively, males, females, and situations and hands.

The other series use the same approach to focus on other areas. The books in the *Faces and Heads* series focus on males, females, and ethnic and character types; the *Children* series, which covers infants through teenagers, is divided into males, females, and situation poses and hands. The models are attractive and the poses are useful, and the ethnic and character types are extraordinary. Simply put, the Fairburn System is an essential studio tool. In addition, Ernest Burden's *Photographic Entourage* (McGraw-Hill, 1990), a more modestly priced collection of snapshots, is a useful source of background figures, automobiles, boats, and trees.

The Fairburn System of Visual References has thousands of photos taken with the illustrator in mind. Every pose is shown from numerous angles. The collection of ethnic and character faces is very useful.

Stock Photos

Although stock photo houses primarily cater to clients who buy photographs for reproduction, they will also research and supply high-quality photos for illustration reference. Don't worry about blowing your budget—most stock photo houses even have special reduced rates for illustrators.

One of the best sources for historical reference, movie stills, and news photos is the Bettmann Archive, in New York. Stock houses like H. Armstrong Roberts and Camerique tend toward more commercially oriented images. Sample offerings of the stock house can be seen in various annuals and in the houses' own catalogs.

Video and Photography Combined

This method is wonderful. It requires a video camera, a four-head video cassette recorder (VCR) with freeze-frame capabilities, and a 35mm camera with an adjustable shutter speed. You can shoot action sequences with the video camera, replay them on a television with the VCR, and select, frame-by-frame, the perfect pose for your illustration. Then, with your 35mm camera mounted on a tripod, and using a shutter speed of $1/30$ second or slower, photograph your chosen frames right off the television screen. The possibilities for

Reference pictures taken from freeze-frame videotape images. These shots show how well color film can capture the video image, although you could also use black-and-white film.

dramatic reference photos from such shots is endless. The combination of 35mm photos, one-hour photo labs, and the VCR produces the most valuable reference available to today's illustrator.

Finally, a closing word of caution regarding reference photography: Don't let the camera's capabilities become a substitute for your own. Blind faith in the accuracy of photographic reference has spawned an unfortunate school of illustration in which every detail is painfully rendered and every edge is painted with unrelieved sharpness. The problem with this is that humans don't perceive objects this way. In essence, *photo-realism* is a contradiction in terms. Trust your eyes, and use reference photography as a tool, not a crutch.

CHAPTER 4
TRANSFERRING THE DRAWING

Most illustrators enjoy creatively working out the initial drawings and compositions, and we all enjoy making the final illustration, but between these initial working drawings and the finished piece is a task nobody enjoys: transferring the drawing.

The time-consuming process of transferring drawings has been with us since the earliest days of the graphic arts. In this chapter, we'll explore several approaches toward this tedious but nonetheless important task. Some of the methods discussed herein have been with us since antiquity; a few employ new materials to update these old methods, in an effort to make them more efficient; and some, like blueline transfer, are fairly recent innovations that may be new to you. Any of them, however, can help to speed you through an otherwise dull task.

THE LIGHTBOX

This method is useful when transferring your drawing onto a piece of paper. The underdrawing, which is usually done on tracing paper, is taped to the back of the drawing paper then placed on the lightbox, which should be bright enough to shine through a sheet of three-ply bristol board. In order to achieve a finished drawing, rather than a tracing, it's important to have a well-positioned lamp illuminating the drawing on the lightbox—without it, you will tend to *copy* the underdrawing, rather than *refine* it. As you work, use a magnifying lens mounted on a flexible gooseneck to refine small details.

PROJECTED PHOTOGRAPHS

One of the pitfalls inherent in drawing directly from a projected photo, such as described in Chapter 3, is that the omission of the preliminary sketch often leaves many drawing problems unresolved. This often results in those horrid illustrations where the photo reference is dreadfully obvious. Norman Rockwell solved this problem by taking the extra step of using his photo reference to produce a completely rendered drawing of the proposed illustration. In this technique, the drawing is done at the same size as the finished piece, and all of the details are worked out in this working drawing, allowing any problems to be solved at the drawing stage. The drawing is then photographed, and *that* photo is projected onto the canvas.

When using this method, it's best to break down the illustration process into ordered

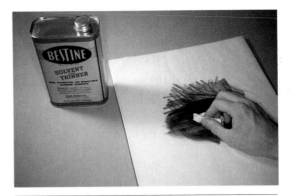

Making smudge-free transfer paper with graphite from a soft pencil, dissolved and rubbed with rubber cement thinner onto a piece of tracing paper.

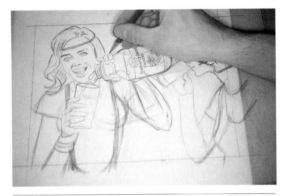

To keep track of which lines have been transferred, use a hard colored pencil, such as the No. 744 red Berol Verithin used here.

Saral transfer papers: The graphite color is for working on light-colored supports; the red and yellow are for transferring to dark supports.

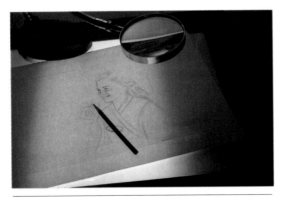

A blank sheet of bristol board on a lightbox. Note the preliminary underdrawing underneath the bristol board.

sections. While not all projects will require such a structured approach, sticking to this plan teaches you to anticipate and think ahead, thereby avoiding time-consuming mistakes.

1. The concept stage—quick ideas and thumbnails, value studies.
2. Pose your models and gather reference.
3. Use your photo reference to make a working drawing, which should be the *same size as the finished illustration*. All problems of composition, placement of lights and darks, perspective, and expression should be solved here.
4. Photograph the completed working drawing.
5. Paint color studies on extra prints of the photo.
6. Project a copy photo onto the support, same size as the working drawing.
7. Solve any remaining problems with the drawing, as well as any relating to values; work out the color. All that remains is to apply the paint and concentrate on finishing the piece.

Learning to think of the creative process in these terms saves time and, in removing many potential problems, results in a seemingly effortless illustration.

GRAPHITE TRANSFER

While using a lightbox is a splendid way to transfer the drawing from tracing paper to board or paper, the lightbox is useless when transferring a drawing to illustration board; for that, we need transfer paper. Think of transfer paper as a form of carbon paper placed between the working drawing and the illustration board.

The old standard method is to rub graphite from a soft pencil all over the back of the working drawing and dissolve it with Bestine rubber cement thinner, applied with a tissue. The drawing is then traced over with a red pencil. The red pencil lines help you to keep track of where you've been. A variation of this is to use Saral transfer paper, which is made in five colors: graphite, non-repro blue, red, yellow and white. Saral is made in 12-foot rolls and is a useful product.

There are several problems with this method: Tracing over the drawing with a

red pencil destroys the drawing; the transferred drawing can look mechanical and crude; and applying too much pressure while tracing can indent the surface of the illustration board.

PHOTOCOPY TRANSFER

This is a wonderful way to transfer highly detailed drawings. Using a photocopy machine, copy your drawing onto clear copy film, which should be available at most copy centers that make overhead projection slides. Flop the film to produce a mirror image, and then make a paper copy of it. Place the copy face-down on the illustration board and, using a paper towel soaked in xylene or acetone (the choice of solvent depends on which copier you use), wet the back of the copy. The solvent causes the photocopy ink to transfer to the illustration board.

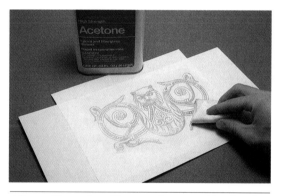

After making a clear-film copy of your working drawing and a subsequent photocopy of the film, lay the photocopy face down on your illustration board and lightly moisten the back with acetone.

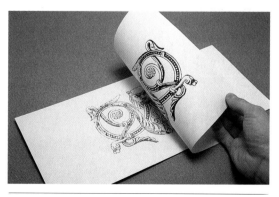

By the time the acetone evaporates, the photocopy will have transferred to the support.

BLUELINE TRANSFER

This method is done photographically, and is a time-saving way to transfer your working drawing to illustration board. Start by sending your drawing to a darkroom to have a negative made. When you have the negative, spread Guide-Line Sensitizer Solution, a photosensitive emulsion, on the surface of your support. When it's dry, place your negative in contact with the illustration board and expose it to a high-intensity light source or sunlight for about five minutes. Then wash away the unexposed emulsion with Guide-Line Developer. The light-struck areas will remain as non-repro blue lines, which can be bleached if they are too bold.

FIXING

Once the drawing has been transferred, it must be protected from the layers of paint that will follow, so that the drawing and paint don't react with each other. Graphite, for instance, tends to smudge or strike through even the thickest layers of paint. The most common method of preventing this is with spray fixative. Krylon Workable allows subsequent erasing and reworking, and can add tooth to a surface that has become slick through overworking.

The solvents in oil paint, however, easily dissolve Workable fixative. Krylon Crystal Clear provides greater protection, and with repeated applications yields a glossy

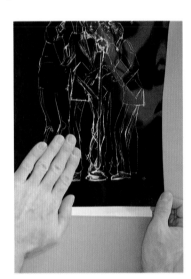

Blueline transfer: After the board has been coated with Guide-Line Sensitizer Solution, a film negative of the working drawing is laid onto the board's surface and exposed to sunlight.

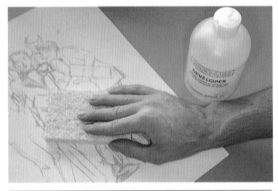

Guide-Line Developer is then applied over the board and the drawing is developed in non-repro blue.

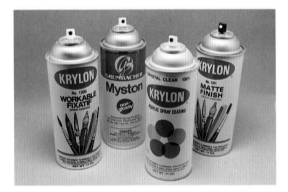

Isolating fixative sprays. Workable Fixative is the weakest, Crystal Clear the strongest.

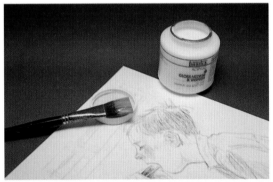

If you are painting in oils, isolate the drawing with acrylic medium or varnish.

surface. Krylon Matte Finish protects just as well, but dries to a flat matte finish.

When applying water-soluble paints (watercolor, gouache, etc.) to slick surfaces that may repel water, an isolating spray of Grumbacher's Myston provides a congenial surface. You can even paint watercolor on glass and metal after it has been sprayed with Myston.

After applying the appropriate fixative, the surest way to prevent the drawing from bleeding or being scrubbed away by layers of painting is to paint a coating of clear acrylic medium over the surface. A thin coat of Liquitex Gloss Medium, for instance, will withstand any paint except lacquer.

—— GESSO OVER THE DRAWING ——

If your transferred drawing is too strong and dark (as may be the case when transferring a photocopy, for instance), or if the surface of the paper is overworked or mortised, or if you just want to work on a smooth gessoed surface, just apply several coats of acrylic gesso to the support. I prefer to apply it with a spray gun. Don't be afraid to cover your drawing. After the gesso dries for half an hour, sand it with 320-grit sandpaper until the surface is smooth and the drawing shows through the gesso. Depending upon how much gesso is sanded off, the drawing will appear faint or bold—the choice is yours. And the drawing obviously won't bleed through a layer of gesso, no matter how thin that layer is.

The absorbency of acrylic gesso varies. Liquitex is the most absorbent gesso, and most resembles traditional rabbit-skin glue gesso; Daniel Smith's World's Best Gesso has the hardest finish and is least absorbent. For a particularly smooth surface, try using World's Best and sanding it with 2000-grit sandpaper. And Holbein gesso comes in three different types: "S" has the finest grain, "M" has a medium grain, and "L" has an aggressive tooth.

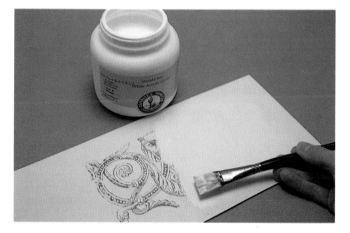

A thick coat of acrylic gesso painted over an image can tone down a drawing that appears too strong and provide you with a smooth working surface.

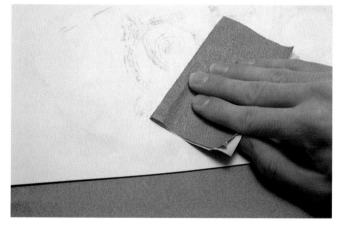

After the gesso dries, the surface is sanded until the image begins to show through. This thin remaining coat is enough to isolate the drawing and provide an excellent painting surface.

CHAPTER 5

SUPPORTS

Whatever you draw and paint on, whether it's paper, canvas, board, or wood, is called a *support*. Today's improved manufacturing practices have given us supports that are at least as good as anything used by the old masters, and manufacturers are concentrating enormous and effort and resources toward producing additional supports and surfaces that will capture the artist's fancy. New *strippable* surfaces, for example, are manufactured to meet the changing technology of laser-based color separation. Optical brighteners are now added to paper pulp to make white surfaces even whiter. Modern canvas primed with acrylic primers won't crack or turn yellow like those primed with white lead oil primer. Unlike traditional drafting vellum, polyester-coated vellum won't buckle from moisture or yellow with age. Unless you are working on newsprint, these modern supports practically guarantee that your artwork will outlive you.

TRANSPARENT PAPERS AND ACETATES

Transparent tracing paper, although rarely used for finished pieces, is indispensable for working drawings. The upright lucy can focus through its glass copyboard and directly onto the back of tracing paper. And because of its transparency, tracing paper is ideal when used as an underdrawing on the lightbox. It can be made even more transparent by spraying both sides with workable fixative.

Heavyweight *vellum* is slightly less transparent than tracing paper, but it is more durable. Unlike tracing paper, vellum will take ink without cockling and buckling. Unfortunately, it tends to become brittle and yellow with age, making it less than ideal for finished illustrations.

Denril, which features a smooth polyester surface with a subtle tooth, has all of the advantages of vellum and none of the problems. It will accept ink, colored pencil, marker, and most paints, and even allows you to scratch back into the surface for corrections or scratchboard effects.

Illustrators have a wide choice of *acetates*. The most popular is frosted acetate, which accepts ink, colored pencil and most paints, and, like Denril, allows you to scratch back into the surface. Prepared acetate is glass-clear but has a special surface that accepts water-based paints. Acetate tends to swell and contract with weather variations, so if your project demands dimensional stability, use *prepared mylar*, a stable polyester film.

Transparent tracing paper. This support is fine for working drawings, but is not sturdy enough for finished illustrations.

Denril is almost as transparent as tracing paper, but is much sturdier. Its matte surface accepts all dry and wet media.

Frosted acetate accepts most dry media and some wet media.

Prepared clear acetate has a coating which allows it to accept inks and aqueous media. It does not accept most dry media.

OPAQUE PAPERS

Paper is classified by weight, color, and surface finish. The weight-classification system can be confusing, as the formula is based on the weight of 500 sheets of a supposedly "standard" sheet size that actually varies from paper to paper. Text-weight papers, for example, are generally manufactured in larger sheets than cover-weight stock, so that 60-pound cover paper may actually be the same weight as 110-pound text paper. Don't worry if this sounds confusing—you'll learn the weights of the papers you prefer. To help you along, get a copy of the *Pocket Pal*, a graphic arts production handbook distributed by International Paper Company. It's available from paper supply companies and is free to professionals.

Specifying paper color is obvious, but most of the time you'll be using white; of greater concern to the illustrator is the surface finish. This is another opportunity for confusion— one papermaker's cold press finish is another's rough. There just isn't much agreement on nomenclature among the different mills, although you can generally assume that hot press means very smooth and cold press implies a moderate tooth, at least within a given product line. Here's a rundown of some of the more common products: Arches, the 500-year-old French papermaking firm, produces gelatin-sized, 100-percent-rag watercolor papers in hot press, cold press, and rough varieties. Arches 90-Pound Hot Press is similar in weight and surface to Strathmore 2-Ply Cold Press Bristol. Strathmore Hot Press, or Plate Bristol, has no tooth and a bit of a shine to its surface. Arches Hot Press works well for all but the finest of pen lines. Strathmore Hot Press Bristol is smoother, and is capable of holding the faintest of pen lines. And for airbrush work, Badger's Brite White (in Hot Press and Cold Press varieties) and Frisk's CS 10 are specifically designed for the medium. Obviously, the choices here will depend on your needs and preferences.

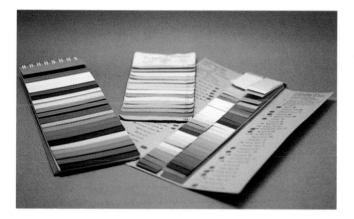

Swatch books such as these, which show the color ranges of various brands of pastel papers, can help you sort through the maze of color and surface-quality options.

These Arches papers were photographed in a raking light to show the textures of, from left, their White, Cold Pressed, Rough, and Hot Pressed, and White finish papers.

Halfway between hot press and cold press is kid finish, which, like the others, varies from mill to mill. Somewhat more standardized are laid finish papers, which feature impressions left in the wet paper pulp from the lattice-like wire of the paper mold. Laid surface papers are commonly used for charcoal and pastel drawings—the distinctive horizontal lines imbue the drawing with a "fine arts" feeling. My favorite is Bainbridge No. 169 Laid Finish Illustration Board.

Similar to laid finish papers are linen surface papers. Most commonly used as writing and stationery paper, this stock is also particularly useful in creating line art that has the appearance of tonal shadings. Among the various brands avaiable, Neenah Paper's 24-pound Classic Linen is a good choice.

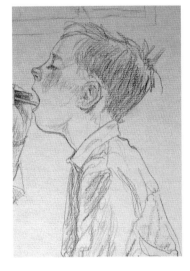

A pencil drawing on a laid finish board. Note the horizontal texture of the surface.

Another paper with an embossed finish is Bainbridge Coquille board. Bainbridge Coquille No. 2 has a coarse surface suitable for artwork that will be reduced, while No. 3 has a fine surface designed for same-size reproduction. If you are more concerned with line art, black Spectracolor and Korn's lithographic pencils both work well on coquille and linen surfaces.

ILLUSTRATION BOARD

Illustration board is actually high-quality drawing paper mounted to chipboard. Crescent, Letramax, Bainbridge, and Whatman are some of the most commonly available brands. Since the top layer is drawing paper, different papers can be used to create different boards. Whatman, for instance, offers cold-pressed, hot-pressed, and rough watercolor paper mounted on heavy chipboard.

Paint, gesso, and heavy layers of acrylic can warp and buckle some illustration board; *double-weight* Bainbridge board is your best defense against this. For dry media and pen and ink, Letramax 2000 or the ultra-smooth Letramax 4000 are excellent. Letramax and Crescent also make strippable boards, which allow the surface to be peeled off the backing board for color scanning (see Chapter 2). In fact, all boards can be stripped if you're careful about it, but only the new strippable surfaces can be remounted to their carrier boards.

Strathmore Hot Press Bristol board is thin enough to see through when used on a lightbox. For pen and ink, it's hard to beat.

Crescent 59208 strippable Scanner Board, Bainbridge No. 80, and Letramax 2000, with its super-smooth surface.

If you intend to use oil or alkyd paints on paper or illustration board, isolate the paper with gesso, gelatin, or an acrylic medium, or else the oil will soak into the surface, staining it. One of the best ways of applying gesso is with an airbrush—the spraying process.minimizes buckling and warping. If you want the paper surface to show through, you must size the surface with a clear acrylic or gelatin dissolved in hot water. Gelatin provides a wonderful working surface—try it.

There are several types of patches you can execute. To add a figure or object to an illustration, draw or paint the figure to be added on a similar piece of paper. Cut out the figure, being careful to keep the knife perpendicular to the surface, and glue it into position on the illustration with 3M Spray Mount. Then burnish the edges through a protective sheet of paper. Because the laser scanner doesn't cast shadows, the cuts will be invisible.

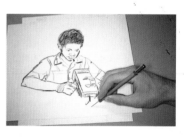

To patch an area, cut an irregular shape (*not* a square shape, which is difficult to hide) from a thin sheet of paper similar to the illustration surface. Feather the edges of the back of the patch with sandpaper (so that the edge will be less apparent to the camera), glue it in position with Spray Mount, and continue the drawing.

More radical than a patch is a *mortise:* Simultaneously cut an irregular patch through the drawing and an identical sheet of paper. Remove the section from the drawing and replace it with the identically shaped patch. Tape it on the back and burnish the cuts together through a thin sheet of paper.

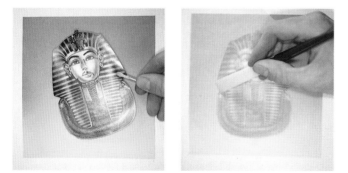

This Egyptian figure was drawn on one-ply Strathmore HP Bristol board and cut out. The back of the drawing was then coated with Spray Mount. The figure is positioned on the illustration board (left), to which an orange-yellow background has already been applied. The edges are then burnished through a tracing paper slipsheet (right). The cut marks are invisible to the printer's laser scanner.

Cutting a mortise: First, lay an identical piece of paper (two-ply Strathmore CP Bristol in this case) under your drawing and cut through both pieces at once. Be sure that the drawing to be transposed is positioned over the part of the underlying sheet where you want it to appear. When you finish, remove the blank shape from the underlying sheet and replace it with the identically shaped section that contains the drawing. Then tape the drawing in place on the reverse side. Any visible edges can be burnished out of sight.

MASONITE

Masonite fiberboard, the sturdy support, is cheap, readily available from lumber yards in 4-by-8-foot sheets, and easy to cut with a saw or craft knife, and it will not buckle. Of the two available thicknesses, the ⅛-inch untempered board is suitable for all but the largest of pictures.

In most cases, you won't want to work on the surface of the Masonite itself. One or two coats of gesso over the Masonite will provide an ideal painting surface. Sand the Masonite to provide a mechanical tooth to bond with the gesso. Acrylic gesso (I favor Liquitex and Daniel Smith's World's Best) is easy to apply with a brush or spray equipment. For a foolproof method of applying a smooth, even coat of gesso, use an inexpensive airbrush, like the Badger 350. To achieve a surface that adds liveliness to charcoal and pencil drawings, apply a thick coat of gesso with a coarse brush. Don't worry about the gesso warping the board as it dries—Masonite can withstand it.

Abitibi, also found in lumber yards, is ⅛-inch Masonite with a white enamel finish. It's as slick as a refrigerator door—too slick for ordinary painting—but its nonabsorbent surface is perfect for a wet, runny oil wash. If you find its finish to be *too* slick, it can be lightly sanded to give it tooth.

Masonite and Abitibi share one common disadvantage: They cannot be wrapped around a scanner's drum. A copy transparency must be made for reproduction purposes.

MAT BOARD

Mat board, an underrated drawing support that is particularly good for pastel, is available in a wide range of surfaces and colors. Bainbridge No. 4009 has a white silk surface, perfect for fabric-textured line drawings, while Bainbridge No. 4016 has a raw linen surface that is ideal for oil, acrylic, and casein painting.

Bleaching out selected areas of colored mat boards can be useful for opening up highlights. This can be done to most inexpensive colored mat boards with household bleach; the top-of-the-line boards, however, are bleach-resistant. (Remember to use synthetic-fiber brushes with bleach—it dissolves sable and bristle.)

Untempered Masonite is sold in 4-by-8-foot sheets at lumber yards.

Abitibi, a tempered Masonite panel surfaced with white enamel. A light sanding with 2000-grit wet/dry sandpaper will help paint adhere to its slick surface.

Gatorboard is composed of a layer of foam sandwiched between two layers of very hard plasticized fiberboard. Stronger and lighter than Masonite, Gatorboard requires a thorough sanding before it will accept gesso or primer.

No other support has the look of canvas. Canvas can impart a "fine arts" look to the most commercial illustration. And because it's a flexible support, canvas can be wrapped around the scanner drum.

We'll start at the bottom: canvas boards, which are just cheap canvas mounted on even cheaper cardboard. There's no reason to use them—your work deserves better. Moving up the ladder a bit, Fredrix produces several lines of factory-stretched canvases. These are made from real artist's canvas mounted on real wood stretcher bars. They range in size from 5 by 7 inches to 30 by 40 inches, and can be bought in a serviceable cotton duck, an ultra-smooth duck, and a Belgian linen.

Factory-stretched canvas, which usually comes acrylic-primed (the supposed advantages of oil-primed canvas are nonexistent), is a boon to the illustrator, whose time is valuable. But if you wish to stretch your own canvas, a traditional favorite is Fredrix No. 108 Stuyvesant, a double-primed smooth cotton with a light-gray surface. It is sold in 40-inch-by-6-yard rolls.

To avoid a monotonous canvas texture, you can create a more painterly base to work upon. Start by painting white lead over the canvas with a 1-inch bristle brush. Thin the paint with turpentine—it should brush out easily but still have enough body to leave distinct brush marks. As the turpentine evaporates, the white lead will return to its original stiffness; after this happens, smooth down the peaks with a large palette knife and leave it to dry for at least a week. Because of the long drying time, it's wise to prepare several canvases at once.

Another very attractive surface is raw linen that has been sized with rabbit-skin glue or a clear acrylic medium. Sized raw linen has a warmth that is otherwise unobtainable—the tone of the raw linen is a perfect middle tone.

Fredrix makes prestretched artist's canvases in a wide range of sizes and finishes. These are a big timesaver for a busy studio.

Applying turpentine-thinned white lead to the canvas with a coarse bristle brush (top) is a good way to achieve a more painterly surface. After an hour or two, the paint will have dried and thickened enough for you to smooth down the high sections with a painting knife (bottom). After a week's drying, the canvas will be ready for use.

PRO'S TIP: POSITIONING YOUR SUPPORTS

Whenever you want to preserve the textures made with liquid paint, your support must be kept horizontal—this will keep the puddles of color from running. Conversely, when you want smoothly graded washes, keep your support aligned in a vertical position.

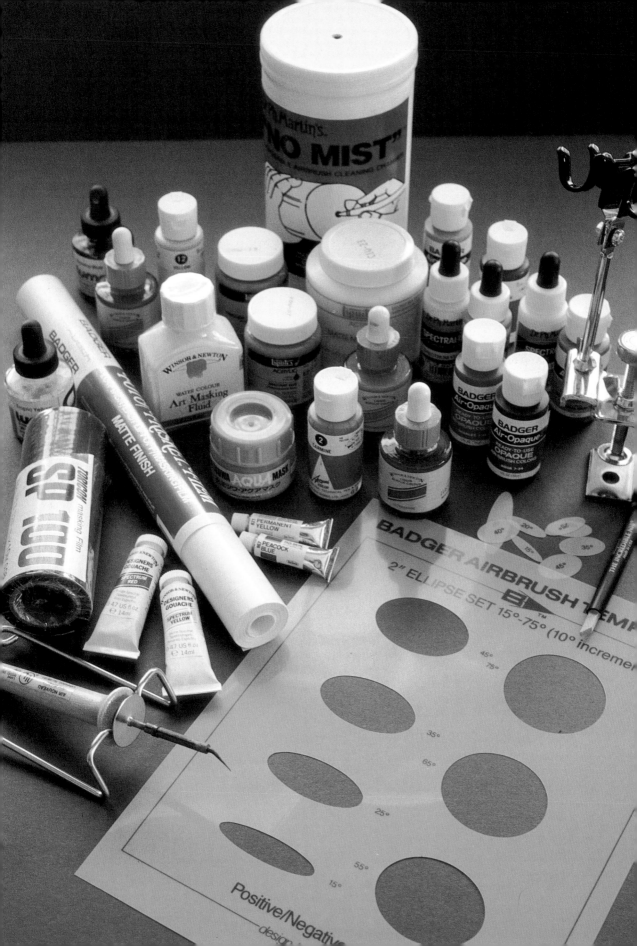

CHAPTER 6

MASKS AND FRISKETS

It's all right if you get paint on your hands. It's even acceptable for a bit of paint to get onto your clothing. But submitting an illustration that has the remains of unwanted paint spilling out from under a masked edge guarantees a rejection. All of us have had the experience of peeling away masking tape or a frisket only to see streaks of paint that have crept underneath or, even worse, trying to remove the tape or frisket only to have it grab and rip the surface of the illustration.

This chapter will show you how to avoid such disasters, providing you with the inside tricks of taming masks and friskets, masking razor-sharp edges, cutting flawless friskets without cutting into the support, and how to remove stubborn masks without damaging the underlying surface.

TAPE

Masking tape is a heavy-duty product made for use in automobile body shops—it's not made to be used by illustrators. Your best choice is Scotch Magic Plus 811 Removable Tape, a low-tack, ultrathin, clear tape with a matte surface. As its name implies, it won't damage delicate surfaces when removed. In order to prevent your paint from creeping under the tape, seal the edges with a thin coat of acrylic matte medium. (The acrylic won't affect most paint, but test its reaction to your paint on a test scrap first, just to be sure.)

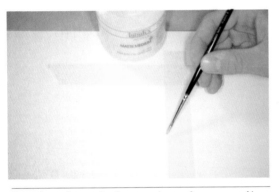

In order to keep paint from seeping under your masking tape, seal the tape edges with a light acrylic coat.

PRO'S TIP: REMOVING ADHESIVES

Here's a handy tip for removing masking tape, friskets, or any adhesive that threatens to damage the illustration as you remove it. Warm the adhesive with an electric hair dryer. While it's still warm, slowly pull the tape or frisket away. Any adhesive residue can be removed with Bestine rubber cement solvent.

MASKING FLUID

Masking fluid (also known as liquid frisket), a water-based latex that becomes water-repellent when dry, enables you to paint or draw lines and areas that will resist watercolor, airbrush, and light coats of acrylic. It is used for everything from keeping highlights open to masking out foreground figures while the background is painted.

Masking fluid is liquid rubber, and is difficult to remove once it dries on a brush, so never use good brushes when applying it. And before using masking fluid, wash your brush

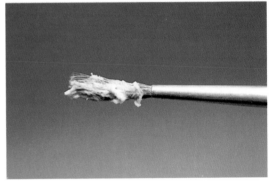

Masking fluid that has been allowed to dry on an expensive sable brush. Although the dried rubber can be removed, the brush will never be the same. Use a synthetic brush instead.

The Incredible Nib and its accompanying Incredible White Mask are the best combination for masking.

with soap and water and leave a little soap in the brush—this will keep the fluid from creeping into the ferrule.

Masking fluid can also be applied with a pen or, for straight lines, a ruling pen; remember to wash these tools frequently. A tool especially made for applying masking fluid is the Incredible Nib, a plastic barrel with a hard fiber nib at one end and a chisel nib at the other. It works quite well and is much easier to clean than a brush, and comes in a kit with a jar of white masking fluid and a rubber cement pickup for removing the dried mask. Winsor & Newton produces W&N Water Colour Art Masking Fluid in white and a lightly pigmented version. You might prefer the latter. It's easier to see. Masking fluid must not be allowed to stay on the surface of the artwork for any longer than necessary—it can stain!

An interesting but ultimately unnecessary variation on masking fluid is Mitsuwa Aqua Mask. It's much more fluid than latex-based masks and is designed for use with airbrushed acrylics. After acrylics are sprayed over Aqua Mask, the dry surface is lightly washed with water, removing the acrylic from the Aqua Mask–treated area. Unfortunately, most acrylics made for airbrush do not have enough binder to allow them to be washed without damage in the first place, and washing the surface of your illustration is asking for trouble. Aqua Mask is a solution to a nonexistent problem—stick with latex-based masks.

FRISKETS

Friskets are nothing more than adhesive stencils. Before the invention of frisket films, illustrators made their own friskets by coating sheets of tracing paper with rubber cement. But wet paint caused the tracing paper to wrinkle, and the paint would creep underneath it. No wonder the airbrush fell out of favor. Today we have a wide choice of prepared vinyl frisket films: high tack (highly adhesive), low tack, matte and gloss finish, colorless and tinted. High-tack frisket films, used for sign painting and on canvas and cloth, are much too adhesive for use by the illustrator. But low-tack frisket film can be laid onto painted surfaces without picking up any of the paint, making it ideal for illustration.

A good frisket film shouldn't leave any residue. It should be transparent, to let you see where you're cutting. It should be easy to cut, and should seal tightly enough to avoid any underspray. With these standards in mind, the various brands of supposedly "low-tack" frisket film vary widely. Frisk Film is one of the best, and Badger Foto/Frisket film, because of its exceptionally low tack, is a big favorite in my studio. Personally, I prefer the matte variety, because it accepts pencil.

Most manufacturers only offer frisket film in large sheets, but the Badger frisket offers the additional advantage of availability in an 8 1/2-by-11-inch size, which can save time when cutting and drawing a sizable number of friskets that must register with each other.

Low-tack vinyl frisket films are available in gloss and matte finish varieties.

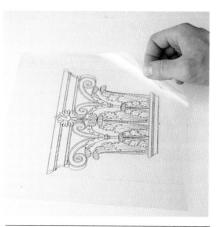

A sheet of Badger matte frisket film that has been run through a photocopy machine, with the preliminary drawing perfectly transferred. This is the ideal way to produce multiple friskets.

I make one drawing and photocopy it onto 8½-by-11-inch sheets of Badger matte frisket film. The Badger frisket film, which holds the photocopied images perfectly, is the only brand small enough to be fed into an office copier. Remember to feed both the film *and* its backing sheet into the machine—the heat of the copier may make the adhesive hold more aggressively to the backing sheet, but it won't affect the final tack when it's placed on your artwork.

Because the airbrush produces thin layers of paint with a relatively low level of opacity, any preliminary drawing on the support will still show through after being airbrushed. In order to avoid this, all drawing should be done on the frisket, not on the support. The easiest method for transferring a drawing to the frisket is to lay the adhesive side of the frisket onto an unfixed pencil drawing. Rubbing lightly with a burnisher will cause the drawing to offset onto the adhesive surface, after which the frisket can be laid onto the support.

If you intend to cut friskets, it's important to have a delicate touch with the knife—if you cut a frisket too deeply, you cut into the board. The best way to develop the soft touch you'll need is by practicing with Rubylith or Amberlith. The clear backing film will show just how deep you cut through the film. The ideal is to barely scratch the backing film. All it takes is a sharp knife and practice.

There are various ways to peel or "weed" friskets. We've all had the experience of using a knife tip to pick away at a frisket's edges, only to nick and tear the surface of the illustration. For small areas, use a beveled cutter from a compass. Just slide it flat to the surface and it will slip harmlessly under the film. Anything rubbed along a gouache surface, however, will leave a mark—for these extra-delicate surfaces, press the tip of a piece of masking tape near the edge of the frisket to be weeded. The masking tape has more of an adhesive tack than does the frisket, allowing you to lift the frisket without ever having to touch the illustration surface.

PRO'S TIP: TINTED FRISKET FILM

One of the difficulties encountered with airbrushing through friskets is the difficulty of seeing whether you've actually exposed the section to be painted. Many illustrations consist of a complicated series of frisketed areas— it's easy to become confused about which section is open and ready for painting. Tinted frisket films are a great aid in keeping track of where you are, and where you've been. If you don't have any tinted frisket film, you can easily make your own by spraying a light coat of a transparent acrylic color on the frisket film. Let it dry for at least 10 minutes before using it.

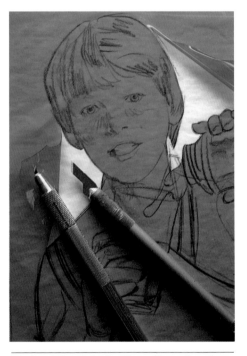

Toricon SP 100 frisket film will not disturb even the most delicate surface. Here the tinted film is used over a pencil drawing.

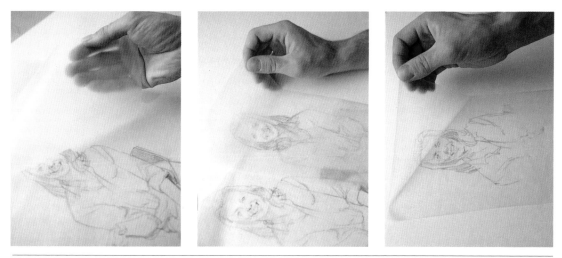

To transfer a drawing to a single sheet of frisket film, lay the film adhesive-side-down over an unfixed pencil drawing (left) and rub with a burnisher. The drawing will offset onto the underside of the frisket film (center). Then position the frisket on the support. The pencil lines will not transfer to the support, leaving the finished painting free of pencil lines striking through the paint.

To avoid tearing the surface of your support when picking up or "weeding" the frisket, pull it up at 90°.

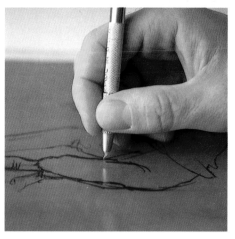

Cutting out frisket shapes is delicate work, because even the slightest cut marks that go though to your support will be glaringly apparent when paint is applied around them (top). In order to develop a lighter touch, practice with sheets of Amberlith.

— TORICON SP 100 MASKING FILM —

In the search for better, more efficient methods of illustrating, mistakes inevitably happen. When those mistakes threaten a deadline, the illustrator becomes desperate for a solution. Many of the techniques and discoveries in this book were born of such desperation.

In one such case, I had a series of 14 illustrations to do for an annual report. The concept involved illustrated figures moving among charts, which were rendered in perspective. The designer and client had agreed on an overall color for the background, which was to match a color chip from the PANTONE Color Specifier. One approach would have been to mix the color and then spray and sandpaper the 14 backgrounds, plus a few extra, in case of accident. But to save time—one or two days, by my reckoning—I decided to use large sheets of PANTONE paper in the desired color, mounted onto illustration board, and work directly on them. I tested paints on the PANTONE paper, and they worked perfectly.

It's always best to do the most mistake-prone aspects of a project first, so I began by painting in the figures—if anything went wrong with them, I could easily start again without risking the entire illustration. The charts, though simple to do, were time-consuming, because of the enormous number of friskets required—one for each color.

After two days, all the figures were painted and I was a day ahead of schedule. Because the chart colors had to be identical, I decided to airbrush the illustrations on a production-line basis—all of the red areas would be frisketed and airbrushed at the same time, then all of the blue areas, and so on. I positioned a sheet of low-tack frisket film on the first board and cut out the first area to be airbrushed. When I lifted the film, however, some of the PANTONE surface came away with it. Panic set in.

At this point, I saw that I had made a serious preparation oversight: The PANTONE paper had been tested for everything *but* its compatibility with frisket film. Even the low-tack Badger frisket film picked up some of the surface color. This is not an indictment of

Even low-tack films will pick up the delicate surface of PANTONE *paper.*

Toricon SP 100 Masking Film, which comes in blue (left and center) and clear, is the only film that won't damage delicate surfaces, no matter how long it's left on.

either the Badger film, which usually causes no such problems, or the PANTONE paper, which was never meant as a support for illustration.

Obviously, I would have to start over on the marred illustration. But what about the others? Could another solution be found? If all 14 illustrations had to be redone by the mix-and-paint method I had originally eschewed, I wouldn't be able to meet my deadline. First I tried to see if I could *make* the two products compatible. Warming the frisket film with a hair dryer, which usually loosens any adhesion (see Pro's Tip, page 50), did not help. Hoping to strengthen the surface so that it wouldn't tear when the film was removed, I sprayed it with fixative, which helped only slightly. Then came a coating of acrylic medium, which also helped, but the fundamental problem was unchanged: The paper was too delicate to resist tearing. The prospect of starting over from scratch loomed ominously.

Then I remembered a masking film which I'd never gotten around to trying, Toricon SP 100. It's a frisket film that adheres somewhat like plastic food wrap. This barely adhesive film stayed on the surface as well as regular frisket films, but could be removed and repositioned without removing any of the PANTONE surface. The Toricon film brought the job in on time and ultimately saved thousands of dollars of studio time.

Let's take a closer look at this product: SP 100 is a film with a softer surface than vinyl frisket films; because of this softer surface, it requires a bit more care in cutting. It comes in rolls ranging in width from 5 to 29 $^1/_2$ inches, and in clear and blue-tinted varieties. This is a product that every studio should stock.

ACETATES

Friskets allow you to mask out a sharp edge. But for a softer edge, you'll need to cut *acetate friskets*. Any acetate will do—Badger makes No-Tack, a 3.5-mil film that resembles Denril. Because acetate friskets are not adhesive, they can be raised from the surface as you airbrush, yielding a softer edge than an adhesive frisket. Acetates can be held in position with weights or magnets. The most common method is to hold them with the hand not holding the airbrush.

Cutting acetates requires less skill than cutting friskets. Regular shapes are easily cut with a knife; irregular shapes are more easily cut with a *stencil burner*, a miniature electric soldering iron with a fine tip. When using the stencil burner, be sure to have ample ventilation—the fumes from burning plastic can be extremely harmful. In my studio, we use Artograph's 836 Spray System, the best studio air-filtration system I've encountered—it mounts on the back of your drawing board. Even with a good ventilation system, however, don't place your head directly over the burning plastic as you work on it—it won't take much exposure to the fumes to land you in a hospital.

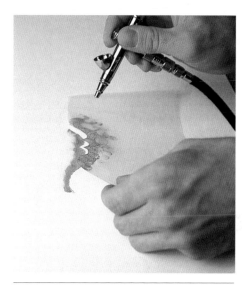

Acetates can be cut to shape and held on the surface for a sharp edge, or raised from the surface for a softer edge.

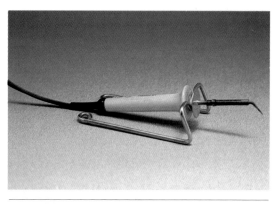

A stencil burner can cut intricate acetates and friskets much faster than a knife. It leaves a slightly ragged edge.

LASER-CUT FRISKETS

The ellipse and circle templates made for drafting are too thick to be used with an airbrush. Badger has produced a series of laser-cut ellipse and circle templates cut from their 3.5-mil film. The laser cuts are so accurate that the centers of the circles and ellipses register perfectly, allowing you to use both the negative and positive shapes—knowing that the negative and positive shapes mate perfectly, you can spray an ellipse through the negative template and then remove that template, fit the corresponding positive template over the area, and spray in the background color with no overlap of the colors. These inexpensive templates are essential for any studio.

PHOTOMECHANICAL FRISKETS

These products are known by many names—transfers, rub-down type, Identicolor proofs, Chromacolor proofs. Because they are produced photomechanically, they provide a great savings of time when you're cutting friskets, and can be used with any water-based paints. The most commonly known transfers are made by Letraset, whose rub-down letters are useful as friskets—each letter is made of a waxy substance that resists water-based pigments. After spraying color over rub-down lettering, the letters can be removed with masking tape, leaving the letterforms exposed against the sprayed background.

Letraset type, however, is limited to the typefaces offered, and thus is of limited use.

The artistic possibilities are expanded with the use of Chromacolor and similar systems, which can reproduce any line art—typography, illustration, a logo—as a frisket, and thereby free you from the constraints of stock typography. You can also order both negative and positive transfers, enabling you to frisket both the foreground and the background.

Often overlooked are the rub-down sheets of textures, which can add interest when used as a frisket material; Letraset calls theirs Instantex. And don't forget to investigate the wide range of rub-down rules, decorative borders, symbols, stars, arrows, ovals, dingbats, and so on that can be used as instant friskets.

After transferring, the surface should be cleaned with Bestine to remove any waxy residue that may have adhered to the surface. In order to end up with as little residue as possible, use very light pressure to apply rub-down proofs. Try a technique known as *prereleasing:* Rub the back of the proof while it's still on its backing sheet—it won't transfer to the backing sheet, but when applied to any other surface, it will adhere with little (if any) pressure. This is a particularly handy technique to use when applying proofs to an irregular surface, like a ball or an egg.

Pieces of coarse fabric, along with a variety of natural items, such as leaves, can be used as friskets as well. I once used a woven bamboo screen for a background frisket in an illustration of a samurai sword, for instance. Keep these sorts of possibilities in mind, so that you'll be prepared to use them when the appropriate project comes along.

Badger's laser-cut templates are much more accurate than their conventional drafting-oriented counterparts (left). Because of the laser cutting, the inside shapes fit perfectly with the outside shapes.

I used a bamboo screen as a background frisket to create the subtle background texture to this illustration. A solid yellow was painted first, and then the screen was laid over it and sprayed with a lighter color.

Cutting friskets for lettering can be very difficult, especially when delicate serifs are involved. Using rub-down type, as shown in this demonstration, can save hours of tedious labor.

Right: A pressure-sensitive Identicolor proof is rubbed down onto a 70-percent gray background of acrylic paint. A few strokes of lighter and darker gray are sprayed over it.

Far right: Coatings of lighter gray are laid over the transfer proof.

After the paint has dried, the type is removed with high-tack masking tape, revealing the underlying dark gray.

In order to achieve a sculptural quality, each letter is highlighted and accented with colored pencil.

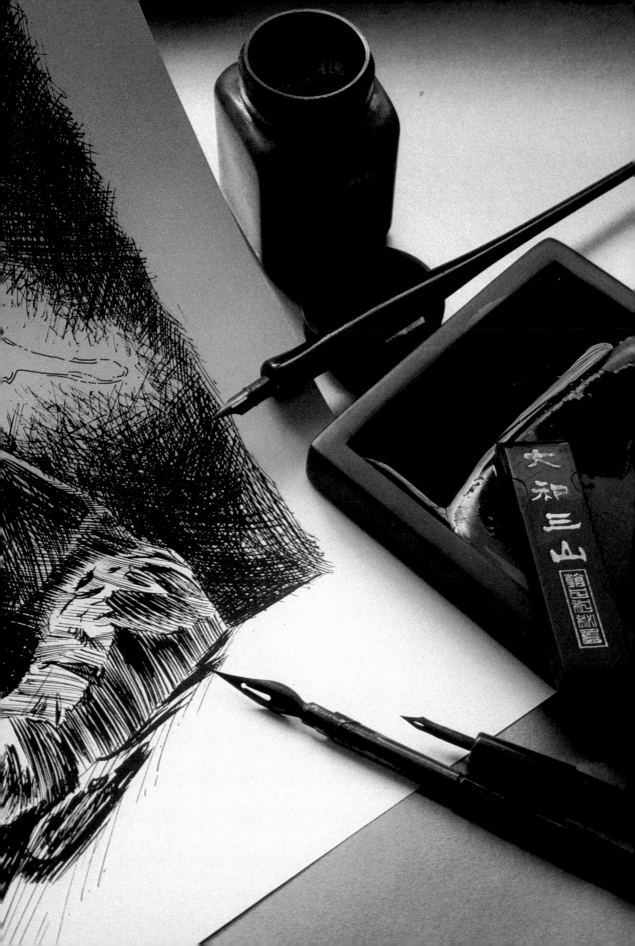

CHAPTER 7

LINE TECHNIQUES

With the increased use of full-color reproduction in recent years, it would be easy to imagine that line art has become a thing of the past. In fact, however, nothing could be further from the truth—newspapers, books and magazines still constitute a large market for line art, and desktop publishing service bureaus are now emerging as a major line art market as well.

For our purposes, we'll define line art as a black-and-white drawing with no grays—just black and white. Pen and ink, in which the artist creates the illusion of gray tones through hatching and stipple, is the best-known form of line art. The purpose of this chapter is to take you beyond pen and ink to introduce you to an assortment of offbeat line techniques. They're easy to learn and fun to do, and can transform a lackluster drawing into a jewel. Moreover, many of these line techniques can be combined with tone and color, providing you with added flexibility as you consider your approach to a given project.

— REPRO AND NON-REPRO COLORS —

The printer's process camera and the photostat camera see color in an odd way: To the process camera, there is no difference between black, red and orange—they all register as black. We call these colors *repro* (short for *reproducing*) colors. Light blue line art, however, is invisible to the camera, and is called *non-repro*. This has several implications for the illustrator, including one with immediate practical benefits: If you make your underdrawing with non-repro tools, rather than with conventional pencil, you will not need to erase it—you can simply do the drawing or painting stage right on top of it. In addition, you can work out solutions or provisional details at virtually any stage with non-repro tools without fear of their being reproduced.

Non-repro-blue drawing tools include water-soluble pencils made by Verithin and wax-based pencils by Prismacolor and Spectracolor. A non-repro ballpoint pen is produced by Illustrator, although this must be used judiciously, as the ballpoint tip can indent the surface of the paper, causing subsequent drawing tools to skip when they are used on the same surface later in the project. And many non-repro fiber-tip pens are available from a variety of manufacturers.

PENS

On the repro side, there are several tools to make lines and shapes visible to the camera, led off by pen and ink. A huge variety of steel pens is available, ranging from Gillott's minuscule Tit Quill to immense lettering pens.

Line art is like the typeface you are reading—black on white. Continuous tone is broken down into elliptical dots by a halftone screen. Line art has no true grays that require such screening, although many line techniques allow you to simulate grays.

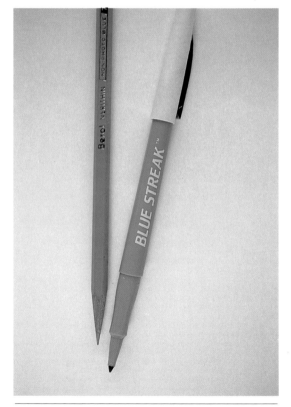

A non-repro pencil and felt-tip marker. Anything rendered with these tools is invisible to the printer's process camera.

Don't store your pens loose—put a block of Styrofoam into a box and stick the base of the pens into the block. Protect the points with a cover that does not rest on the pens.

Pay particular attention to the choice of your *pen holder*—most are poorly designed plastic or wooden handles with circular grooves that allow the pen to wobble about. My personal favorite is Joseph Gillott's No. 156 Universal Pen Holder, which is light, elegant, and, unfortunately, hard to find. My second choice is Grifhold's aluminum pen holder, which has an adjustable collet to hold the pen firmly. Watch out for the knurled collar—it can grate your hand like a file. Sand it down, or wrap it in tape.

Moving beyond the realm of steel pens, *quills* from turkeys and geese can be cut and shaped with a sharp knife to produce a marvelous drawing tool. Other feathers can be used with varying success. Give them a try.

Technical pens, which produce an unvarying mechanical line, are designed for the engineer and architect, not the artist. Don't waste your talent trying to achieve such cold precision— you're better off with more expressive tools.

For skilled penmanship, there's the *flexible pen*. Hunt and Gillott both make excellent versions—Gillott's No. 291 Mapping Pen is a favorite of mine. These pens, while somewhat difficult to master, allow you to vary your lines from fine to bold, are sensitive to the slightest pressure, and ultimately can help you to develop the delicacy of touch that is the foundation for all professional drawing and painting.

Unless your work specifically calls for them, avoid ballpoint pens—they tend to indent the drawing surface.

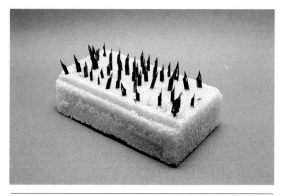

Pen nibs should be stored in a block of Styrofoam.

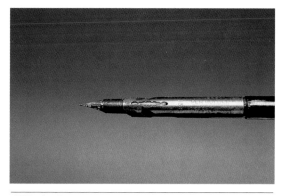

Gillott's No. 156 Universal Pen Holder.

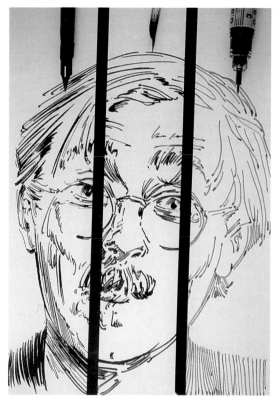

This face was rendered in three sections, each with a different tool. From left: a flexible steel pen, a quill pen, and a technical pen. Compare the lively lines made by the flexible steel pen and the quill with the lifeless line of the technical pen.

Anyone who has ever bought a steel pen knows that ink doesn't flow smoothly from a new pen's tip—it beads up. New pens, like new cooking skillets, need to be seasoned before they are used.

The traditional method is to hold the pen over a lit match to deposit a layer of carbon on it. Although this practice is common, *don't do it*—it takes the temper out of the steel, leaving you with a stiff, brittle pen. Instead, soak your new pens for an hour in vinegar. Don't rinse them—water will cause them to rust; just wipe them dry. Then dip them in India ink and wipe them dry once more. Now they're seasoned and rust-resistant.

Even after they are properly seasoned, all pens need to be broken in before they can actually be used on a professional illustration. Ten minutes of doodling will break in the pen to your particular touch, after which the pen should never be handled by anyone else.

Smooth-flowing inks are the best to draw with. India ink contains waterproofing shellac, and most of us have had it turn into a gummy sludge on our pen at one time or another. To avoid this problem, many pros mix India ink with water in a 2:1 ratio. Large brush-applied areas of this thinned-down ink may appear a bit thin, but these thin blacks will nonetheless reproduce as a good, solid black.

The smoothest drawing ink for a steel pen is Higgins Eternal Black—it has no waterproofing additives and won't become gummy.

PENCILS, MARKERS, AND MASKING FILMS

Spectracolor 1406, Prismacolor 935, and Negro pencils reproduce as a solid black, and can be used instead of pen and ink, especially on frosted acetate, where the pencils draw smoothly and easily and produce a extraordinarily black line. Choosing between them is strictly a matter of personal preference. The Negros are produced in several hardness grades. They can be smudged, and therefore must be protected with fixative. The Spectracolor 1406 and Prismacolor 935 models won't smudge, although Prismacolor pencils are brittle and tend to break a sharp point with annoying regularity.

Opaquing markers and masking films are useful for filling in large areas quickly. The films, like Rubylith and Amberlith, are sheets of clear acetate coated with a transparent red or orange strippable layer. The colored layer can be cut and removed, forming shapes that will reproduce in black. Removing the unwanted sections can be tedious if you just use a knife edge and try to pry up the edges; instead, use a piece of masking tape to pick up the edges.

If you prefer a self-adhesive masking film, Formapaque and Parapaque are easily cut polyester films with a repositionable adhesive backing.

One nice thing about markers and masking films is that they are transparent, so that non-repro lines and black key lines are easily seen through them, allowing greater control over your work.

A comparison of the lines made by (from top) a medium-hard No. 3 Negro, a black Prismacolor, and a black Spectracolor. All three can be reproduced as line art.

These tools all produce lines and solid shapes that reproduce as solid black. From left: Rubylith film can be cut in any desired shape to block out large areas; markers are also good for rapidly filling in large areas; and pencils can be used instead of pen and ink. Note that some of these tools are black and others are red—to the process camera, it makes no difference.

Amberlith can be used to create solid areas. Here the foot shape has been cut out, and the surrounding Amberlith is being removed with a piece of masking tape. The remaining Amberlith will print black; the clear backing beneath the removed Amberlith will have no effect on the illustration.

The non-repro-blue drawing is visible to our eyes under this Amberlith overlay film, but not to the process camera.

Denril, a translucent vellum with a polyester surface, is a delightful drawing surface. It has the advantages of frosted acetate but it doesn't create static electricity or attract dust like acetate does. Denril accepts pencil, oils, watercolors, pastel, marker and pen and ink.

Both acetate and Denril allow you to scratch out lines with a knife. You can use the knife to create scratchboard effects and to "erase" (scrape out) lines drawn on the surface. Consider all the implications and your final desired effect before going this route, however—once you scrape Denril's surface, you destroy its tooth, making it difficult to draw back into a scraped-out area.

This sequence, in which a variety of visual reference images are used to create an overbearing character threatening a more mild-mannered type, offers a good example of the effects you can achieve with pencil on Denril.

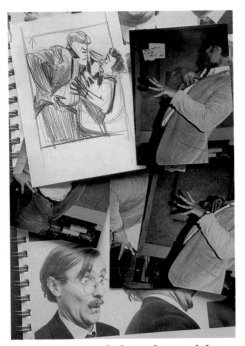

Visual reference, clockwise from top left: one of several sketches; color photos processed by a one-hour photo lab; a page from the Fairburn Faces and Heads *series.*

Three photos, cut and spliced together. Always try to get as much information as possible into your reference photos. Here, for instance, the shirt was stuffed with cloth, to create a paunch. Having this visual data present in the reference shot is much easier than trying to fake it in the drawing.

Compare this with the photos shown in the collection of visual reference shown above. Few humans can bend this far back, so several photos were cut, mutilated, and pasted together to exaggerate the action of this figure and achieve the desired effect.

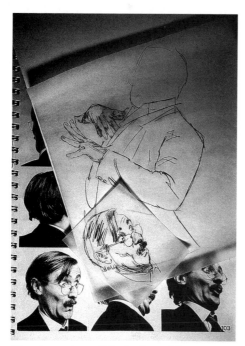

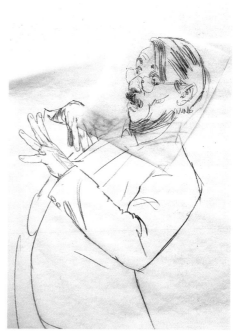

Rough tracings of the body and face, as they were drawn on the lucy. I changed the face (note the receding chin) to emphasize the meek expression of this character.

The head is flopped (an advantage of working with tracing paper) and positioned on the body. At this point, everything is in place and the drawing can be developed.

Our pugnacious character gets drawn and assembled in the same manner.

Both characters are developed in the underdrawing. They're ready to be put together. Overlapping sections are cut away.

The characters are made to interact with each other: The meek chap's nose is bent from the pressure of the bully's finger, and the finger is bent from pressing against the nose.

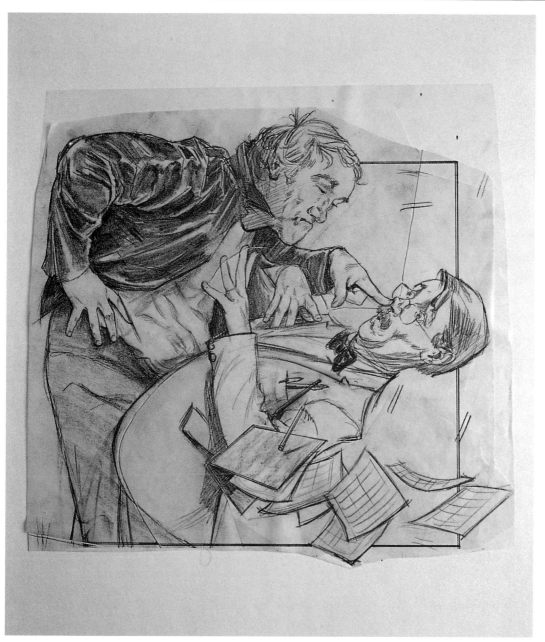

Scattered papers and pencils are added to improve the composition and add action. A border is drawn to contain the characters, while some of the action spills out. The underdrawing is now finished.

Placing a sheet of Denril over the underdrawing, I turn my attention to the finished illustration. I use a Prismacolor pencil, which produces lines that resemble pen lines. Note how black the Prismacolor lines appear on the smooth Denril surface.

Some of the lines are scraped away to create an engraved character to the line. Areas of the hair have been enhanced in this way.

Building up the blacks. In order to maintain the feeling of pen and ink, the drawing is done stroke by stroke. Because most potential problems have been worked out in the underdrawing, the finished illustration progresses rapidly.

Creating a uniform pattern of hatching is easy when you have a parallel glider. I vary the spacing slightly so the pattern will look hand-drawn.

The finished illustration, reproduced as line art. Total working time (including underdrawing, but not reference photos): 4 1/2 hours.

Most of us make stipple drawings by laboriously tapping out dots for hours with pen and ink. There's an easier way: coquille board, also known as pebble board, which has tiny dots embossed into its surface. Bainbridge makes two grades of coquille board—smooth and coarse. Drawing on it with pencil produces a stippled effect by depositing pigment on the raised dots. The harder you press, the larger and closer the dots become. Use smooth coquille board if your drawing is to be reproduced same-size, and coarse board for drawings to be reduced. Large areas of solid black can be applied with brush and ink, and white gouache can be used to erase areas or add highlights.

Another option is to use linen-textured paper, which is usually produced for use as stationery. It can be used in the same manner as coquille board to produce a line drawing. This is an easy way to make elegant drawings.

Keep other textured papers in mind, too: watercolor papers, chain-laid charcoal paper, embossed blotter paper— these surfaces can give you that special line quality that can help you to set your work apart from other artists'.

Here are some examples of the varying effects you can achieve by working with different paper textures. The working time for each piece was about 45 minutes.

The underdrawing, executed in pencil on tracing paper (above), and a detail of same. Note the various gray tones of graphite pencil on paper. This drawing would have to be reproduced as a halftone, not as line art.

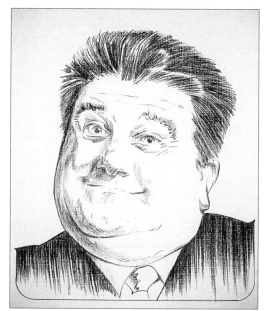

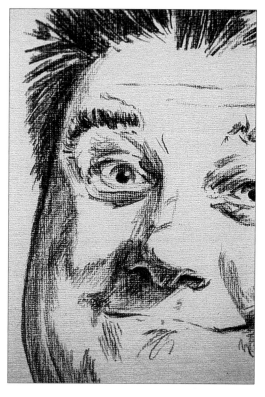

This piece was drawn with black Prismacolor pencil on a linen-finish writing paper. The linen texture is apparent in the detail (right). This drawing consists of only blacks and whites, and can be reproduced as line art.

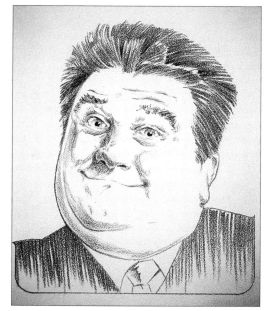

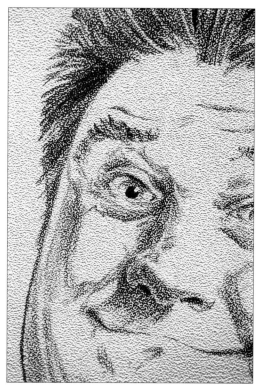

The same drawing done on coquille board with black Prismacolor pencil. The pebble texture of the coquille board is visible in the detail (right). Minor corrections and the catchlight in the eyes were added with white gouache.

So far we've examined paper surfaces produced by commercial paper mills, but here's a surface you can make for yourself. Start by using a 1-inch bristle brush to paint a thick coat of acrylic gesso on a board. Using short, choppy strokes, work the brush into the surface as the gesso is setting—this will yield the greatest texture.

Using a larger brush and longer, sweeping strokes will produce another exciting drawing surface. If you like, try adding a small amount of powdered pumice (available from a hardware store) to the gesso—this will give the surface even more tooth.

Since gesso tends to buckle paper, use double-ply illustration board or Masonite panels. The result is a great textured surface for pencil work.

Short, choppy strokes of gesso being applied with a coarse bristle brush. Using pencil on this highly textured surface produces an interesting line quality.

Another way of preparing a textured drawing surface is to apply the gesso in long diagonal strokes (above). A subsequent drawing done in medium Negro pencil on this surface (right) can be reproduced as line art with very little loss of detail.

Here's a quick way to produce a pen and ink drawing with the feel of an old etching. Start with either a black-and-white photograph of your subject or a wash drawing, take it to a stat house, and ask for an etchline or steel-etch conversion. It's best to ask for three different exposures—light, medium, and dark. Be sure to specify that the stats must be shot as line, with no tone.

The stat will come back looking thin and incomplete—that's where you come in. Lightly swab the surface of the stat with a thin solution of dish detergent and water to prevent your ink from beading up on the surface. Let it dry, and then mount it on a board.

Choose a pen that matches the line quality of the stat and add outlines, deepen shadows, paint in highlights, and so forth. Your clients will be amazed at the effects you get from this quick, easy trick.

This example, printed on a soft finish pastel stock has the look of an etching, although it's essentially just a retouched stat.

Resist techniques are fun because they are not completely controllable. They are useful for decorative vignettes.

Because Verithin non-repro pencil is water-soluble, use it to do the underdrawing. Then use a brush to apply poster paint (I still use the same brand I used as a kid, Rich Art) to all areas of the underdrawing that you don't want to be black. Now, paint over the entire piece with waterproof India ink (Artone Extra Dense Black works nicely). Apply the ink quickly, without letting it dissolve the poster paint, and let it dry hard, or until it no longer feels cool to your hand—about 15 minutes, depending on your local climate.

Here's the fun part: Hold the drawing under slow stream of cold tap water—the ink will flake off the board, allowing the drawing to emerge. Ink will be left clinging to the surface in unexpected places, depending on the thickness of the poster paint, the time spent under the tap and various other factors.

The sequence that follows shows how I used this approach to create a decorative vignette. Aside from the drying time, this is a relatively quick technique that can produce excellent results—give it a try.

Detail of the underdrawing with poster paint fully applied. At this point, I have painted over the background areas, leaving the line areas open.

After making an underdrawing in non-repro blue, I use white poster paint to paint out everything but the lines. Because this is to be used as line art, I'm using white poster paint, although colored poster paint or tube gouache can be used for work that will reproduce in color.

The drawing is covered with a layer of Higgins Waterproof India ink, left to dry, and placed under a tap of cold water (left). The ink flakes off the areas painted with the poster paint but remains on the unpainted areas (right), leaving a drawing with an interesting line quality. Working time: 1 hour.

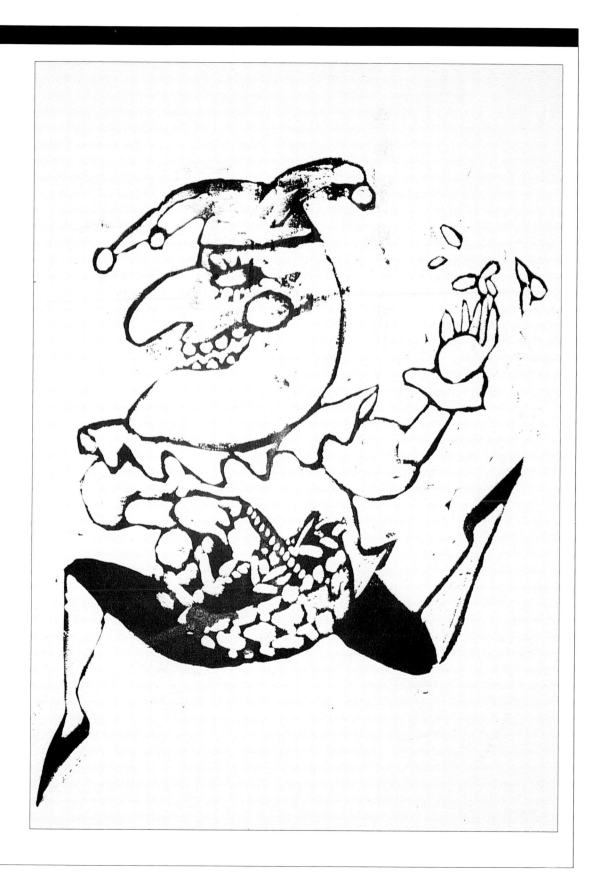

Here is an example of materials being used "the wrong way": Pen and ink is traditionally meant to be used with a nonabsorbent, plate-finish paper, and rice paper is generally intended to absorb and hold inks for block printing. They're not meant to be used together, but they can work quite well for illustrators.

Because a sharp pen point can catch on rice paper, use a *bowl-pointed pen*— Hunt's No. 512 is a good choice. As for the paper, there are lots of rice papers on the market; I prefer Tableau paper, which has a close texture, a low price, and ready availability. Because Tableau is translucent, you will be able to see your working drawing through it—a distinct advantage.

As you'll quickly discover, the variation in the line is a result of varying the *speed* of the line, not the pressure on the pen. The longer your pen stays on the absorbent Tableau paper, the bigger the dot. I like to use this technique for decorative cartoons, but many other possibilities can be explored as well.

After the ink is dry, spray the back of the drawing with Spray Mount and position it on a board. The spray adhesive, in addition to adhering the drawing to the board, makes the drawing surface less absorbent, so that you can go back later to add sharply defined black areas with brush and ink, further enhancing the image.

The underdrawing was done with Ebony pencil on layout bond paper. The toad was done separately using the same technique, and was then pasted into position.

The underdrawing was placed under a sheet of transparent rice paper. Simple tracing with a pen produced the varying line qualities seen here.

The rice paper drawing was mounted onto a board with spray adhesive, which also served to stabilize the surface for the application of further detail. India ink, which would normally run and blot on untreated rice paper, was applied with a brush. Compare the sharp brush-drawn edge with the pen line. Total working time, excluding underdrawing: 25 minutes.

The nineteenth century saw the development of wood engraving as the predominant method for reproducing illustrations. In order to meet deadlines (yes, even back then they had deadlines), the larger engraving blocks were cut up, with each section engraved by a different artisan. it therefore became necessary to develop a uniformity of rendering style among the artisans. With the introduction of photoengraving, scratchboard illustration quickly filled the niche left by wood engraving, and traditional scratchboard rendering is directly linked to wood-engraving technique.

Scratchboard is nothing more than bristol board coated with a white chalk. The surface resembles a perfectly smooth gesso panel. Drawings on scratchboard are usually done with brush or pen and India ink. After the ink dries, fine white lines can be scraped through the black. For predominantly dark illustrations, scratchboard is also available precoated with India ink—this product is known as *black scratchboard.*

Tools for scraping the board's surface are simple: spear-point, spade-point, and multiple-line gravers. You can also get interesting effects by using sandpaper as a scraping tool.

Underdrawings for work on white scratchboard should be done in non-repro blue; for black scratchboard, underdrawings should be done in red or yellow.

The tools for scratchboard are simple and few: prepared scratchboard, scraper, X-Acto knife, and India ink.

Transferring the drawing to black scratchboard with yellow Saral transfer paper.

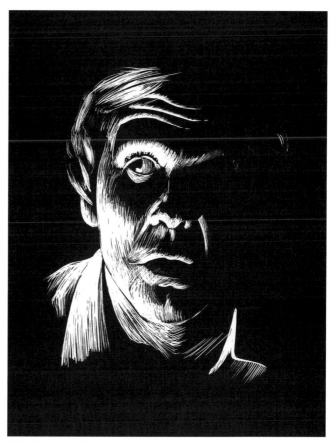

The finished illustration, done on prepared black Essdee scratchboard with a Speedball scratchboard tool. Total working time: 45 minutes.

This is the technique that will have everyone asking, "How did you do it?" Monoprints are usually printed by running an inked plate through an etching press, but our monoprint drawing method is not as elaborate. All you need is a sheet of glass (20 by 30 inches should be enough for most jobs), oil-based blockprint inks, a rubber roller, paper, and pencils. You *must* use oil-based inks—the whole technique depends on the ink being stiff, and the stiffer the better. Commercial offset inks are ideal. As for the paper, I've had good results with Arches 88 and Strathmore Bristol HP, both of which are manufactured in several weights. The heavier the paper, the thicker the final line of the drawing will be.

Start by rolling out a thin layer of ink onto your glass. In order to avoid spreading too much ink over too large an area of the glass, cut a bristol board mask a bit larger than the desired final size of your illustration and place it over the glass before applying the ink. Wait five minutes to let the ink set up and then lightly lay your paper onto the inked glass. If the ink is stiff enough, it should not transfer to the paper. Then, using a bridge to keep your hand away from the paper (a ruler suspended between two rolls of tape will do), use a pencil to draw on the back of the paper. The ink will transfer to the paper where you've drawn. Keep in mind that the inked image will appear on the other side of the paper— not the one you're drawing on—so you'll have to draw a mirror image of your desired illustration. When you finish, let the drawing dry for a few hours.

Monoprint drawing can be used in combination with other techniques. It's startling when combined with pen and ink, for example. To do this, wait until the monoprint is dry, spray its surface with workable fixative, so that the oil-based ink will accept the drawing ink, and then proceed to add the pen and ink work.

You can also use monoprint drawing for a novel color technique. While the monoprint is still wet, position it face-down on a clean piece of glass. Tape the upper edge of the drawing to the glass, rub on the back of the drawing, and flip the drawing up without removing the tape. The drawing will have offset onto the glass, where you can use it as a guide for painting with thinned blockprint inks or oil paints. Flipping the drawing back down onto the painted glass (the tape hinge will keep it in perfect register) and rubbing it on the back will transfer paint from the glass to the drawing. More pressure on the back will cause more color to transfer. Although the tape will keep the drawing in register, you can get even more control of where to paint and rub by placing the glass over a lightbox as you work.

An original pencil drawing being transferred from tracing paper to Strathmore HP with a burnisher.

In order to avoid rolling ink over too much of the glass, I make a mask from bristol board and lay it onto a clean sheet of glass.

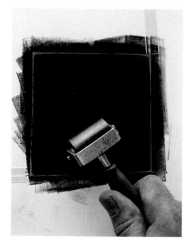

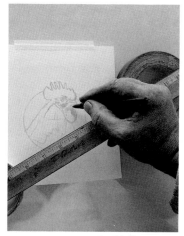

Far left: Next I roll out a thin layer of stiff oil-based blockprinting ink onto the glass.

Left: After taping the transferred drawing to the inked glass, I make a crude but effective bridge from a ruler supported by rolls of tape. This keeps my hand from pressing against the paper as I trace a ballpoint over the pencil lines.

The final drawing. Note that the lines have great variation, especially where they intersect. Total working time: 1 hour.

This fast-moving painting technique must be tried to be fully appreciated. Casein, an underused, underrated medium, is water-soluble when applied but becomes water-resistant on drying, and dries to a perfectly matte finish.

I like to work on a smooth black mat board with a black core. For line art, do the underdrawing in red on the black board. It will be invisible to the camera. Use the casein straight from the tube. As with the poster paint technique, the object is to paint everything but the lines of the drawing. Casein has a tendency to drag on the brush, leading to a distinctive painterly texture. If you need to cut in some fine details, thin the paint with water. Always keep your brushes wet—casein is gritty, and nothing will injure a brush more than allowing casein to dry on it. For large background sections, save yourself some painting time by cutting out white paper and pasting it onto the illustration. The camera won't know the difference.

The preliminary drawing is transferred with red Saral transfer paper. Remember, to the printer's camera, red on black is just a plain monochromatic black field.

Casein is extremely opaque, so there's no need to go back over your strokes, and its dry consistency helps to create a highly textured line.

If you make a mistake, such as I did by painting in this area of the head, just go back over the casein with a black marker.

Instead of spending time to paint out the background, cut out a mask from white bond paper. Total working time: about 25 minutes.

The casein technique can also be done in color. The specks of black that peek through the color have a unifying effect on the picture. This is a *very* fast-moving painting technique—you have to try it to fully appreciate its capabilities.

As in the black-and-white demonstration, the drawing is transferred with red Saral transfer paper.

Because this will be reproduced in color, the red lines will be visible. They can be easily erased once the paint has dried, however.

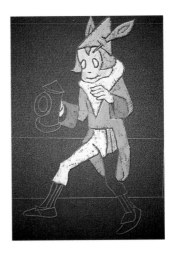

Once you start painting a figure, it comes along very quickly.

The area immediately around the figures is painted white. White bond paper is cut to mask out the background.

Instead of struggling to draw uniformly thick lines with the soulless technical pen, use Chartpak flexible tapes. They can be laid down, picked up, and repositioned with ease. Smooth transitions from straight lines to curves, which are difficult to do with a pen, are simple to do with flexible tapes. They are available in a wide range of sizes.

Charrette flexible matte tape, Chartpak tape and amber film make short work of diagrammatic drawings.

A finished piece, complete with uniform line width and no smeared ink. Total working time: 25 minutes.

For this technique, which is a splendid way of introducing texture into your painting, you will need regular rubber cement. Get the old-fashioned kind, not the one-coat variety.

Start by making a working pencil drawing. Paint a layer of rubber cement over the drawing and, while it's still wet, blot it with a bunched-up paper towel. Continue blotting until the rubber cement starts to dry. As you blot, the paper towel will pull irregularly shaped pieces of rubber cement from the surface of the board—don't lift too much at once.

Apply black India ink to the appropriate areas, let dry, and blot to pick up any hidden bits of wet ink. Gently remove the rubber cement with a pickup. Repeat the process until you are satisfied.

Instead of using a drawing, you can also use a frisket to apply the rubber cement over a given area. And you can use any water-based paints to introduce the resist texture in your color work as well.

Applying rubber cement to the surface.

Blotting at the rubber cement with a paper towel.

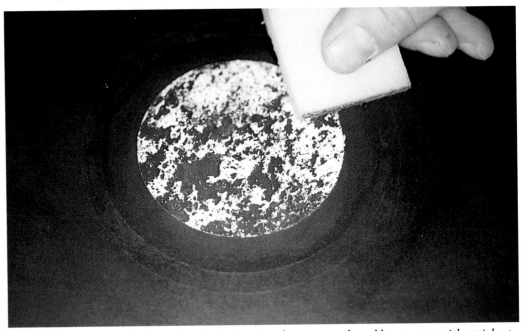

After applying a coat of India ink and allowing it to dry, remove the rubber cement with a pick-up, as shown here in a frisketed circular area. If the texture is not to your liking, the entire process can be repeated.

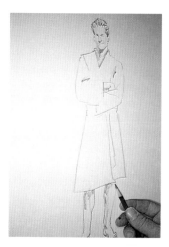

The resist technique can also be done with color work. Here a drawing is done with a Terra Cotta Prismacolor pencil on No. 80 Bainbridge board.

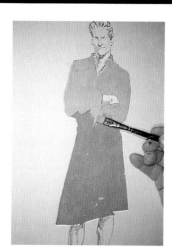

After the robe is painted on with a coat of pink Acryla gouache, a layer of rubber cement is painted on and blotted from the surface. A coat of turquoise Acryla gouache is laid in and allowed to dry.

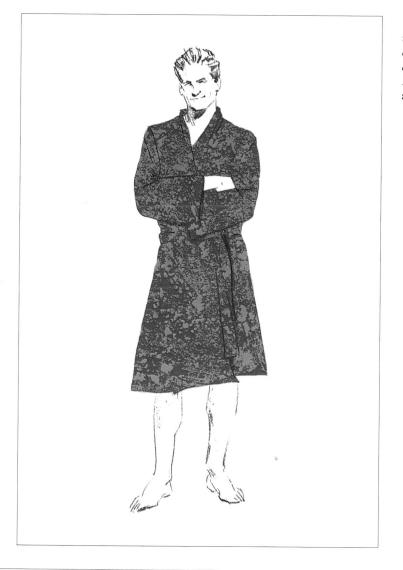

The rubber cement is removed with a pick-up and a few defining lines are knocked in with the Prismacolor pencil. Total working time: 25 minutes.

This technique, which can produce a variety of natural-looking textures, is good for making graphic illustrations, such as those used in logos, trademarks, and so on. Start by making a drawing on a layered board, like illustration board. Then use an X-Acto knife to cut around the drawing and remove the waste board, and use a ballpoint pen to engrave lines, by drawing into the surface.

The image can be inked with a roller and blockprint inks, and then printed onto a piece of drawing paper. This will produce a pleasing but regular texture. Or you can soak the surface of the cardboard cut with several layers of India ink. Printing the ink-soaked cardboard creates dramatic textures reminiscent of gravestone rubbings. Variation comes from the amount of ink on the cardboard cut, the thickness and type of paper being used, and the amount of pressure used to transfer the image. The biggest advantage? No two prints will be exactly the same.

After the drawing is rendered with a soft pencil (to avoid indenting the surface of the No. 80 Bainbridge board), an X-Acto knife is used to cut around the major shapes and remove the waste.

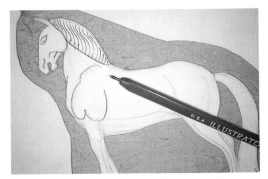

A ballpoint is used to indent lines into the surface.

Three coats of India ink are quickly applied on the surface, which must be kept damp with ink.

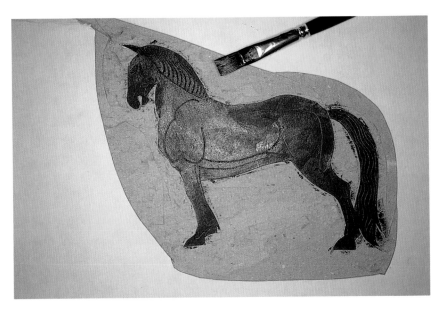

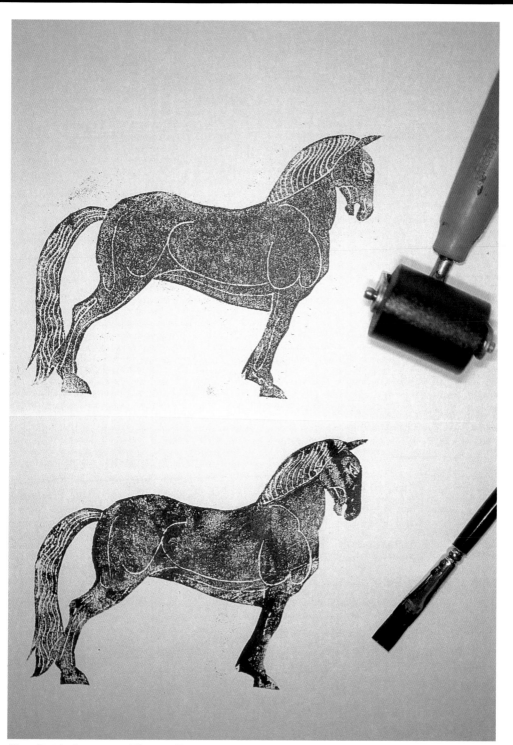

Two finished versions: The top illustration was printed with oil-base blockprinting ink onto Plate Finish Strathmore Bristol. The regular texture reflects the surface of the No. 80 Bainbridge board. The bottom piece was printed with India ink on Plate Finish Strathmore Bristol. The variable texture assures that no two will be alike. Total working time: 45 minutes.

This technique (often referred to as *combo*, a printer's term for combining line and halftone) addresses the problem that inevitably arises when a line and wash drawing is converted into halftone—the piece can't be treated as a pure line piece, because the wash has gray tones, but the line part of the illustration appears soft after being shot through a halftone screen. Printers have solved the problem by shooting the illustration as two separate elements in perfect register.

If you are working on such a piece, there are several ways to prepare the art for combo reproduction. One method is to draw the line art on one sheet of paper and paint the wash on another, keeping the two sheets of paper in register on a light box. The printer can shoot the two elements separately and compose the resulting plates into the finished image.

The preferred method, however, is for the illustrator have the line art shot as a film positive and, as in the above example, paint the wash on another sheet of paper. This method has the advantage of allowing you (as well as your client) to see how the finished piece will look, since you can register the film positive over the wash.

Perhaps the slickest method of doing a combo is to make a blueline print. To do this, get the Fluorographic Services kit that consists of Guide-Line Sensitizer and Developer. Apply the Sensitizer to your illustration board, or any other support, with a sponge. After it dries, lay a film negative of your drawing on the surface of the sensitized board and expose it to sunlight for 6 to 8 minutes. Then sponge the Developer over the board—you will be left with the drawing, in non-repro blue. You can apply a grisaille wash, color wash, or opaque colors onto the board, with the film positive remaining in perfect register.

Applying Guide-Line Sensitizer to a piece of Crescent No. 100 illustration board.

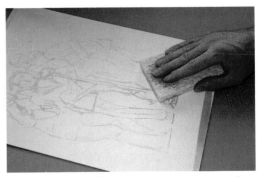

After making a film negative and positive of a quick pencil drawing on tracing paper, I contacted the negative with the surface of the sensitized board and exposed it to sunlight for 6 minutes. An application of Guide-Line Developer removes the yellow sensitizer and reveals a non-repro-blue version of the drawing.

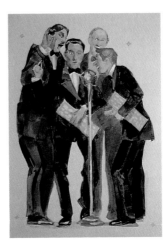

Acryla gouache painted over the blueline drawing. The blueline will be in perfect register and be covered by the black lines on the film positive.

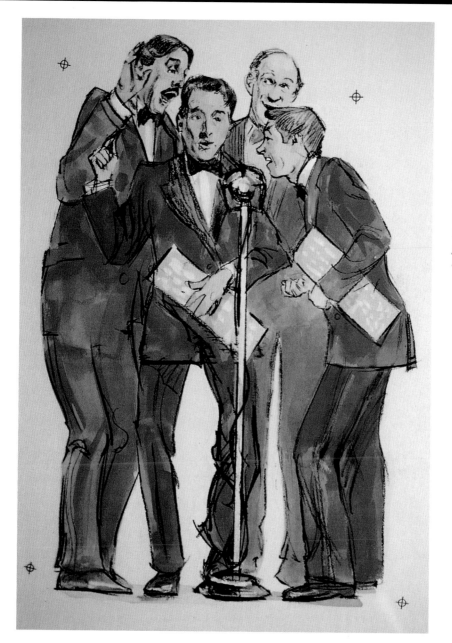

The film positive covers any of the unpainted blue lines. The artwork on the board is shot as a color separation and the film positive shot as line art. The two are then stripped together in perfect register by the printer.

PRO'S TIP: FILM POSITIVES

Some film bases have a tint. While this won't affect the reproduction quality of the film positive, it's best not to have a client view a wash through a tinted film. So when you are having your film positive of the line art made, tell the cameraman you want clear, untinted film.

PASTEL AND COLORED PENCIL

Pastel is by far the fastest method of painting. Yes, I said *painting*—just because the pigment is applied dry doesn't mean that it's not a painting medium. And painting with pastels has one advantage over all other painting methods: the colors won't change as they dry.

One of pastel's greatest appeals is that the pure pigment is untainted by a medium. Most paints use mediums, whether oil, alkyd, acrylic, or gum, which inevitably dull the brilliance of the pigment. Pastel, on the other hand, is pure pigment bound with a negligible amount of a gum solution. A strong solution produces a harder pastel; a weak solution produces a soft pastel, which has more brilliant color.

On the down side, pastels do have a very delicate surface, but don't let this scare you off—watercolor, dye, and airbrush illustrations are just as easily damaged by careless workers.

Aside from oil pastels, which tend to gum up and therefore are not a useful illustration medium, pastels are grouped into two categories: hard and soft. Hard pastels are used in the early stages of the painting; when the pigment gets built up, subsequent layers of hard pastel won't adhere properly, so soft pastel is then used. Some pastel brands are softer than others, making them more useful for the final strokes.

HARD PASTELS

The best-known hard pastels are the 96 colors of Nupastels. Their thin shape makes them easy to use for drawing details. I use Nupastels to lay in about 75 percent of an illustration and then proceed to increasingly softer pastels. Another hard pastel brand is Holbein's excellent but oddly named Soft Pastels, which are actually almost as hard as Nupastels. Holbein has a useful selection of 144 colors, with two or three values of each hue. Conté also has a line of hard pastels that they call "soft pastels," and have added to the confusion by manufacturing them in same small size as their traditional Conté Crayons. Inexplicably, they've even *named* these small pastels Conté Crayons. The original sanguine and sepia Conté crayons dissolve easily in water or turpentine, and have a bit more drag than a pastel; these small pastels do not handle like the original Conté crayons, but are wonderful in their own right.

SOFT PASTELS

My own collection of soft pastels includes many made by Rembrandt, Girault, and Sennelier, as well as a fair representation of Rowney pastels and four or five boxes of Grumbacher's Portrait Selection (which are available in half-sticks).

An assortment of hard pastels.

An assortment of soft pastels. These are useful for the later stages of an illustration, when the surface will no longer accept hard pastel.

Othello pastel pencils are capable of fine detail and are hard enough to be sharpened in an electric pencil sharpener.

The otherwise excellent Conté pencils are too wide to fit into a standard electric pencil sharpener. Hand sharpening is too time-consuming in a busy illustration studio.

Because of pastels' inherent fragility, it's imperative to protect them in individual bins. Many of the deluxe pastel sets are packaged in wooden boxes with dividers for each stick. The ArtBin portable pastel box holds 132 sticks and offers superior protection over the wooden boxes.

PASTEL PENCILS

Pastel pencils, all of which are hard, are used for laying in fine details. Othello pencils are water-soluble, leave very little dust, and, significantly, can be sharpened in an electric pencil sharpener—an important consideration for the illustrator working on a deadline. Manual pencil sharpeners grind away too much of these expensive pencils, and such time-consuming chores as sharpening with a razor blade and rubbing out a point on sandpaper have no place in an efficient studio, so don't take this issue lightly.

Othello pastel pencils are available in 60 colors. Although they are supposedly available individually, I've only seen them sold in sets. Conté pastel pencils are superb but are inexplicably sized—they are much too stout to fit into a standard electric pencil sharpener—rendering them useless to the illustrator, who cannot work at a leisurely pace.

SUPPORTS FOR PASTEL

Pastel can be used on paper, canvas, wood, sandpaper, and even velour. Several papers are made especially for use with pastel,

including the readily available Strathmore 500, a 64-pound chain-laid rag paper that comes in 14 colors. It's particularly useful for charcoal or chalk drawings that are highlighted with white chalk, and gives a "fine arts" look to your illustrations.

Although there are scores of other fine pastel papers, I prefer Canson Mi-Teintes, a midweight 65-percent rag paper available in most art supply shops. This paper, which has a smooth felt finish on one side and a mechanically rough texture on the other, is inexpensive, comes in 51 colors, and is available in 19-by-25-inch sheets, 51-inch-by-11-yard rolls, and, for 17 of the colors, mounted on 16-by-20-inch boards. Its gelatin sizing makes it very strong, capable of withstanding repeated scraping with a razor blade (which is how to erase pastel, by the way). This paper's only drawback: Water will make it wrinkle and pucker. Otherwise, it's great stuff.

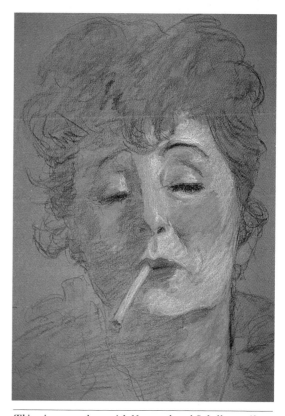

This piece was done with Nupastel and Othello pencils on a sheet of toned Strathmore 500 paper. The drawing is kept open and the background tone unifies the colors. Total working time: 35 minutes.

PRO'S TIP: COLOR REPRODUCTION

Illustration is meant to be reproduced in print. Certain pigments will not print true, including fluorescents, metallics, and iridescents. Various specialized printing techniques and inks are available to take advantage of these pigments' unique characteristics, but they are often prohibitively expensive. Stick with pigments that can reproduced through conventional four-color process printing.

As for other brands, Daler Rowney produces a midweight felt-finish cover stock. Canford Cover Paper is available in an array of 56 colors; the heavier Canford Card stock comes in 22 colors. Because Canford has a smoother tooth than Canson Mi-Teintes, it can hold less of the pastel pigment. However, it is a superb support for colored pencils.

Mat board is an often overlooked support for pastel. Although the dyes used in mat board are not lightfast and should not be used for fine art, the surface is excellent for illustration. Bainbridge manufactures two lines—regular and Alphamat, an archival-quality board—in over 90 colors and in sheets as large as 40 by 60 inches.

BLENDING TOOLS FOR PASTEL

Delicate, smoothly blended transitions are one of pastel's great charms. Stumps, tortillions, chamois, sponge brushes and bristle brushes are tools designed to blend and smooth pastel strokes in order to achieve this effect. Be careful when using these tools—it's easy to overdo it and create a figure that looks as smooth as a balloon. This overly smooth look is the first indication of an amateur's work, so use your blenders sparingly.

FIXATIVES

Fixative varnishes are usually sprayed over finished pastel illustrations, to help protect the delicate surface. This can lead to

PRO'S TIP: PADDING YOUR SURFACE

Try to get into the habit of putting several sheets of paper beneath the piece that you are using for your drawing. All drawing techniques profit from this extra padding, which keeps the texture of your drawing board from imposing itself on the illustration surface. Pastels benefit the most from being cushioned with three or four sheets of paper.

PRO'S TIP: BLEACHING

Regular mat board has a special quality: It can be bleached, using ordinary chlorine bleach and a synthetic brush (the bleach will dissolve natural-bristle and sable brushes). Various colored boards bleach out differently—some go dead white, others produce faint tints. The possibilities are limited only by your imagination.

Household bleach applied to a piece of mat board. The graded tones result from working the bleach into a wash of water and blotting the surface before it becomes fully bleached.

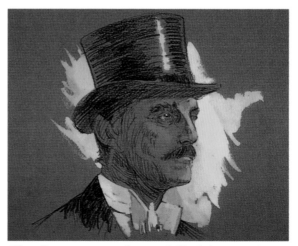

This illustration was done with black Spectracolor pencil, with selected board areas bleached out. Total working time: 30 minutes.

problems—all of us have experienced the dark spots that result from a coarse spray of fixative on a pastel painting. A finely atomized spray avoids the dark spots but, if used heavy-handedly, can distort the colors—dark colors get darker and lights get lighter. The least damaging approach is to spray several light, mistlike coats. Spray above the work, not directly onto the surface, and let the fine mist slowly settle onto the surface. This technique causes the fixative to land on the surface in a partially evaporated state, thereby allowing it to dry on the surface without soaking into the pigment and causing it to discolor. Workable fixative, the weakest form of spray fixative, is the least likely to distort your colors; Krylon Crystal Clear acrylic spray, the strongest form of spray fixative, is alright for pencil drawings but distorts chalk and charcoal renderings and fairly disfigures pastel.

Whenever spraying fixative, *you must have adequate ventilation.* Open windows and cross-ventilation will suffice in the warmer months, but during cold weather you must have a ventilation system designed to handle studio sprays. Of all the air purification systems, the Artograph 836 Spray System is probably the best (see Chapter 6). Spray booths and separate spray areas are not as effective, because they require you to stop work and transport the illustration to another area for spraying. Apart from the dangers of spray fixatives, pastel itself produces airborne contaminants in the form of pigment dust. Many heavy metal pigments are very toxic. A hand-held vacuum cleaner is the safest, cleanest way to remove pastel dust.

Given the aesthetic and health-related concerns that come with using fixative, you may instead want to try what Degas and Toulouse-Lautrec used: steaming. This works just as well as the spray-fixative methods—the steam causes the pastel's binding gum to go into solution, after which it forms a bond between each particle of pigment. Although the wet steam immediately darkens the pigment, the true colors return when the steam evaporates.

Degas and Toulouse-Lautrec used steam from a tea kettle; today, we have hand-held electrical drapery steamers and steam irons.

The old and the new tools for steaming pastels: The electric drapery steamer (foreground) allows for consistent fixing of the pastel, and is much safer than a kettle full of boiling water.

The left area has been fixed with a light coat of workable fixative. Note the darkening where each droplet of fixative has dried. The right side was steamed.

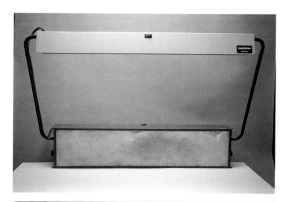

The Artograph 836 Spray System with accessory light. This air filtration system is de rigeur for pastelists. Note how much pigment has been caught in the front filter—and this represents only a few hours' work. Using anything less effective compromises your health and safety.

Be careful when employing this technique—the key is to use a fine mist of *steam*, not water, as sputtering droplets of water will discolor the pastel. Moreover, the steam can cause your drawing paper to buckle and warp; if your drawing paper is held in place with tape, however, it will return to normal after the steam has evaporated.

Even a fixed or steamed pastel painting can still be easily scuffed through inattentive or clumsy handling. Surrounding it with a double mat is the surest protection. To do this, tape the painting by the corners to a piece of sturdy illustration board or chipboard, with the mat hinged over that. Then hinge a piece of tracing paper over the entire mat, with two tabs of tape at the bottom to hold the paper taut and away from the surface of the pastel. To protect the tracing paper, hinge a piece of heavy cover stock over the mat and the tracing paper. Both the cover stock and the tracing paper should carry the following warning: CAUTION—DELICATE SURFACE.

COLORED PENCILS

There are two broad types of colored pencils. First we'll examine the *water-soluble* type, like Berol's Verithin or Staedler's Karat pencils. These pencils can be drawn onto a sheet of paper and washed with water for a delicate watercolor effect. They can also be drawn into wet areas, creating an interesting line. Derwent and Caran d'Ache both make particularly strongly pigmented water-soluble pencils, which can create interesting effects and are worth trying.

Whereas water-soluble pencils produce results resembling watercolor, *wax-based* colored pencils produce a more painterly result. Some specialists spend hundreds of hours using these pencils to produce works resembling oil paintings, but such an approach is impractical for a busy illustrator, who will tend to use colored pencils to add details to such mediums as acrylic, casein, and watercolor.

Derwent Studio, the hardest of the wax-based colored pencils, yields the finest detail, but the pigments are rather dull. Prismacolor has the softest leads, and comes in more than 120 bright, smooth-blending colors, although the soft points break with annoying regularity. Far and away the best colored pencils for the illustrator are Faber Castell's Design Spectracolor pencils, which come in 60 exceptionally brilliant colors. The leads are medium-soft, not brittle, and they blend smoothly.

All wax-based colored pencils can be reduced to a wash with turpentine. Wetting the paper with turpentine and drawing into the wet area produces unusually brilliant and thick layers of color—try it.

Spectracolor pencils—less brittle than Prismacolor and much more brilliant than Derwent.

Prismacolor and Spectracolor pencils can be dissolved into washes with turpentine. This is useful laying in large, flat areas, or for making overworked areas workable again.

The pastel illustration shown on page 98 was done in what I consider to be a fairly traditional approach. The paper is a medium-gray Canson Mi-Teintes, which has a unifying effect on all of the colors. The arrangement of colors with Grumbacher's Portrait Selection speeds up my initial application of color.

I spend most of my time in the earliest stages, laying in colors and tones at the various reference points. Once those landmarks are in, the rest of the painting progresses rapidly.

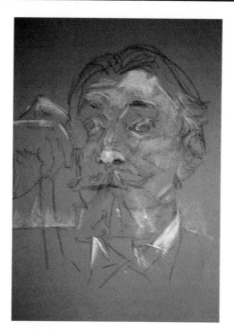

Right: The drawing is loosely sketched with vine charcoal. The major flesh tones are laid in at various reference points with Grumbacher's Portrait Selection.

Left: After a base of Nupastel is applied, soft pastels are used to build solidity into the flesh tones.

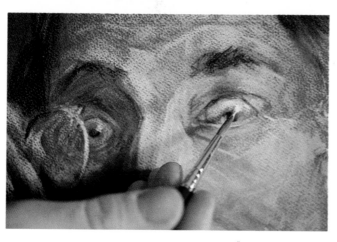

Details are added with Othello pencils; white gouache is used for the catchlights.

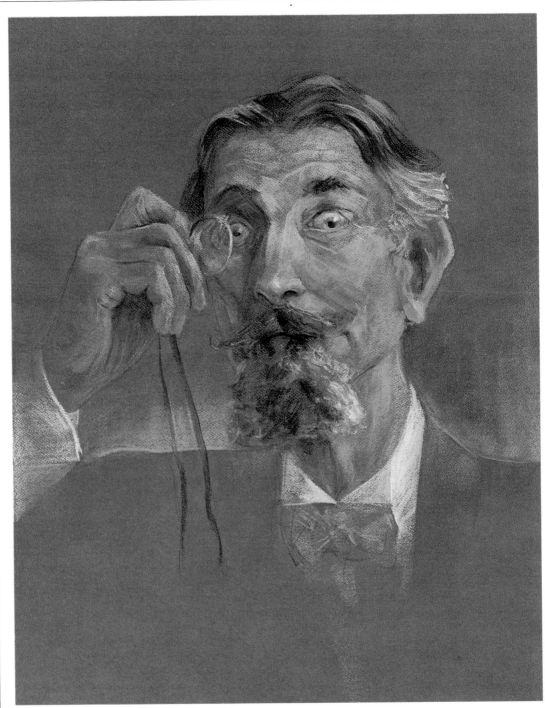

The finished piece. Total working time: 2 hours.

Pastel and colored pencil are also excellent for doing quick comprehensive sketches like this one, which was done in 30 to 45 minutes with Negro pencil, Nupastel, Othello pencils, and a few touches of gouache. This type of drawing, because of its quickness and sketchiness, leaves you a lot of latitude when you do the finished illustration.

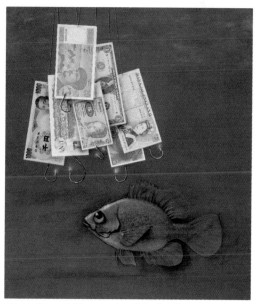

Here I used Nupastels, Othello, Spectracolor, and Negro pencils, gouache, airbrush, and assemblage on Canson Mi-Teintes paper. Total working time: 6 to 8 hours.

This piece was drawn on the felt side of Canson Mi-Teintes with Grumbacher's Portrait Selection. The dark accents were done at the end with Nupastel and a soft Negro pencil. Total working time: 1¹/₄ hours.

In this quick method, an acrylic wash is used to lay in flat areas of local color with no attempt at rendering—that is, all areas of grass are painted as flat areas of green, all rocks as flat areas of gray, and so forth. Just painting the flat areas makes for a quick underpainting.

The best paints to use for the acrylic wash are the ones specifically made to be diluted—colors like Liquitex Jar Colors and Rowney Cryla Flow are heavily pigmented and can be diluted far more than tube paints. To make certain that the wash will adhere under layers of pencil, I add a small amount of Matte Medium to the wash water.

Lay in the washes as you would a watercolor, leaving the whites open. Once the underpainting has dried hard (at least half an hour), you can start laying in your colored pencil. You'll be surprised at how

fast the illustration progresses. If the layers of colored pencil get built up and become slick, just spray a light coat of Myston to restore the tooth. Let it dry for at least ten minutes before resuming your drawing.

Acrylic wash creates a marvelous tooth for later drawing with colored pencil. You can experiment with laying acrylic washes over areas of colored pencil and, after the wash dries hard (at least half an hour), working over it with more colored pencil. You can achieve very rich effects using this method.

And you're not limited to using acrylic wash: Colored pencils work well over watercolor and, especially, casein washes. The natural tooth of casein is a perfect surface for colored pencil. Also, casein is very tough and can stand up to layers of colored pencil.

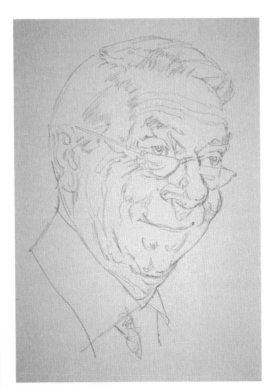

Graphite pencil underdrawing on Crescent Scanner Board, fixed and ready to be painted.

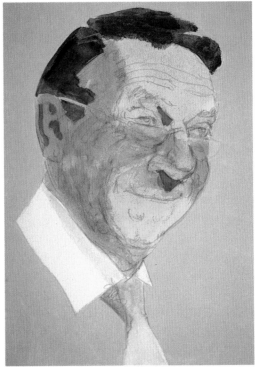

Acrylic wash is blocked in. The background is painted in with full-strength Liquitex Parchment White.

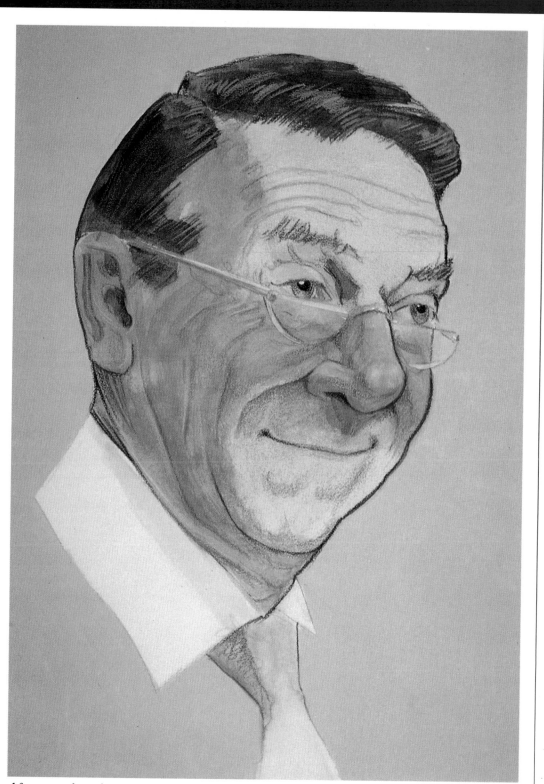

After everything dries, Spectracolor pencils are used to blend colors and define shapes. Total working time: 40 minutes.

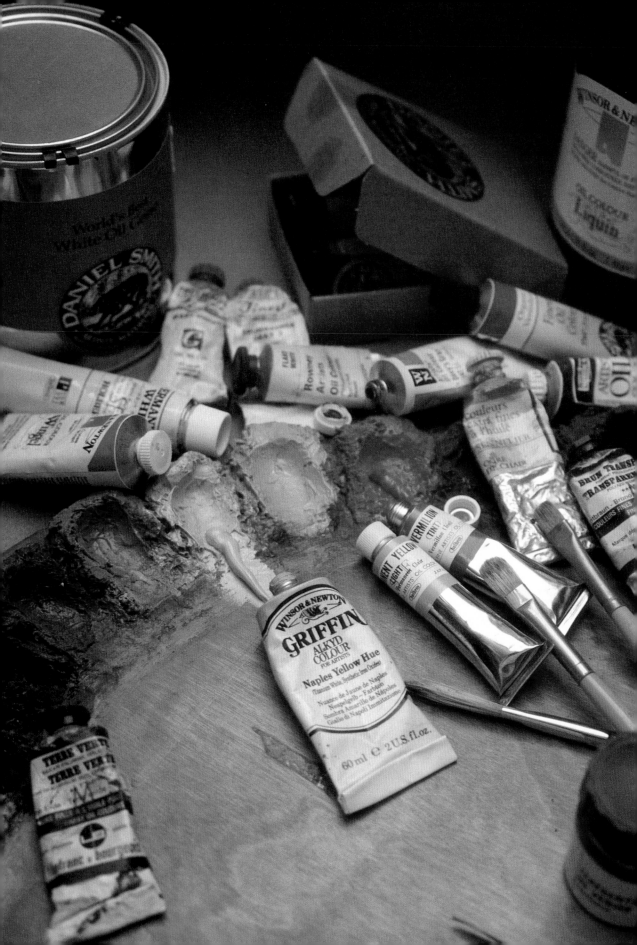

OIL AND ALKYD PAINTING

When most of us think of painting, we think of oil painting—stretched canvases resting on dark wooden easels, long-handled bristle brushes, and color-laden palettes. These elements, which have long been the emblems of the traditional artist's studio, along with the rich smells of drying linseed oil and damar hanging heavy in the air, still provide us a romantic link to the studios of the masters. You can be certain, however, that it was neither a fondness for rich smells nor romantic sentiment that made oil the masters' medium of choice—it was practicality. For versatility, for sheer ease of manipulation, nothing else came close to oil paint.

Oil remains the choice of many of today's professional illustrators. No other medium offers as great a range of effects. From the delicacy of a transparent wash to bravura painterly strokes of rich, viscous paint, oil paint has it all. With its long drying time, oil paint allows ample time for the blending of edges, tones, and colors. Mistakes are easily rubbed out of a wet surface, yet subsequent layers of paint will not dissolve a well-dried surface. It sounds like the perfect medium. However, oil paint is not without its difficulties.

Many of these difficulties arise from artists' belief in the astounding properties attributed to many of the well-known painting mediums. The traditional mediums are leftovers from a time when people still believed in dragons and alchemy. We're all familiar with "recipe books" that claim to be revealing the "lost" medium of some great painter—almost invariably, these recipes involve hours of cooking highly flammable ingredients over the kitchen stove, resulting in a smelly kitchen, a ruined pot, and often a small fire. I've experimented with hundreds of these mediums, and only four did anything to enhance the handling qualities of oil paints. Of those four mediums, three—black oil, megilp, and saponified megilp—are made with lead carbonate or lead monoxide, which can be dangerous to the lives of the painting and the painter. Only the fourth—beeswax melted with oil, varnish, and turpentine, and kept in a warmed container—enhances the

handling characteristics of tube oils without adversely affecting you or your painting. It dries to an exquisite matte finish. However, mucking about with these arcane mediums is time-consuming, and ultimately serves to complicate an already complex subject.

ALKYDS

Alkyds, which offer all of the advantages of oils and few of the disadvantages, are the illustrator's new medium of choice. Oil-modified alkyds are made from synthetic resins composed of alcohols and acids. The *oil-modified* term refers to the drying oil (linseed, tobacco-seed, or safflower) that is combined with the resin molecule during manufacture. Thus, alkyds are intermixable with oils.

Alkyd colors have the feel of oils—they remain moist and workable for 4 to 6 hours, but even a heavily painted canvas will be dry to touch if left overnight. Complete drying takes place in 18 to 24 hours. Use turpentine to speed the drying. Whereas thickly painted layers of oils dry from the outside, leaving the inside still soft, alkyds dry more consistently throughout.

Painting with alkyds is simplicity itself. The Winsor & Newton line is excellent and readily available, and includes only three mediums to be concerned with: Liquin, Wingel, and Oleopasto. Their color chart shows 40 colors and two different whites—about a third the size of their oil paint

A *section of my portrait palette, with part of the Holbein oil color chart in the background. I find oil to be the most versatile, enjoyable, and, at times, frustrating illustration medium.*

Liquitex oil tubes provide the most comprehensive information, including information on the paint's modular designation, value, and chroma.

selection. If your illustration is based on a color that is only available in oils, you can mix the oil color with alkyd paints and alkyd mediums, greatly improving the handling of the oils—Liquin and, especially, Wingel will make an oil paint smoother and faster-drying.

One of the many problems with oil paints is *dichroism*, or the *suede effect*. We've all experienced painting a large area—a blue sky, say—and having the vertical strokes produce a different color effect than horizontal strokes. The only cure is to go over the fresh paint lightly with a large, flat brush, and, in effect, polarize the strokes. Painting with alkyds, however, doesn't entail the suede effect, which helps alkyds to reproduce truer than oils. When alkyds are mixed with oils, the suede effect is proportional to the amount of oil paint in the mixture.

Of the three Winsor & Newton alkyd products, *Liquin*, the general-purpose alkyd painting medium, has the consistency of thick syrup. Liquin is the medium the illustrator will use most often. *Wingel* is a quick-drying glazing medium with some interesting

properties. Right from the tube, it's stiff, and drags when brushed, but a minute or two of vigorous mixing with a palette knife renders it delightfully smooth. After 10 or 15 minutes, it reverts back to its former self, making it ideal for light impasto. Remixing with the palette knife restores its smooth qualities.

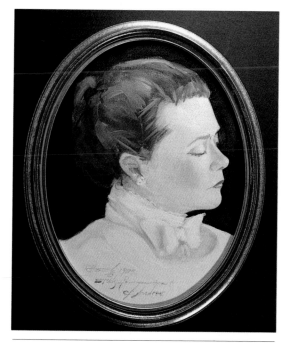

A *wax medium* made from melted beeswax, turpentine, and damar varnish can be mixed with oils to make an exceptionally smooth painting medium that dries to a matte finish. It's my favorite medium to use for quick oil studies like this one.

PRO'S TIP: OILS

Oil paints offer many advantages, including the following:
- The paint dries slowly enough to allow subtle blending of tones, colors and edges.
- Mistakes can be easily scraped or rubbed out.
- Dry oil paint won't dissolve from or otherwise react with subsequent layers of paint, varnish, or turpentine.

On the other hand, the disadvantages of oil paints stack up like this:
- Various colors have different drying times. Raw umber, for instance, dries in hours, while alizarin crimson takes days, or even weeks.
- Upon drying, some colors *sink*, or become flat and dull.
- Oil paint's slow drying may make it impossible to honor tight deadlines.

PRO'S TIP: ALKYDS

The advantages of alkyds are as follows:
- Alkyds offer all of the ease of handling and versatility of oils.
- Various alkyd colors dry uniformly.
- Alkyds dry to a consistent sheen, with no sinking.
- Alkyds dry in less time than oils.
- Alkyds produce slightly more brilliant colors than comparable oils.
- Alkyds are cheaper to use than oils.
- Alkyds do not produce dichroism.

Alkyds have only one disadvantage: a limited color range.

The last alkyd medium, *Oleopasto*, is a quick-drying impasto medium that helps thick paint hold its shape.

How difficult is it for an illustrator who has grown used to painting in oils to switch over to alkyds? It's as easy as scraping the oils off of the palette and replacing them with alkyds. And the transition is made a bit easier when you consider that alkyds are a bit more brilliant and less expensive than oils, too.

OIL AND ALKYD SUPPORTS

The supports we'll discuss, each of which are described in greater detail in Chapter 5, are presented here in the order of their degrees of absorbency.

Canvas is the most absorbent support available. Raw linen canvas has an ideal color and texture to paint on, but it must be primed before it can be painted with oils or alkyds, or else the oils will drain into the fibers and cause them to rot. The traditional priming method is to use a hot solution of rabbit-skin glue; a quicker approach is to use a coat or two of acrylic medium. A light sanding between coats will remove all the "hairs" that sprout up after the linen has been wet with the acrylic medium.

The drawing is usually done with charcoal pencil (avoid graphite, which can strike through the paint). To fix the drawing and reduce the canvas's absorbency, use two coats of Krylon Crystal Clear.

Denril or *coated printing paper* (like Kromekote) has very little absorbency. A lightbox is generally used to transfer the drawing, which can be done with Negro pencil, brush and ink, or brush and oil/alkyd wash. The illustrator's choice of papers is highly personal, obviously, so experiment with different papers to see which one appeals to you and your style. One note of caution: Do not spray Denril with fixative— the solvents in the painting medium will cause the fixed areas to peel off the surface.

Abitibi board is not absorbent, thanks to its slick, shiny surface. If you find it too slick for your needs, a light sanding will give it sufficient tooth. To apply a drawing to Abitibi, use a brush and oil/alkyd wash (which will be eradicated by subsequent painting), or a brush and waterproof ink (which will not be erased by paint or solvent).

PRO'S TIP: OIL OR ALKYD WASHES

To make a medium for an oil or alkyd wash, mix one part Liquin with 8 parts mineral spirits. (Substituting turpentine will cause the paint to dry faster.) If the medium becomes cloudy and discolored, it means that you are not cleaning your brushes thoroughly. *Slow down—* dirty brushes make muddy paintings.

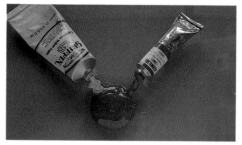

Liquin mixes equally with alkyds or oils. It speeds drying and improves handling oils, leaving little need for any other medium.

Oil on raw linen that has been isolated with a coat of acrylic medium. This is an open and sketchy approach that takes advantage of the warm linen texture as a middle tone.

Just because a piece is done in oil on linen doesn't mean you can't have fun with it. Doing this caricature of George Bernard Shaw manipulating Professor Higgins was made more enjoyable by working in oils.

Art directors are always delighted to be presented with an illustration done on canvas, rather than board. In this caricature of Giacchino Rossini, you can see areas of raw linen and traces of the charcoal drawing in the composer's face. The paint is much thinner than it appears. The lines on the music paper were done with a ruling pen and thinned oil color.

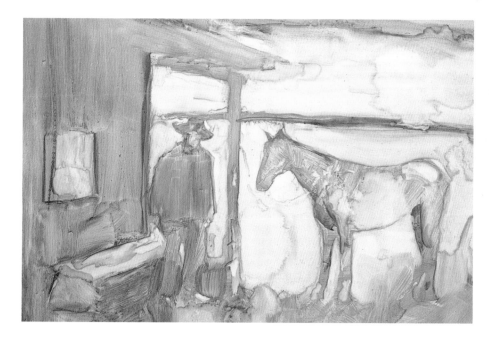

As this little sketch shows, Abitibi provides a slick, slippery surface that lends a special quality to oil washes.

Choosing paint brands is a highly personal matter, and different illustrators will have differing needs. With that caveat in mind, my own choices are as follows.

For alkyds, there's really only one brand: Winsor & Newton. For oils, however, the choices get more complex—there is a much greater selection of colors. Winsor & Newton offers a huge selection of what might be called traditional artist's colors—113 in all. While you might be tempted to believe that this is sufficient, such is not the case. Liquitex fills in some of the Winsor & Newton gaps, offering such pigments as quinacridone red and violet, three portrait pinks, four neutral grays (a very important addition), and unbleached titanium and parchment white. And Liquitex's series of Tole Colors are handy additions to the palette.

Other companies have worthwhile products as well. Shiva employs a special approach with their Permasol Transparent Oil Colors, which are well-suited to oil wash techniques. Lefranc & Bourgeois, a French firm, has built a reputation on its excellent proprietary color mixtures, but, unfortunately, they are ground in so much oil that they need to be drained on blotter paper before use. The proprietary mixtures of the Daniel Smith Company have supplanted Lefranc & Bourgeois's color list. Daniel Smith's organic vermilion is the equal of Winsor & Newton's 45-dollar tube of vermilion, and their moonglow (a transparent mauve) is particularly helpful for laying in shadows on flesh tones.

I've saved a discussion of Holbein oils for last because they have unique qualities. Aside from offering an immense color range of colors (150 colors and six whites), Holbein maintains a consistent viscosity between colors. This is no trifling matter—anyone familiar with oil paint knows about hard-to-manipulate "long" paints and smooth, buttery "short" paints. Painters had always thought these viscosity variations were unavoidable characteristics of oil pigments, and so, it seems, did the manufacturers. But in the 1970s, Holbein created a buttery consistency from color to

PRO'S TIP: CLEANING YOUR BRUSHES

It's no secret that the best way to get brilliant colors is to keep those colors clean and uncontaminated. Sloshing them around in a can of paint thinner just stirs up all of the old dissolved paint and leaves the brush dirty. I use a screen made out of 1/4-inch galvanized hardware cloth, suspend it several inches above the bottom of a paint bucket, and cover it with 2 inches of thinner. Stroking the brush across the screen causes it to clean itself, while the residue sinks to the bottom of the pail, where it can't be stirred up.

After getting this treatment in the first bucket, the brush moves on to a second bucket, where another screen is used to remove any residue. The second bucket also contains a dowel—by slapping the bristles of the brush back and forth against the dowel, the brush is quickly dried. In an 8-hour day at the easel, this method saves an hour that would otherwise be spent cleaning brushes, and does a better job to boot.

A tin painter's bucket with a screen of hardware cloth serving as a barrier near the bottom. The dowel is used for slapping the brush dry within the confines of the bucket, preventing spattering. This simple technique is a great way to clean your brushes.

color by varying the amount of time the paints are ground, and the difference is astonishing. In addition, Holbein, in a joint research project with the Japanese government, developed a new painting white—ceramic white. It's more transparent than titanium white, but has greater covering power than lead white or zinc white, and handles better than any other white on the market.

—————— OIL–ALKYD WASHES ——————

In many ways, the techniques used for oil or alkyd washes are similar to those for watercolor. Unlike watercolor, oil–alkyd washes look best when applied to nonabsorbent surfaces. The slower drying rate and the less absorbent painting surface make it more forgiving when making changes. Working into previously dried areas allows the illustrator to build a depth of color that would be impossible to achieve with watercolor.

Because the paint is extremely dilute, there is a risk of not having enough medium to adhere the particles of pigment solidly onto the support. When dry, paint with too little medium can be rubbed off easily. To avoid this, mix a bit of painting medium into solvent, rather than using solvent alone, and the paint will dry to a durable film.

—————— PREPARING THE CANVAS ——————

When preparing to paint on canvas, the canvas should not be absorbent. A coating of white shellac will seal a canvas that has been primed with acrylic gesso—allowing for drying time, the surface will be ready to work on in less than an hour. Shellac also allows the texture of the canvas to show through. If you have a bit more time, a thin coat of Daniel Smith's premixed World's best White Oil Gesso will dry overnight to a bright, white nonabsorbant surface.

To prepare a more painterly texture for your canvas surface, start by painting white lead over the canvas with a coarse 1-inch bristle brush. In order to avoid the health hazards inherent in white lead, you may wish to use nonlead oil-alkyd paints. Thin the paint with enough turpentine so that it

brushes out easily but still has enough body to leave distinct brush marks. After the turpentine evaporates and the white lead returns to the same stiff consistency it had in the tube, go over the surface with a large palette knife and flatten out the brush strokes. Let the canvas dry for at least a week. Because of individual brush handling methods, everyone employing this method produces a distinct result.

—————— DRAWING AND PAINTING ——————

Once your canvas is properly prepared, use a fine sable brush and waterproof ink to lay in your drawing. If the ink beads up on the surface, spray the surface with a detergent, such as Formula 409, and wipe dry. Make the drawing dark enough to be visible through a layer of transparent paint. After it dries, fix the drawing with Krylon Crystal Clear or shellac, and allow it to dry (10 minutes for Crystal Clear to dry, an hour for shellac).

My preference is to work on a neutral brown ground. Because it's a dead color, any color laid next to it appears to glow. You can make such a ground by neutralizing raw umber with a bit of ultramarine blue in a ratio of about 1:5. Mix it with enough turpentine (or mineral spirits, for slower drying) to make a loose wash. Brush it over your fixed drawing until you've produced a middle value (about a 50-percent tone on a printer's scale). Allow the turpentine to evaporate.

Next, block in your shadows quickly. Don't worry too much about subtleties—you can take care of them later. Your choice of shadow color depends upon the emotion you're trying to convey with your colors. Warm shadows with warm highlights will give your picture a very different emotion than will cool shadows with the same warm highlights, or warm shadows with cool highlights. Experiment on a few small canvases. As an exercise, use the same drawing and midtone but change the color temperatures of the shadows and highlights. The results will expand your artistic and emotional range.

With the shadows now blocked in, take a dry bristle brush and rub away the highlights. The more you rub, the lighter it gets. For large areas, you can rub out with a rag. Then

dip the brush into turpentine and wipe it dry—this will leave enough turpentine on the brush to remove the toned ground entirely, revealing the sparkling white of the canvas. You can now blend the shadows into the middle tones. If you've been using alkyds, the surface will be ready to overpaint within a few hours.

At this point, the pictorial idea should be clearly visible from across the room. If the idea doesn't come across with graphic clarity, then the picture has compositional problems that no amount of painstakingly rendered detail will cure, and you should probably rethink it. Assuming the idea *is* clear, the application of color can either be done *alla prima* or built up with glazes. You can add just a few suggestions of color or use the underpainting as a guide for extensive overpainting. If you have used a barrier coat of shellac, you can paint freely without worrying about harming the underpainting, since you can always scrub away the overpainting and start again.

Finally, a few words of caution: Although Norman Rockwell used shellac on his works, you should avoid it, at least if you are concerned with the archival permanence of your illustrations. There's a chance that it may eventually cause slight surface cracks. (On the other hand, if your illustrations are as worthwhile as Rockwell's, platoons of restoration experts will devote countless hours to preserving them anyway.)

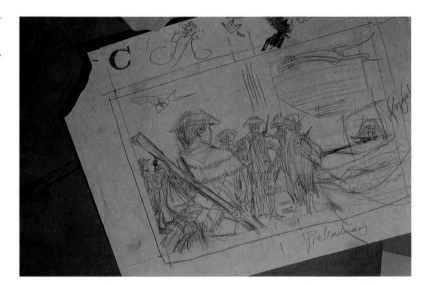

This is the initial pencil sketch for a wrap-around book jacket. The cover is kept quite open with nothing but a frigate on the ocean and a bit of one of the militiamen pointing his musket toward the ship. A scale model of the ship was built and photographed for reference.

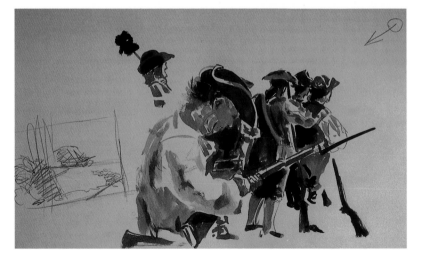

The book's author wanted some adjustments, including changing the figures and enlarging the frigate. Based on these new guidelines, I prepared this value study done in ink wash, prior to posing my models for the final reference photos.

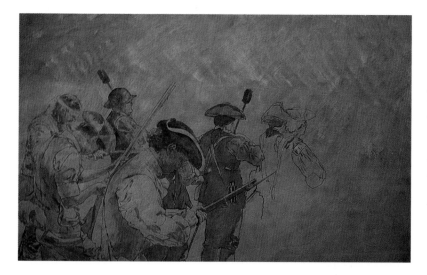

The drawing was laid in with thinned-down waterproof sepia ink on a roughly gessoed Masonite panel. After it dried, it was sprayed with Crystal Clear. A mixture of burnt umber and French ultramarine was then thinned with turpentine and scrubbed over the background. The shadows were laid in with a thin burnt umber wash.

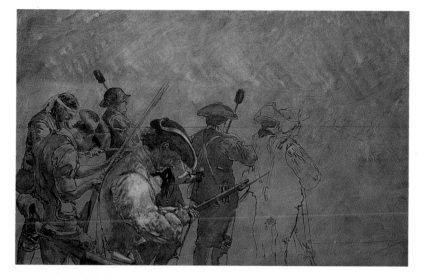

The light sections were scrubbed out with a dry bristle brush.

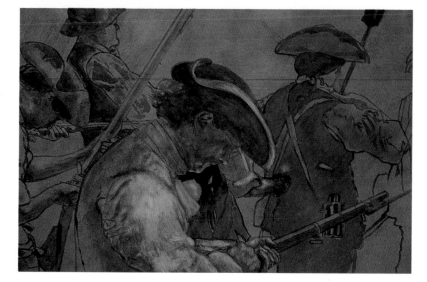

A detail showing the texture of the ground showing through. More figures were added, along with the cannon, the frigate, and some landscape. After the monochromatic painting dried, it was painted with color.

There have been numerous times when I wished I could include hand lettering in an oil or alkyd illustration. Unfortunately, few illustrators are skilled signpainters, and transfer type (used either on its own or as a frisket, as shown in Chapter 6) cannot withstand the solvents in oil and alkyd paints. All is not lost, however—Gerber Scientific Products manufactures a computerized sign-cutting machine that cuts perfect letters out of a sheet of adhesive-backed GSP 220 Scotchcal vinyl. The Gerber will cut a wide variety of type styles in letter heights ranging from ³/₄ to 12 inches. Normally, the machine cuts the vinyl and the operator then removes the background film, leaving only the letters adhered to a backing sheet; of course, being illustrators, my colleagues and I asked for the reverse, so that the letters would be removed, leaving the background vinyl to serve as a beautifully cut frisket. Thankfully, they were able to meet this request. Although Scotchcal vinyl comes in a variety of colors, I prefer the clear base, which gives me a clearer view of exactly where it's placed.

It's important for the paint to dry tack-hard when using the Gerber method, because the adhesive is rather strong, and could lift a weak paint film from the surface of the painting. Before applying the cut frisket, lightly clean the surface with Formula 409, or a similar detergent. After positioning the frisket, apply a tape hinge at its head. Remove the liner, allow the frisket to drape naturally, and squeegee it until it's well-adhered with no bubbles. Remove the premask by pulling 180 degrees back it upon itself, and re-squeegee the frisket. Now you can paint any color or texture you desire. After the paint has dried hard, carefully remove the frisket. Don't let the frisket remain on the painting for any longer than necessary, or it will bond with the surface. If you encounter problems removing it, try warming it with a hair dryer.

After cutting your desired vinyl lettering with the Gerber machine, remove the vinyl's protective backing and apply the film onto the surface.

Squeegee the film.

Remove the premask. What you now have is a frisket with the lettering areas cut out and ready to paint through.

Using alkyds or oils, paint over the frisket.

After the paint dries hard, remove the film.

Lightly smoothing a sheet of tracing paper over the tack-hard letters will flatten any ridges remaining at the edges.

INVISIBLE PATCHING

It happens to all of us—something falls against the canvas and causes a tear, or the art director wants to add a few inches to a finished illustration. This used to be a disaster; now, we simply make an invisible patch using the iron-on patch material found in sewing stores. This type of patch isn't appropriate for a painting meant to last a lifetime, but it's fine for rescuing an illustration meant to be reproduced. There are several types of these iron-on patches; I prefer the type used to bond fabric to window shades.

To make this sort of patch, take a piece of canvas—the same type as was used in the painting—and tape it in position over the back of the area to be patched. Align the weaves of the two pieces, so they match, and then put a piece of Upsom board, Homesote, or soft wood over the patch and turn the entire assembly over. Hold all of the layers together with push pins placed outside of the area to be replaced. Then use a craft knife to cut an irregular shape (or edge) out of both pieces of canvas. Remove the pins, turn the canvas over, and align the patch. Lay the iron-on bonding material over the patch and iron it at the lowest effective temperature. When it is painted, your paint will fill the cut marks.

To make an iron-on patch, tape a piece of identical canvas over the back of the area to be repaired. Make sure the weaves line up.

Using a sharp knife, cut an irregular shape through both pieces of canvas.

Remove the damaged piece and align the patch in its place.

With your iron set at WOOL, press a piece of Fuse-A-Shade to the back of the canvas and the patch. Hold the iron for 15 seconds, and then allow the area to cool completely.

A layer of gesso or paint will fill any seams left in the surface.

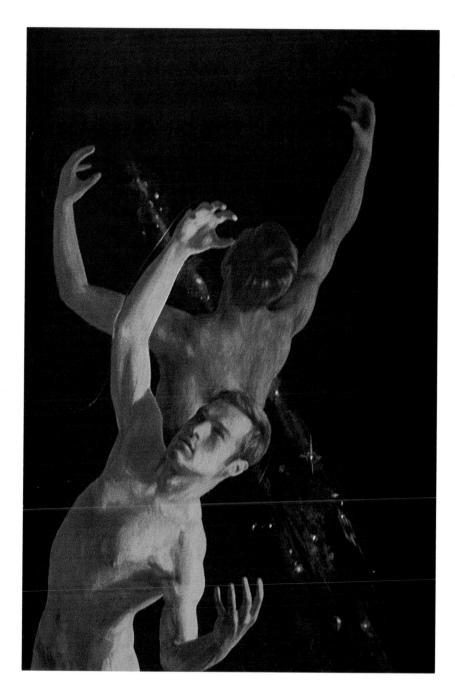

Oil on gessoed paper. After the front figure was painted, the art director wanted to expand the painting and add a background figure. In this photo, you can see the cut marks that made this possible, but they were not apparent when the illustration was reproduced.

OIL AND ALKYD DEMONSTRATIONS

Throughout history, one of the major goals of professional artists has been to discover and develop new methods and materials that help in the rapid and efficient production of high-quality artwork. The following demonstrations show some illustration tricks and techniques being employed to that end. While these techniques are all appropriate for illustration, you should note that some of them yield less-than-permanent results, and therefore should not be used for painting fine art.

One last caveat: Because this book is not aimed at the beginning artist, these demonstrations assume that you are familiar with the rudiments of painting. Thus, you will see no demonstrations of the standard easel painting techniques of glazing, *alla prima*, and so forth.

Although a great deal of an illustration's emotional impact can come from color, the illusion of solidity in a picture relies on properly choosing *values of light and dark*, not color. This is a particularly important point for illustrators, most of whom find it easier to draw than to paint, and to make ink wash drawings than to paint full-color watercolors. Our eyes often become so overwhelmed by the interplay of colors that we become unable to accurately identify their values. To prove this to yourself, experiment with the color controls on your television: With the color turned off, the black and white images are still solid and recognizable. Now set the controls for maximum color intensity—the solidity of the image disappears in the confusion of hues.

Painting in color is an incredible balancing act. The medieval masters simplified their work by rendering their pictures in shades of gray and then adding color by applying transparent color glazes over their monochrome underpaintings (called grisailles)—much like tinting a black-and-white photo. Even without the glazes of color, those monochrome underpaintings were things of beauty that could stand on their own.

In this demonstration, we will paint the main subject in monochrome (which needn't be black and white, by the way). Then we will paint a different color into the background but leave the main figures in monochrome, thereby giving the impression of an illustration painted with a full palette.

The project begins with an outline drawing on white lead–prepared canvas. Note the reference photo in the upper-left corner of the canvas.

A wash of red is scrubbed in, and the shadow areas are built up with a heavy but transparent layer of color.

Some of the background is rubbed out, and a yellow tone is then added. The areas to be highlighted are rubbed out.

Detail of the canvas after 15 minutes. The darks are blocked in and the lights are softened with a dry bristle brush. I go back and forth between the lights and darks, trying to achieve a balance.

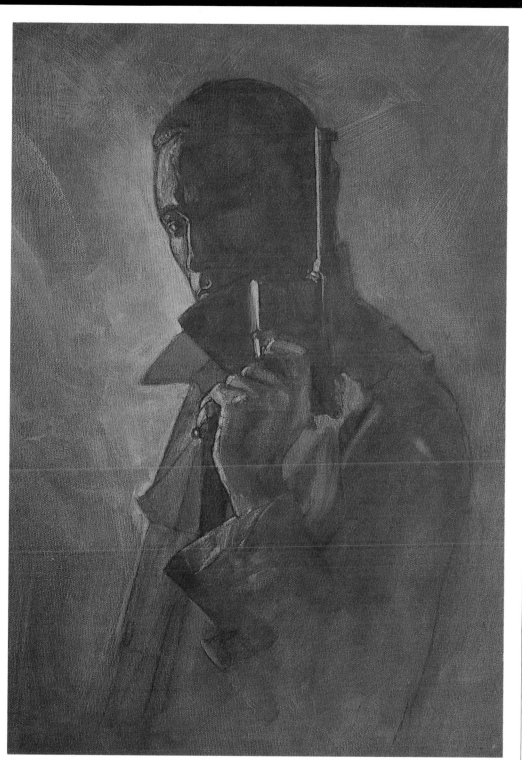

After an hour, the illustration is almost finished. The accents have been made darker and the transitions and modeling have been smoothed. The lightest highlights are achieved with a bit of turpentine on a brush.

An illustration project that had to show a number of busy executives brought me face-to-face with the realities of corporate life—although I wanted to take a reference photograph of the executives, their busy schedules made it impossible for me to get all of them to be in one place at the same time. Eventually I was able to take photos of two of them together, but the others had to be painted from existing photos. The lighting was different in all of the photos. I attempted to unify the picture by using a boldly textured background.

The drawing, done with a soft Negro pencil on Denril, is lightly washed with turpentine to remove any excess pencil.

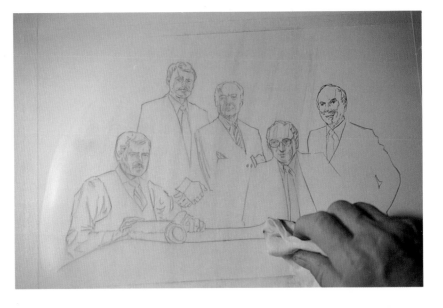

A mixture of Prussian blue and burnt umber is laid in as a very liquid wash. I used turpentine to cut into the outer edges of the picture, allowing it to run and bleed into the base coat of color. The reflections on the table are rubbed out with a cloth and turpentine.

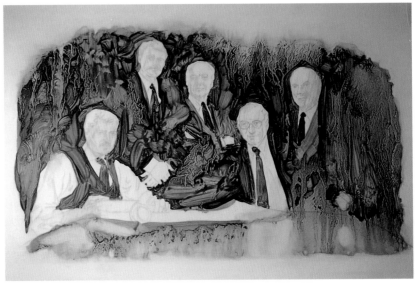

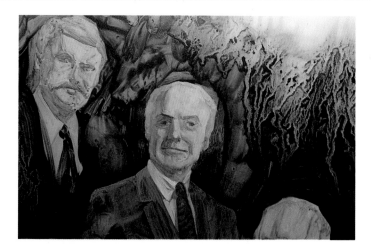

In order to emphasize the liquid textures, this illustration is kept fairly small—each head is smaller than a quarter. They are quickly blocked with washes of raw sienna and burnt sienna. A thin wash of Prussian blue is laid into the shadows of the shirt. Various dark colors are used for the neckties.

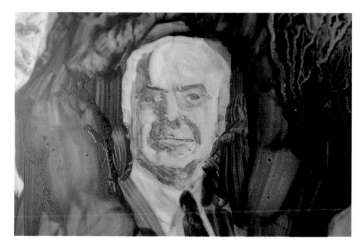

This face was finished with a minimum amount of effort, using an alla prima *technique. The underpainting is allowed to show through. This approach is similar to that of highlighting a drawing with white chalk—it creates an illusion of much more paint (and painting) than actually exists on the Denril.*

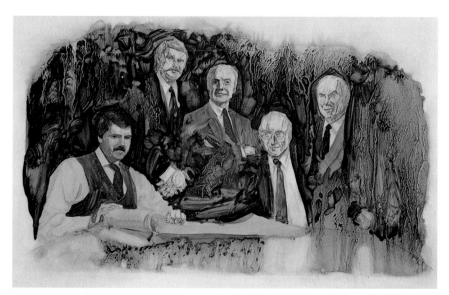

Here the illustration is blocked in and well on its way to being finished. All of the major decisions have been made, and only straightforward work remains— the finishing of a few heads, hands, and some reflections.

This demonstration details the evolution of an illustration that requires more preparation than most. Illustrations like this one, done for a paperback cover, are carefully scrutinized by military buffs. These readers delight in finding flaws in the depiction of the weapons, uniforms, and other small details, upon which they invariably dash off "Gotcha!" letters to the publisher. Because of the need for atmosphere coupled with accuracy, this is the sort of illustration project that lends itself to painting in oils.

The group of figures was adapted from an image on one of the Irish Republican Army's political posters. I rather liked the basic composition of the trio but changed some of the equipment. Because

I wanted all Eastern Bloc equipment, for instance, I substituted an AK47 rifle for the M16 shown in the poster. Changes were also made to the rocket-propelled grenade launcher, so that it would conform to the specifications found in Eastern Bloc weaponry.

Doing an illustration like this one requires a great deal of preparation time, including considerable time devoted to research and posing of models. For this image, the research, full-scale drawing, and color studies took up more than half of the project's total working time. Moreover, the illustration's fairly large size (45 inches tall) required more time and physical effort than usual.

The composition and drawing are refined, changed, and further refined in a working-size sepia chalk drawing that will be photographed and projected onto the canvas. Note the paint, the patches and the overworked changes at the bottom.

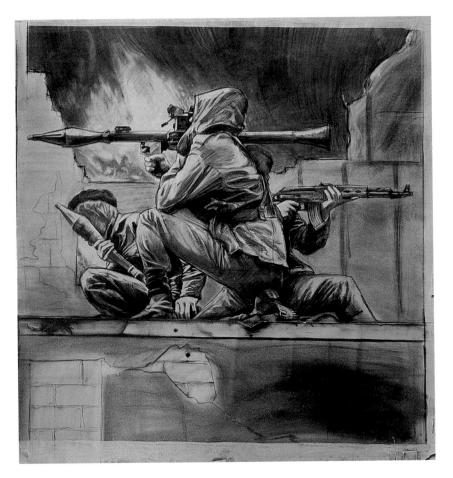

One of the painted photos used as a basis for a color sketch. My intention was to have the figures illuminated by cool moonlight, with the fire as a warm counterpoint. Painting on photos gives you the opportunity to quickly try different approaches to color.

I was unsure of how this figure would be handled against the bright yellow of the fire. Instead of taking my chances on the illustration itself, I did this quick sketch on a scrap of canvas. It was obvious that it needed more contrast.

Detail from the final canvas. Here is the same figure, this time painted in monochrome with deeper darks. It has much more punch than either the painted reference photo or the scrap-canvas sketch. In order to unify the picture, the bluish tones were changed to a sickly green, adding to the mood of the picture.

This detail shows a few warm reflections on the AK47 and the wall. This helps set the figure farther into the background. The deeper back the figure needs to be, the more background color is introduced. This is the reverse of the dictum that "warm colors come forward, cool colors recede," one of many "rules" that don't hold up to scrutiny. A better rule to keep in mind is that introducing the background color into a foreground figure will cause the figure to recede, no matter what the colors are.

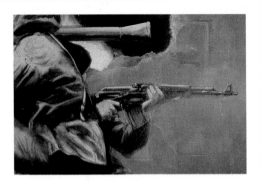

Attention to details adds to the overall story. The reference photos for this passage were taken at a building demolition site; the reference for the bullet holes was a photo of a roadside sign that had been used for target practice.

The finished illustration.
Total working time: 32 hours.

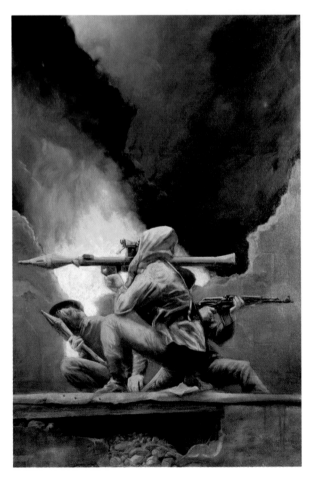

Most of us tend to think of work in oils and alkyds as "serious" painting. This demonstration shows that they are also quite useful for humorous illustration. Additionally, art directors are usually delighted when presented with a picture on canvas instead of on illustration board.

The drawing is done with vine charcoal. After the excess is removed with a drafting brush, the drawing is fixed with workable fixative. The thinned colors are scrubbed in quickly.

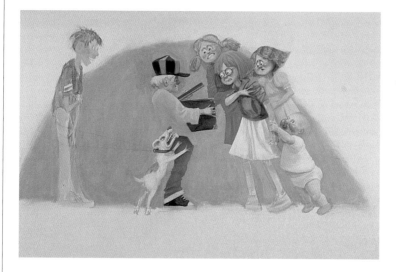

The background color is grayed down to provide a foil for the areas of intense color. All of the figures in the group are brought to finish at the same time, while the lone figure, which is critical to the balance, is finished last.

The alizarin crimson in this cap is grayed with a touch of viridian; the gold is grayed with purple. A greenish-gray is mixed with the fleshtones for the shadows.

The most intense colors are reserved for the girl nearest in the foreground. The colors become softer as the figures recede or approach the edges. Raphael used this technique when painting crowds—it still works.

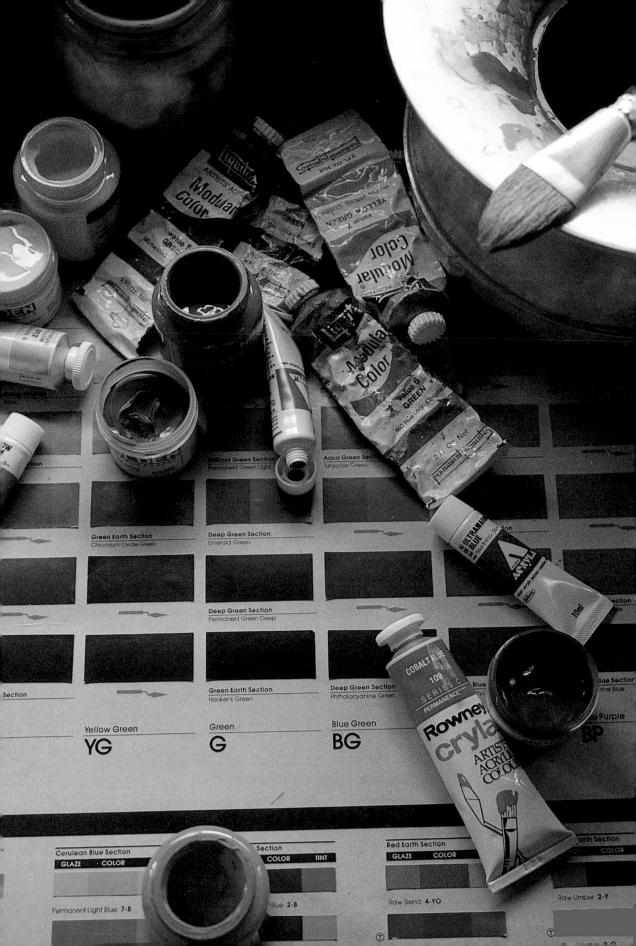

CHAPTER 10
ACRYLICS

We now turn our attention to acrylics made to be applied with a paintbrush. The initial development of acrylic paints occurred when I was still in art school—a fellow student found an acrylic resin similar to Elmer's Glue that could be mixed with gouache or watercolor, or could be ground with pigment and quickly dry to a surface, after which it was impervious to subsequent coats of paint. It was an astonishing breakthrough. The only paints that could theretofore resist subsequent paint layers were oils and, to a lesser extent, caseins.

As revolutionary as those first acrylics were, today's acrylics are light years ahead of those hard-to-brush concoctions we used back then. Contemporary acrylics are the products of skilled chemists, not art students. The dominant force among the acrylic manufacturers is Liquitex, which markets uniformly excellent products keyed to an ongoing concern with the problems faced by artists.

Most artists have difficulty understanding and using color. In the late 1970s, Liquitex addressed this problem by mixing and packaging the colors according to their tonal values. In the Liquitex system, called the Modular Color System, each color (or *hue*) was mixed to the greatest brilliance (or *chroma*) allowed by its degree of light or dark (or *value*). Sadly, many artists, wary of the notion of basing their colors on what they perceived to be a formula or a regimented system, were unwilling to learn the color theory that the Modular system was based on, and so it did not receive the popularity it deserved (some artists are such sticks-in-the-mud).

Fortunately, Liquitex has not abandoned the Modular Color System, which now exists in another form. If you examine a tube of, say, permanent green light, the label gives a variety of information, including a value rating of 5.0 and a chroma of 11. Knowing this, I can lower the chroma of this paint with a value-5.0 gray *without changing its value*. I also could use a value-5.0 red to neutralize the green, again without changing its value. Knowing how to control values is one of the outstanding skills that sets painters and illustrators like John Singer Sargent and Bernie Fuchs apart from the herd.

In order to help artists understand the difficult subject of color mixing, Liquitex has produced a comprehensive collection of instructional aids. Chief among them is the *Liquitex Color Map & Mixing Guide*, which can be used to isolate any color and see how it relates to other colors. The map will also tell you whether a given color is available right out of the tube. If the color has to be mixed, the map shows you what colors to use. Liquitex also offers videos, an excellent booklet, and other materials on color mixing. The most valuable of these secondary tools are Value Finder Cards, which can be placed next to a color to identify its value. These cards, which come in inexpensive packages of 20, are indispensable in the efficient studio.

PRO'S TIP: ARTIST-SPECIFIED PAINTS

By necessity, the large manufacturers of acrylic paints must formulate their products for the "average" artist. Their paints have to perform well enough to satisfy most professionals while retaining appeal to vast numbers of amateurs. Knowing this, professionals have always modified these standardized products to make them conform with their needs.

Now, for the first time since the days of the Impressionists, paints made to the artist's specifications are available. Golden Artist Colors of New Berlin, New York, will custom-match acrylic colors in any quantity. They will also produce fast- and slow-drying acrylics, as well as smooth-flowing and rigid acrylics. Finally, a company that doesn't believe that "one size fits all."

Liquitex (left) leads all manufacturers in clarity of labeling; Holbein labels (right) offer virtually the same information, but it is less accessible.

Golden Artist Colors can be formulated to meet your specific needs.

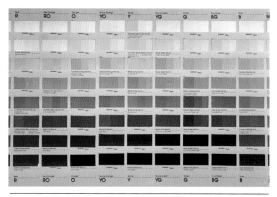

Liquitex lists the value of each color on the side of the label, making it easy to control the chroma of your colors without affecting the value, as shown in this smooth transition from a value-7 blue to a value-7 neutral gray.

The Liquitex Color Map & Mixing Guide locates each color by value, chroma, and hue, thus taking the mystery out of color mixing.

PRO'S TIP: COLOR THEORIES

Color theories—it seems every generation of artists has its own, usually based on the materials available at the time. Back in Hans Holbein's day, when the prevailing color theory was based more on the correct rendition of values than on color interaction, the typical palette included flake white, terra verte, Venetian red, burnt umber, ivory black, and a touch of vermilion.

By contrast, the impressionists' palette had a rainbow of color, due in part to the influence of M. E. Chevreul's masterful 1839 book, *The Principles Of Harmony And Contrast Of Colors And Their Applications To The Arts*, in which Chevreul posited the Law of Simultaneous Contrast of Colors, best summarized by this quote from the French painter Ferdinand Delacroix: "Give me mud and I will make the skin of a Venus out of it . . . if you will allow me to surround it as I please."

Many of the impressionists and neo-impressionists developed a great knowledge of color. Later, adherents of Fauvism, Abstract Expressionism, and other *isms* rejected discipline in favor of impulsive creative expression, inventing color theories along the way to validate their art. Josef Albers and Johannes Itten became the darlings of the university set by intellectualizing color theory—at the expense of any utility to the working artist.

Today we have color undreamed of by past generations of artists, and yet art schools still teach little beyond the dry theories of Albers and Itten, which are of no use to the illustrator. If you are serious about your illustration work, study Chevreul's writings—you'll find it well worth the effort.

The colors available in Hans Holbein's day, counterclockwise from top: a warm brownish black, terra verte, red earth, massicot, white lead, and the smallest amount of vermilion.

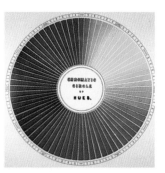

A chart from Chevreul's The Principles Of Harmony And Contrast Of Colors. Most of the Impressionists' color theories were based on Chevreul's findings.

JARS vs. TUBES

Many artists are confused about what differences, if any, exist between the colors packed in tubes and those packed in jars. In fact, these two types of packaging contain two distinctly different paint formulations. Tube colors have a buttery, pastelike consistency that retains the texture left by the brush or knife. The additives required to make this heavy-bodied paint mean that there is less pigment in the paint. Jar colors have a smoother, more fluid consistency, and have a higher proportion of pigment than tube colors, making them well-suited to being thinned for wash and airbrush techniques.

ACRYLIC GESSO

Another important acrylic paint is *acrylic gesso*, which is used as a painting ground and for creating textural drawing surfaces. The traditional gesso, made from rabbit-skin glue and white pigment, has perfect absorbency, drag, and tooth. Applying it, however, is time-consuming and tricky. If you are a careful worker, you can achieve equal results with today's acrylic gesso, which is available in a variety of colors.

Applying acrylic gesso with a brush leaves stroke marks that must be sanded between coats. Depending on the look you are after, you may actually want to use a coarse brush to accentuate this effect. For a smooth application, on the other hand, you're best off using a spray gun, which obviates the need for sanding between coats. Until recently, I used the Badger Touch-Up Gun for this work, but the gesso had to be quite dilute, because the Badger gun is a suction-feed device. Now I use the Iwata RG-2, a gravity-feed spray gun, which can spray heavy paint without any problems. (Gesso right from the jar is too thick for *any* gun to spray, but a gravity-feed gun will handle any paint that can be easily poured.)

After the gesso is dry, you will probably want to unify the surface with sandpaper. A light sanding with a 320-grit sandpaper is fine for all but the finest work. For certain techniques, I start sanding with a 320-grit and get progressively finer until I end up with a 2000-grit wet/dry paper, which yields a high sheen. For the ultimate high sheen, I use

Daniel Smith's World's Best Gesso, which comes in white, stone gray, and black, and has a harder, less absorbent surface than Liquitex—an ideal surface for highly detailed painting.

Liquitex Gesso's absorbency is similar to that of traditional gesso. It has slightly more tooth than the Daniel Smith, and comes in eight colors—blue, yellow, red, white, gray, black, and, most exciting, burnt umber and unbleached titanium.

MEDIUMS AND VARNISHES

Mediums can be thought of as glues—they must be formulated to be strong enough to bind the pigment to the support. A well-formulated medium should dry with minimum distortion of the pigment's color. Varnishes have less binding power than mediums, but serve to enhance the colors and unify the surface. A well-formulated varnish should dry colorless, perfectly transparent, providing protection and a uniform sheen to the underlying painted surface.

Gloss medium is an all-purpose mixing medium. It increases the gloss and transparency of colors with which it is mixed—colors thinned with sufficient gloss medium produce sparkling glazes. Gloss medium can also be airbrush-sprayed as a fixative and as a final nonremovable gloss varnish.

Thinning tube colors with gloss medium will reduce their body. If you want to dilute a paint's color without reducing its body, mix it with *gel medium*, a polymer gel formulated to be used as a heavy-bodied gloss medium.

A close-up view of an acrylic wash on rough gesso. The gesso was applied with a coarse brush.

When mixed with tube colors, it lengthens handling time and imparts a oil-like body to acrylics. Be careful, however—gel medium's prime advantage is the lengthened handling time. When used excessively, it can lead to those horrid textural glazes that make it look like a child smeared jelly on your painting.

Retarder, another medium that can help lengthen the handling time of tube and jar colors, has many of the same characteristics as gel medium, but is not as heavy-bodied. It can impart a slightly gummy quality to your paints.

Given all of this discussion about mediums that can lengthen the handling time of tube colors, it should be plain by now that the fast-drying qualities of acrylics amount to a double-edged sword. Yes, acrylics' rapid drying time makes them more convenient than oils; the problem is, they dry too fast to allow for much subtle blending.

Matte medium creates a flat finish when mixed with tube colors; when mixed with jar colors, matte medium can create a matte surface rivaling those of gouache and casein. It can be used to produce a glareless glaze, or to create a surface that accepts pencil, pastel, and other media. Matte medium should not be used as a final varnish—in this form, it will dull the colors and result in an overall cloudy appearance. (To get a satin finish to the surface, use *matte varnish*, which can be used as a final varnish on matte or glossy paintings and, like gloss varnish, enhances the colors of the painting.)

Matte gel medium is identical to gel medium. If you wish to paint with heavy, viscous paints but want to avoid the "smeared jelly" appearance of the transparent gels, Liquitex makes *Gelex*, an opaque gel medium that can be mixed with paints 50:50 with no color alteration and, when used in greater proportion to the paint, acts as a weak tinting white. For most techniques requiring crisp brush or knife strokes, Gelex offers all of the advantages of gloss and matte gel without weakening the color.

In order to facilitate a more even, consistent application of paint, prevent stickiness, and improve adhesion to slick surfaces, add a few drops of *water tension breaker* to your paint mixture. Liquitex calls theirs Flow Aid Medium. This medium is imperative for hard-edged, flat brushing techniques, and for mixing colors to be sprayed with an airbrush.

PRO'S TIP: ACRYLIC MEDIUM

Thinning paints with nothing but water can result in poor adhesion and dead colors. Instead of water, try this general-purpose acrylic painting medium: Put 1/4 cup of gloss or matte medium, in a 1-quart jar. Add 10 drops of water tension breaker, and then add water to fill. This recipe can be modified to suit your needs. Depending on the effect that you're after, for instance, you may want to increase the amount of gloss or matte medium. And adding more water tension breaker will make the paint sticky. Adding a minimal amount of medium to the water will produce a matte, gouache-like surface. The more medium you add, the less matte the surface becomes, but the brighter your colors will become.

PRO'S TIP: BRAND NAMES

Perhaps you've been wondering why I recommend so many specific brands of products and tools. For example, you should use Saran Wrap—rather than any other plastic wrap—to keep your palette paints workable and moist. Just cover the paint with the Saran Wrap and press tightly to avoid bubbles.

There are numerous clear plastic wraps on the market. Although all of them are clear and seem to do the same thing, such is not the case. Saran Wrap, unlike many commonly available plastic wraps, is made with polyvinylidene chloride, which is up to 500 times more oxygen-resistant than the materials used in other plastic wraps. None of the recommendations in this book is made lightly.

This is a technique for achieving a random visual texture with acrylic paints. Like most textures, it should be used sparingly. My preference is to lay in a thin underpainting with frothy washes of acrylic. When overpainting this layer with opaque layers of color, some of the underlying texture will shine through, thus adding interest.

To make your acrylic froth, combine gloss medium and water 50:50 and mix it liberally with your paint—you're trying to achieve a semitransparent glaze. Using a coarse bristle brush like a cooking whisk, whip the paint into a froth. Jabbing it with the brush will produce larger bubbles.

With your support laying flat on a drawing board, use a coarse brush to apply the froth to the support with quick, sweeping strokes. The strokes will be dotted with bubbles, but this is okay—don't try to smooth them out. For a subtle effect, you can let this dry completely; for a more powerful texture, allow it to dry

until everything but the edges of the bubbles has dried, and then wipe the surface quickly with a paper towel. The wiping will remove those circles of wet paint, leaving the support showing through. This process can be repeated with various colors, creating a complex texture of many color layers. Like all strong effects, of course, it should be used with discretion and in moderation.

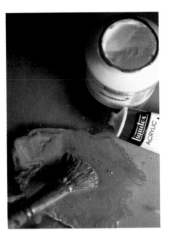

Acrylic paint after being mixed with gel medium and water and whipped to a froth with a coarse bristle brush.

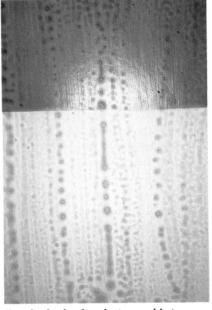

Acrylic froth after drying and being glazed with a transparent green.

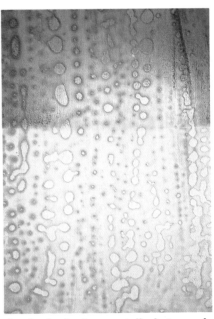

Acrylic froth after partially drying and then being wiped dry with a paper towel.

Another technique that can be done only with acrylics is textural painting on acetate. The technique is similar to painting animation cels, except here we're trying to create a textured painting.

To add color to a line drawing done on acetate, use either an ink drawing on prepared acetate or a film positive of a drawing, and paint your colors on the reverse side. This will allow greater freedom, avoid obliterating the lines with paint, and impart a texture unattainable with any other medium. Thinning the paint with a 50:50 water-medium mixture will make more definite, textured brush strokes. When the paint dries, turn the acetate over and lay it on a variety of colored backgrounds. This is an extremely fast technique that offers limitless possibilities.

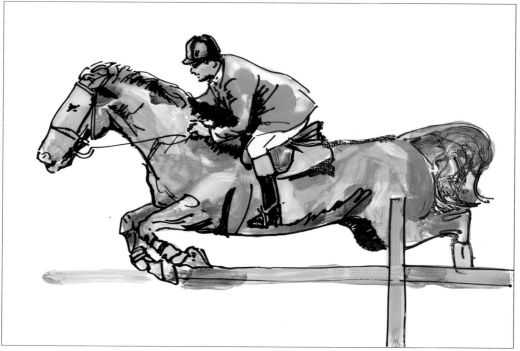

Gloss medium-thinned acrylic painted on the back of an ink drawing on acetate.

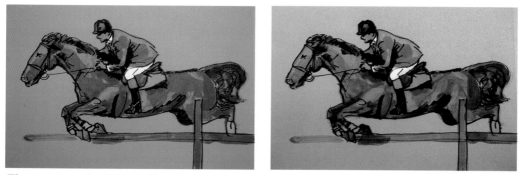

The same piece laid over a blue background (left) and an orange background. Because of the thinned paint, the background permeates and unifies all of the colors.

In another chapter we learned about preparing a panel with a roughly painted coat of gesso. While the rough gesso surface creates a splendid ground for drawing, it's also a good surface for painting, and creates a texture all its own.

After the drawing has been applied and fixed, lay the support horizontally on your drawing table. Using the same paint mixture used in the acrylic froth technique (but *without* whipping up the froth), lay in your washes. Whereas the drawing stays on the top surface of the grooves, the washes settle into the small grooves left by the paint brush. As with acrylic froth, too much of this texture can become tiresome. Fortunately, the grooves are so minute that they do not affect heavy-bodied paint.

One of hundreds of frames for a slide show. These had to be done very quickly—about three per hour. The drawing was scrubbed in with black Prismacolor, and a layer of acrylic medium was washed over the surface. The paint was applied very quickly, leaving bubbles and streaks. The first layer was allowed to dry and then opaque paint was laid in. I worked on about 20 paintings more or less simultaneously, which gave them a cohesiveness.

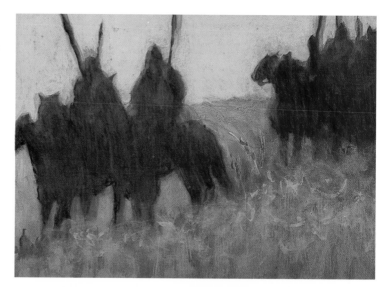

The composition for this magazine illustration was carefully worked out with the eventual placement of type held foremost in my mind. A bubbly wash of warm brown was laid in over the drawing and opaque colors were painted over it. The large open areas were used for the typography. Total working time: 2 days.

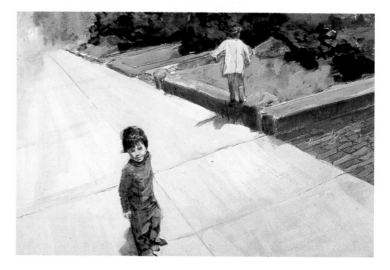

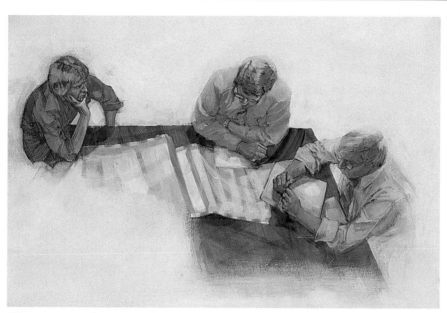

This piece was done on gessoed Masonite, using transparent colors that were mixed with gel medium and laid in over the drawing. Areas of the streaky underpainting show through in places like the table. The rest of the painting is straightforward. The white in the background was cut in with white casein.

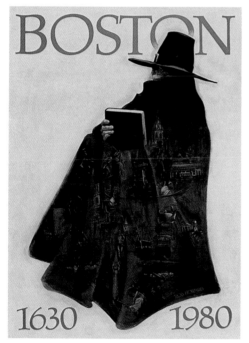

This poster was painted in acrylic mixed with matte medium. The matte surface was ideal for drawing onto with Prismacolor pencils. The hand lettering was done by a signpainter using One-Shot enamel.

This piece was painted on smooth, gesso-coated Masonite. Sections of the computer and the unicorn were rendered in airbrush, other areas with a brush. A few details were executed in Prismacolor pencil.

CHAPTER 11

GOUACHE AND CASEIN

Most artist's mediums hearken back to a time when artists got their materials from the barnyard. To this day, hens provide the basis for egg tempera, milk is still used to make the vehicle for casein, and various tree saps are still utilized to make the gum binder used in the manufacture of gouache.

The tremendous binding powers of eggs and milk should be apparent to anyone who has ever tried to wash dried milk or egg yolk off a dish—as they dry, their constituent proteins become less water-soluble. While egg tempera never gained much acceptance among illustrators, casein was a mainstay medium until fairly recently, when it was largely supplanted by acrylics. Although the gum medium in gouache does not change form upon drying, and therefore remains easily water-soluble, it alone has remained a favorite medium with designers, decorative artists, and illustrators.

GOUACHE

Gouache, which can be thought of as an opaque watercolor, is ideally suited for laying in perfectly flat areas of body color and creating superfine opaque details. It dries dead matte, accepts colored pencil better than any other medium, and, because of its great opacity, is the medium of choice for graphic designers creating comps, lettering, and finely ruled lines. It is also favored by illustrators specializing in hyper-realistic painting. In addition, gouache can be thinned with water to produce a roughly transparent wash that has a charm of its own.

Gouache is manufactured in tubes, which can dry out, and in cake sets, which are a better choice if you will only be using gouache occasionally. Although Winsor & Newton makes a useful set of cake gouache, I prefer the 24-color set made by Pelikan, because their cakes dissolve more readily. Take note, however, that the Winsor & Newton and Pelikan cakes are less opaque than their corresponding tube colors.

As for tube gouache, the 120 tube colors of Winsor & Newton Designer's Gouache are clear and brilliant. They flow smoothly from their 14-milliliter tubes, and are generally the most opaque of all the gouaches.

Rowney Designer's Gouache, which is sold in 22-milliliter tubes, comes in 59 colors, and is almost identical to Winsor & Newton in brilliance. Although Rowney gouache's consistency is more buttery than that of the Winsor & Newton colors, it actually flows less smoothly, and is less opaque.

Holbein Gouache is manufactured in 63 exceptionally brilliant colors. Holbein grinds their pigments finer than those of other manufacturers, which makes their paints particularly smooth-flowing. While not quite as opaque as the Winsor & Newton gouache, Holbein is far more brilliant and less chalky.

Schmincke gouache colors offer the highest brilliance, and the brilliance is undiminished even when applied to a dark background, but they also have the least opacity of any gouache I've tried.

PRO'S TIP: OPACITY AND BRILLIANCE

The tests I used to measure opacity and brilliance of various brands were simple operations that you can perform in your own studio. Using identical colors made by the different manufacturers, I painted a swatch of each brand on a sheet of paper with printed typography. Only the most opaque paint could hide the black character printed on white.

Brilliance can be tested by painting swatches of an identically named color on a neutral gray board.

Don't overrely on these quick studio tests—there are many other factors to take into consideration, including staining power, durability, and permanence. To find the paint best suited to your needs, try as many as you can afford.

Color drawdowns of various brands of gouache. Tests like this one are useful ways to determine the comparative opacity and brilliance of various brands.

Gouache cakes, like these, made by Pelikan, are not as opaque as tube colors, but are a good choice for the occasional user.

Winsor & Newton Designer's Gouache colors—a high-quality, readily available paint.

Rowney Designer's Gouache—note the tube size, which is about 50 percent larger than the size of the Winsor & Newton tubes.

Holbein's traditional gum-based gouache is more finely ground than any other manufacturer's paint, resulting in exceptional smoothness.

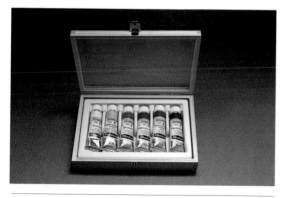

Schmincke makes some of the finest gouache in the world—hard to find, but well worth the hunt.

PRO'S TIP: SLICK SURFACES

When applied to a slick surface or acetate, gouache often beads up and fails to adhere. When faced with this problem, don't use glycerin and products like Colorflex, as they can impede proper drying. Instead, try mixing a small amount of *ox gall* into the gouache—it will increase the wetting property of the gouache's binding gums, enabling the paint to flow out on the surface and dry normally. Ox gall will also eliminate the streakiness so often associated with gouache, and airbrush artists will find that it improves paint flow and cuts down on clogging.

Holbein has made a huge leap forward in addressing many of gouache's problems. Aside from gouache's easily marred surface, for instance, the paint's water-soluble gum often allows the underpainting to dissolve or bleed through topcoats of paint. In addition, some colors look very different wet than they do after they dry. Holbein's color chemists have eliminated all of the negatives and maintained all of gouache's virtues by substituting an acryl resin in place of the gum, resulting in Acryla Designer's Gouache—80 low-resin colors that dry to a perfect matte finish, flow more smoothly than gum-based gouache, cost a bit less, and go from wet to dry with no change in color. Because these colors are ground in a pure acryl resin, rather than in a milky emulsion, what you see when the paint is wet is what you get when it dries. When all these factors are thrown into the equation, I find this line to be the cream of the gouache crop, and I use it exclusively. (Be careful—Holbein's line of acrylic polymer colors is also called *Acryla*, and it's easy to get confused. Check the label carefully to be sure you're getting a gouache.)

To prevent your gouache colors from sinking into a dark background, treat your surface with thin coat of Winsor & Newton Prepared Size, a gelatin product that will keep the colors brilliant and on the surface. Another ideal surface for gouache is gesso—I prefer Daniel Smith's World's Best Gesso, which is relatively nonabsorbent and can be polished smooth with fine sandpaper.

PAINTING WITH GOUACHE

Painting with gouache is very direct. The traditional method is to block in the body color and then add rendering and detail. Rendering can be done using either a dry-brush approach or hatching. Smooth transitions are easily achieved with a brush or an airbrush, a tool that works superbly with gouache, although rendering with a brush yields more solidity.

Gouache is good for more than realistic illustrations—it also lends itself to a variety of decorative effects. (Indeed, Winsor & Newton Designer's Colors were originally conceived as an aid to carpet designers in the late 1800s.) Its opacity and smooth flow make it unsurpassed for painting intricate detail.

Holbein Acryla Gouache, ground in a clear acryl resin, is a unique product with none of the disadvantages of traditional gum-based gouache.

PRO'S TIP: FIXING

Gouache's matte surface can take on an unwanted shine when rubbed. You can spray the surface with fixative to counter the problem, but this will harm the colors' opacity and brilliance. A thinned down solution of gelatin can be applied to the surface, where it acts as an effective fixative with no adverse effects. Spraying the dried gelatin with a 4-percent Formalin solution will harden the surface, but this may not be worth the effort, especially since heavily painted areas can then crack and fall off the surface when flexed around a color scanner's rotary drum. The best way to avoid problems in this area is to handle your surfaces with care.

Gouache is well-suited to flat decorative effects. This little vignette was done with Winsor & Newton on No. 172 Bainbridge board.

This illustration for a paperback book cover was done in Winsor & Newton gouache on gesso-coated Masonite.

Sometimes a successful illustration depends on knowing what to leave out. In order to add dimension to this gouache illustration of a crab, I left the rear legs partially unfinished—sharply rendered details would have jumped forward from the image, flattening the space.

The project begins with an outline drawing on Crescent Watercolor Scanner Board. The shadows are washed in over the drawing with dilute Acryla gouache. The darkest darks are established at this stage.

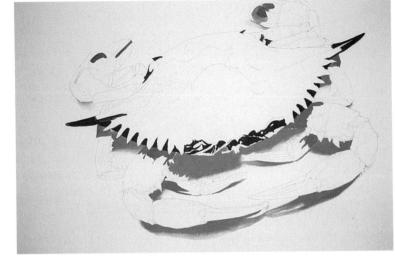

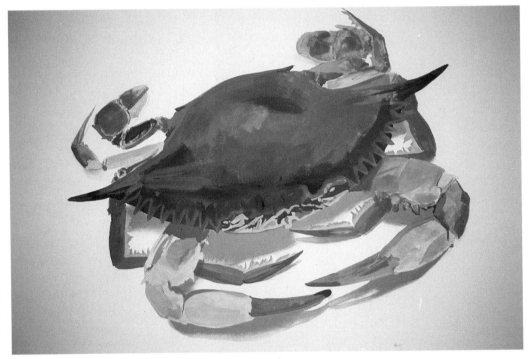

Local color is quickly applied with semiopaque washes.

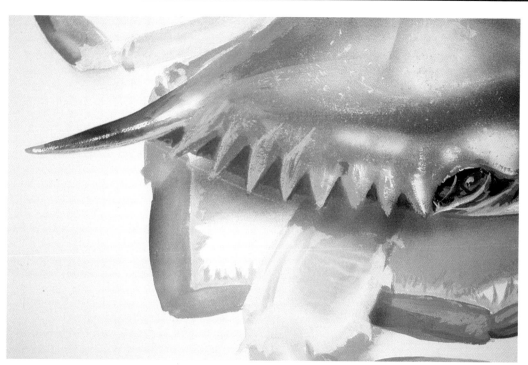

Detailing moves along quickly, as opaque Acryla gouache is applied with brush and airbrush.

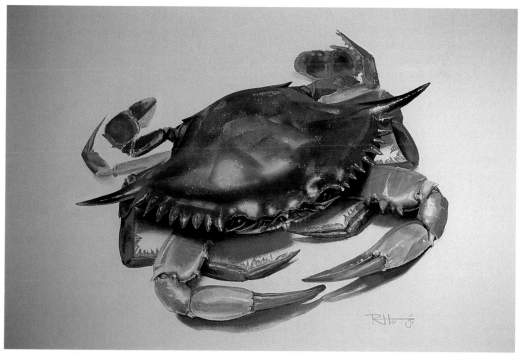

The finished piece. Total working time: 7 to 8 hours.

CASEIN

Casein is a phosphoprotein of milk. When combined with ammonia, it becomes water-soluble and can emulsify oils, which are added to improve its handling qualities. Up until the 1950s, casein was widely used for illustration, and was made by most of the major paint manufacturers. Those who used it prized it for, among other things, its quick, almost instantaneous drying time.

When acrylics were first introduced in the 1950s, most people thought the death knell had sounded for casein. After all, they reasoned, casein's only real advantage is that it dries faster than oils. Otherwise, it's just another water-based paint, right?

Not quite. There's a lot more to casein than its quick drying time, including its outstanding durability—some casein examples are almost 2,000 years old. Unfortunately, the skeptics, however misguided were essentially correct—today only one company still manufactures casein. Fortunately, that company is Shiva, which always made the best casein anyway.

PAINTING WITH CASEIN

Because of its extremely rapid drying time, casein is not an easy medium to master, which is why many have abandoned or avoided it since the advent of acrylics. Straight from the tube, casein is as stiff as oil paint. Like oils, it can be worked with a knife or brush. It produces a pleasant, perceptible drag on the brush, making it ideal for painting dragged and scumbled textures. Add a little water to the paint, and it has all the control and smooth flow of gouache. And, of course, it can be reduced with water to create semitransparent washes.

Casein dries to a velvet matte surface—the perfect surface for being photographed. Casein is more water-resistant than gouache, and becomes more so as it dries. Thus, you can paint over an area that has had several hours to dry, and if you don't like the most recent layer of paint, you can wipe it off with

PRO'S TIP: CASEIN PALETTES

Because of casein's rapid drying, your palette must be airtight when not in use. A light spray of water followed by a covering of Saran Wrap should do the job. And for keeping casein manageable while you're painting, a spray bottle will help keep the paint wet while you smoothly blend your colors—just wet your support with enough water to allow the paint to flow smoothly (but not so much that the paint creeps).

Shiva is the last remaining manufacturer of casein. They make a fine, uniform product.

a damp sponge without disturbing the dried paint. Obviously, this can be invaluable when fixing the inevitable accidents, and also makes it easy to apply deep, luminous glazes.

I'm particularly fond of casein for making grisailles—monochromatic gray paintings. The lightness and delicacy of tone I can get with Shiva halftone black and titanium white are impossible to achieve with any other medium.

Casein can be difficult for the illustrator who tries to apply the techniques learned with oils or watercolors—you've got to develop a feel for it. Still, adapting to casein is easier than, say, learning how to draw with pen and ink. If you want to try it out, get Shiva's little introductory set or, better yet, get the extraordinary halftone black and titanium white. First and foremost, keep in mind that casein is hard on brushes (synthetics are best), which must be kept wet at all times. As you paint, remember that building from transparent to opaque and from thin to thick layers is the surest way to succeed with casein. Whether laid on in thick impasto or in thin washes, you'll find that casein looks like nothing else, and it might be just the thing to help your work stand out in the crowd.

This grisaille study was done with Shiva halftone black and titanium white casein. Note the rich casein halftones, which are more luminous than those found in other opaque paints.

Shiva halftone black and titanium white were used in a rather painterly manner on this product illustration. Prismacolor black pencil was used over the casein to achieve the look of brushed metal.

Casein's incredible covering power makes it the most opaque of all the paints. This factor, along with casein's rich, painterly texture, makes it a perfect choice for rapid painting over dark backgrounds.

The illustration begins with a background of Shiva halftone black, which is then overpainted with blue and purple. The pillar is loosely added in halftone black.

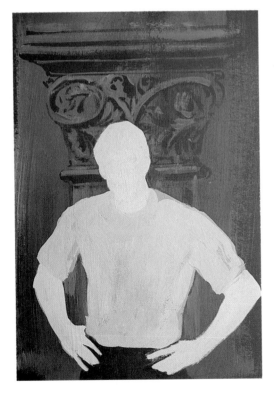

The figure is blocked in with a green and a flesh tone. Note that the pillar and background are completely obscured—casein is so opaque that it can cover dark colors like these without losing any brilliance.

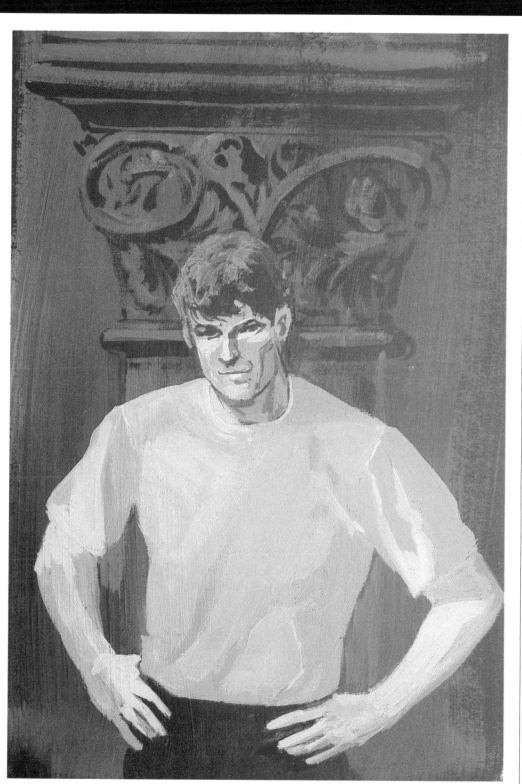

In this case, the finishing touches are kept loose and painterly. Casein is versatile enough to provide a more highly detailed, finished look than this, however.

CHAPTER 12

INKS, DYES, AND WATERCOLOR

(page 147)

Although their effects can appear similar, there are considerable differences between watercolors (which consist of mostly *permanent* pigments bound in a gum solution), dyes (which are made with *fugitive* pigments in a gum solution), and inks (which are made with *semipermanent* pigments in a shellac solution).

More instructional books are written about watercolor technique than about any other artistic application. This chapter will not attempt to go over the same ground. Instead, we'll discuss some nontraditional techniques that might make some watercolor purists shudder. Since the introduction of Aldus Gallery Effects software for the Macintosh computer, purists have a lot to shudder about—the software enables a nonartist to transform a photo into a traditional watercolor in a matter of minutes. But for the time being, these nontraditional approaches remain out of the reach of computers.

Yes, they're all black liquids, but an ink wash is very different from a black watercolor wash. For starters, ink wash is monochromatic, while watercolor is polychromatic. Moreover, different inks produce different effects. Try this: Wet a piece of smooth-surfaced paper or board and then put several drops of different inks and black watercolor into the wet. You'll see that India ink fragments into tiny shapes, while other inks will dilute more evenly; watercolor, meanwhile, will diffuse into a smooth gradation.

Higgins Eternal Black and Higgins Engrossing Ink are traditional favorites with illustrators, although I prefer Higgins Non-Waterproof Black Ink, an intense carbon black that is extremely workable and produces a full range of neutral grays. Japanese Sumi ink has similar working qualities, and is one of the very best inks to use for pen and ink techniques.

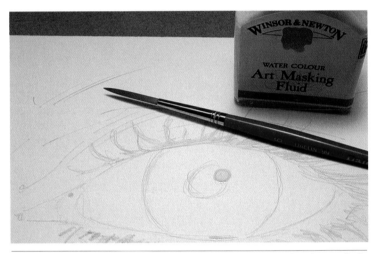

Winsor & Newton's tinted Art Masking Fluid can be applied with a synthetic brush, as was done here to create a highlight in the eye.

Waterproof India ink (top) fragments erratically in the presence of water, making it ill-suited for use with ink wash drawings. A better choice is Higgins Eternal Black, which dilutes evenly in water.

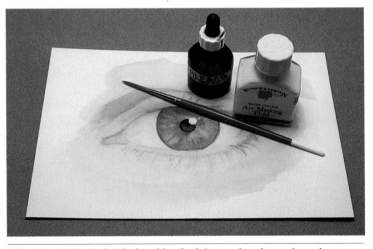

After the painting is finished and has had time to dry, the mask can be removed, leaving the white highlight underneath. The same effect could also be achieved through bleaching.

KEEPING THE HIGHLIGHTS OPEN

There is a variety of ways to keep open highlights in your black-and-white washes or watercolors. One of the easiest methods is to use *liquid frisket*, a liquid latex solution that dries to a waterproof rubber mask. You can apply it to the appropriate spots on your support (it works best on smooth-surfaced papers) and then paint over and around it. After the painting dries, the liquid frisket can be easily removed with a rubber cement pickup. As always when using a new material, test it on your support before actually using it on a job.

Winsor & Newton makes two liquid friskets, called Winsor & Newton Art Masking Fluid. One is a white liquid that dries almost invisible; the other has a yellow tint, which makes it easier to locate on the support. I prefer the latter, although it can stain if left on the paper for too long.

Liquid frisket is usually applied with a brush, but it invariably gums up the bristles. Prewashing the brush and leaving soap in the bristles helps, but does not eliminate the problem. Instead, try applying liquid frisket with the Incredible Nib (see Chapter 6), which won't get gummed up with dried frisket and can be run along a straightedge or template to boot. Jerry Griffith Art Products, manufacturers of the Incredible Nib, have also developed White Mask, a clear liquid frisket that doesn't stain and has better flow characteristics than any other liquid frisket.

Another way to open up highlights is to paint the appropriate area with full-strength household *bleach*. Apply it with a synthetic-fiber brush—chlorine bleach dissolves sable and hog's bristle in a matter of minutes. Keep a blotter or paper towel handy to pick up the excess after the bleach has done its job. The effect varies with different inks and paints—some colors bleach out completely, and others merely change. Bleach tends to stay in the paper for quite a while, so any subsequent layers of paint will be affected by the residual bleach. Test your bleach and paint together before using them in a finished piece.

DYES

Dyes have a tendency to fade—when placed in direct sunlight, some colors can fade in a matter of hours—so illustrations done exclusively with dyes may not survive for long. Still, dyes have their value and, handled properly, can add a great deal to an illustration. When used in conjunction with traditional watercolor, for instance, dyes can expand the illustrator's palette. Using the dyes as a base and letting them shine through subsequent layers of watercolor is a very good approach. And dyes, like watercolor, can be mixed with ox gall and used to color photostats and photographs.

Unlike tube watercolors, which are opaque when squeezed out full strength, dyes are truly transparent. Both Dr. Ph. Martin's and Luma manufacture bottles of liquid dyes. The product lines are essentially identical.

Luma dyes.

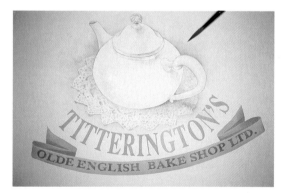

This piece was done in Luma dyes, applied with a brush on two-ply Strathmore CP Bristol. The rustic lettering was executed with Winsor & Newton Designer's Gouache.

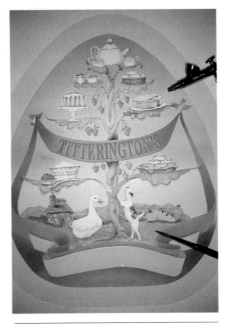

This illustration was done in Luma dyes as well—the graduated background and ribbons were airbrushed on, and the rest was executed with a brush. The powdered-sugar effect for the cake near the airbrush was achieved by using dilute bleach over the dyes.

Traditional watercolor technique relies on an absorbent paper that catches and holds the pigment exactly where the artist applies it. But here I'd like to examine *watercolor rubout*, a technique that relies on a slick surface to hold the pigment on the support, allowing later manipulation. This technique, brought to prominence by a group of exceptionally skilled New York illustrators during the late 1960s, is the most painterly of the watercolor techniques.

The choice of support is a matter of personal preference—just be sure it has a smooth, hard finish. Plate-finish Strathmore Bristol (at least three-ply) is fine, as are illustration boards like Letramax 2000 or Crescent Scanner Board. Once you've chosen your support, two coats of a nonabsorbent gesso provide a good surface. I like to use Daniel Smith's World's Best Gesso and then sand it down smooth with 2000-grit sandpaper.

One feature of this technique is that the color always appears to be wet, even after it dries. To help achieve this, use big brushes that can hold lots of paint. When the large amounts of paint hit the slick surface, drips and runs will start to form. You can control these by changing the tilt of your board, and the slick surface makes it easy to remove, soften, or lighten the paint by rubbing with a brush or paper towels (I prefer Microwave Bounty, the only brand that doesn't leave lint).

If you don't do much watercolor, consider getting your paint in cake form, because tube colors will dry out before you have a chance to use them up. Holbein watercolors, which are extremely finely ground, afford the best control and brightest colors. On the other end of the scale, some of the cheapest watercolors can be diluted with water to produce a grainy, broken texture that can be quite charming.

Because the pigment will barely adhere to the surface of the smooth support, a light spray of workable fixative or Myston provides a good way to keep the pigment from rubbing off. But don't overdo it—anything more than a light coat will cause the colors to shift.

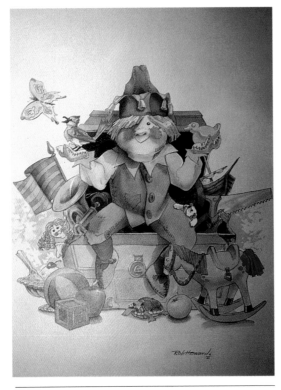

Luma dyes over a hard Negro pencil drawing resulted in this illustration. The edges were cut back with bleach.

The development of this illustration of
Medusa offers a good look at the potential
of the watercolor rubout technique.

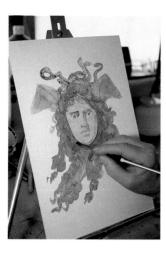

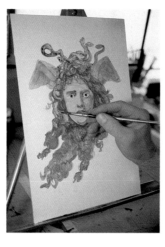

*Far left: Here the illustration
is well on its way. Holbein
watercolors are being used on
super-smooth Letramax 2000
illustration board.*

*Left: Applying dark accents.
Note how the wet paint eats
through the previous layer of
color, creating a distinctive
texture.*

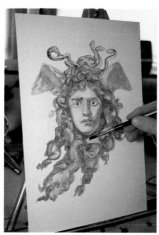

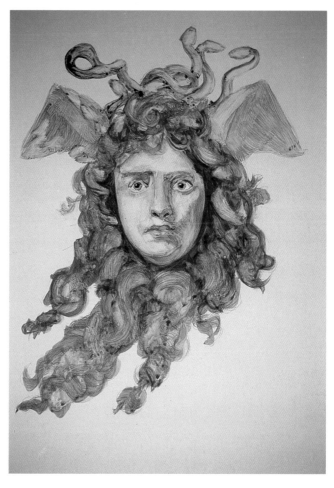

*Above: Rubbing out
highlights with a wet brush.
Dripping can be controlled
or allowed to meander
throughout the illustration.
Don't worry about rubbing
out too much color—you can
always apply more.*

*The finished piece—a
more painterly and gutsy
illustration than traditional
watercolor could hope to
produce. Total working
time: 1 1/4 hours.*

THE AIRBRUSH

As I prepared to write this chapter, I had used the airbrush on a regular basis for more than 25 years, yet it never became one of my favorite tools. To me the airbrush was a poorly designed, quirky device that inevitably spit paint in the middle of a job, destroying hours of labor. My low regard for the medium was compounded by the hordes of airbrush illustrators who had recently been cranking out reams of tasteless, garish illustrations, with every figure looking as smooth as a balloon, and every hair frozen in focus.

Unfortunately, I was condemning everything related to the medium just because I disliked certain aspects of airbrush art. In writing this chapter, I was determined to approach the airbrush with a clear and honest eye. What I learned in four months of investigation has changed my attitude forever—I've actually become an airbrush aficionado. And what started out as just a cursory chapter on the airbrush has become a major component of this book.

If you look through various illustration annuals, you'll see that airbrush illustrations offered by most artists are indistinguishable from one another. Most have a "plastic" look. Airbrush equipment, like camera equipment, has a way of imposing its own look on the final piece, rendering it anonymous. Rising above these limitations will take all of your artistic will and strength.

Airbrush work, more than any other medium, requires a thorough knowledge of the equipment, the materials, and their use. I now know that the spitting and spattering I used to encounter were simply the result of using old-fashioned, poorly designed equipment. Today's airbrushes are dependable and a joy to use. Now there are paints formulated especially for the airbrush, as well as new frisket films and special boards and papers—the full list of equipment can be expansive. The list can also be expensive, but good equipment is always worth the price.

TYPES OF AIRBRUSHES

Before examining the range of today's modern airbrushes, let's start with a more rudimentary form of airbrush, the *mouth atomizer*, which is still used to apply fixative. It consists of two tubes held perpendicular to each other. Blowing in the horizontal tube causes the vertical tube to siphon liquid from a container. When the liquid comes in contact with the air stream, it is broken up and atomized.

Moving on to more advanced equipment, the simplest and cheapest of today's airbrushes is the *single-action airbrush*, which lets you control the flow of air by pressing a trigger on and off but does not allow you to modulate the flow of paint. Commercial spray guns, touch-up guns, and most large-capacity airbrushes belong to this group. They tend to be well-suited to spraying even coats of gesso and large backgrounds, but are of more limited use for fine work. Single-action airbrushes can be either internal- or external-feed—the external-feed models have no needles and are ruggedly built and easy to clean, while the internal-feed airbrushes have fixed needles, are a bit more difficult to maintain, and can be easily damaged through careless handling.

The single-action airbrush is the simplest of all, with the main lever acting as a simple on–off button that controls the airflow. In external-feed airbrushes, the paint flow is adjusted at the nozzle, while internal-feed models meter the paint via a fixed needle.

The double-action airbrush is more versatile, with the main lever operating both the air flow (shown in red) and the needle (yellow), which meters the paint flow.

The Paasche AB is the most complicated and difficult airbrush to use and maintain. The main lever operates similarly to the lever on a double-action airbrush, operating the air flow and needle (shown in red and orange, respectively), but several points require constant adjustment (blue). Additionally, in order to use the AB, the needle and nozzle must actually be bent *into shape (yellow).*

The *double-action* airbrush allows you to control and vary the flow of air by varying your pressure on a trigger. Additionally, the trigger can be used to control the needle valve that modulates the flow of paint. There are two major types: Siphon-feed airbrushes have a removable paint reservoir cup under or alongside the brush's shaft, allowing you to change colors quickly; gravity-feed tools feature the reservoir permanently mounted on top of the shaft. Gravity-feed brushes can handle thicker paints, but the cup must be emptied and cleaned in order to change colors.

In a class by itself is the Paasche AB Turbo, a unique, complicated mechanism that is really neither single- nor double-action. Designed in the 1920s, it operates by diverting part of the air flow to spin a small turbine, which in turn causes a reciprocating arm to move a fine needle past the paint reservoir. The needle picks out droplets of paint and delivers them to an air nozzle, where they are atomized. The needle shuttles back and forth as the turbine emits a high-pitched scream at 20,000 RPM. The result is a fine-lined spray.

The AB is complicated, to be sure, but it's also capable of delivering some of the finest results of any airbrush. For decades, however, Paasche supplied almost no instructions for the device, leading many illustrators to become frustrated with its complex design and ultimately resulting in many AB models being consigned to gather dust. This situation has improved somewhat—Paasche now has a printed set of instructions available, but it is not packed along with the airbrush itself. If you have an AB Turbo, write to Paasche for the instructions, which will show you how to perform the dozen or so modifications and adjustments that can help you take advantage of this tool's extraordinary capabilities.

Single-Action Airbrushes

A more detailed look at single-action airbrushes begins with the Paasche H, a metal-bodied, external-siphon-feed instrument designed to cover broad areas quickly. It can siphon paint no thicker than light cream from a cup or jar. Its nozzle position is adjusted with an allen wrench. Because of the awkward positioning of the trigger, the airbrush's balance is thrown forward, making it tiring to use for extended periods.

The Badger Model 350 is a well-balanced external-siphon-feed airbrush capable of medium to heavy spraying of paint no heavier than light cream. It has a fairly wide range of adjustments, which are easily made with a knurled ring. A good inexpensive brush.

The Badger Model 200 is an internal-siphon-feed capable of moderately fine and controlled spraying. The flow of paint is regulated with an adjustable needle valve. Although the Model 200 is inexpensive, it is quite capable of producing acceptable rendering.

Fixed Double-Action Airbrushes

Turning to fixed double-action models, the Iwata RG-2 is an internal-mix gravity-feed airbrush. This is a full-fledged professional spray gun, capable of extraordinary results. As you pull the trigger, a constant flow of air is released. Pulling the trigger further causes the

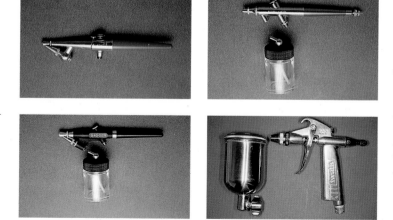

The Paasche H airbrush.

The Badger Model 200 airbrush and its removable paint reservoir.

The Badger Model 350 airbrush, with its removable paint reservoir.

The Iwata RG-2 airbrush with its large-capacity cup.

NOTE: All instruments shown on pages 155–57 were originally photographed upside-down to provide greater illumination on the most important mechanisms.

paint-regulating needle to meter the flow of paint. The gravity feed allows the RG-2 to feed everything but the heaviest paint, yet it is also capable of producing surprisingly fine detail. It comes with a large-capacity cup. An excellent tool.

The Toricon-Hohmi YT is a gravity-feed airbrush with a difference: It can adjust the air pressure at the nozzle cap. Smaller than the Iwata RG-2 and capable of exceptionally fine detail, it comes with 0.2-, 0.3-, and 0.65-millimeter nozzles, providing it with enough versatility to handle everything from gessoing panels to painting minute detail. The trigger design makes it comfortable to use over a long period. A beautifully made tool.

Double-Action Airbrushes
Focusing now on double-action instruments, the inexpensive Badger Model 150 features a siphon feed located on the bottom, which

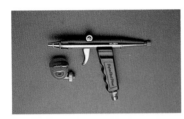

The versatile Toricon-Hohmi YT airbrush.

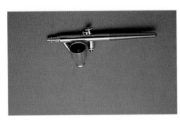

The Badger Model 150 airbrush.

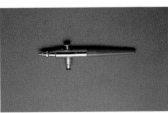

The Paasche V airbrush.

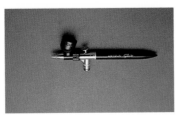

The Aerograph Sprite airbrush. Note the use of both plastic and metal parts in this high-value, low-cost tool.

enables the Model 150 to use cups and bottles. The airbrush's complete kit comes with three different head and nozzle assemblies, two jars, a cup, an air hose and adapter, a holder and a wrench. If you want to turn out presentable illustrations with only a modest investment, the Model 150 is a good choice.

If you prefer a traditional favorite, the Paasche V has remained virtually unchanged since the 1940s. The V-1 and V-2 (the separate designations refer to the different tips that can be used) have a side-mounted siphon feed capable of holding cups and bottles. These were once the most popular airbrushes, although they have now been largely supplanted by more modern designs. It's not too hard to see why—the internal parts are made of unplated brass, which can bind at crucial moments, and the needle protrudes past the nozzle, so it is frequently bent.

The Aerograph Sprite, a low-priced airbrush patterned after the higher-priced Aerograph Super 63, is constructed from a combination of metal and plastic parts. It's a gravity-feed airbrush designed for the hobby market. The action is surprisingly good on this inexpensive little tool, making it satisfactory for the occasional user.

The Badger 100 XF is a siphon-feed airbrush with a side-mounted cup. Like most of the Badger brushes, it is a good value. Its action and controllability are particularly good.

The Badger 100 LGIL, Badger's entry into high-end design (without the high-end price), is a well-balanced gravity-feed airbrush that will satisfy the needs of all but the most exacting professionals. It offers a good design with smooth action, and can produce extremely fine lines. One small complaint, however: The cup is a bit too close to the trigger for those of us with large hands. Otherwise, a superb product, and an excellent value.

The Aztek 3000S, born of its makers' frustration with having to constantly disassemble and clean traditional airbrushes, is based on entirely different design principles. It's basically the "better mousetrap" of the airbrush world: The needle valve, which resembles that of a technical pen, is enclosed in a removable nozzle. Nozzles are easily interchangeable and can be cleaned under the tap. The spray width is adjusted with a

handle-mounted dial. The hose connects in the back of the handle, rather than the center.

The 3000S performs much better than its low price would lead you to expect. The well-conceived system offers one design innovation after another. Four nozzles are available: fine-line, general-purpose, high-flow, and spatter. And perhaps the greatest tribute to the airbrush's low-maintenance design is its lifetime warranty. For those who are considering an airbrush purchase but are unsure of whether an airbrush is worth the investment, the Aztek 3000S and the Badger 100 LGIL are both highly recommended.

High-End Airbrushes

If you need top-of-the-line equipment, the Toricon-Hohmi Y-2 Dash, imported by Holbein, is a gravity-feed precision airbrush that fairly shouts its quality. The machining, the weight, and attention to detail immediately tell you this is one of the world's great airbrushes. The action of the trigger is 100-percent positive and dependable. The 0.3-milliliter cup may initially strike you as being too small, but actually it's the perfect size for precision airbrushing. Other superlative features include the built-in pressure control adjustment at the nozzle cap,

the virtually indestructible platinum alloy used to make the nozzle, and the long, gradual taper of the needle, which makes the paint flow much more controllably than with blunt-tapered needles. Superb in every way.

The Iwata HP-C, which features a $^{1}/_{3}$-ounce top-mounted gravity-feed cup, is the most popular of Iwata's airbrushes, and justly so. Among the nicer touches is the ergonomically designed trigger, which makes a real difference. The HP-C can feed any paint, and is designed for quick color changes and cleaning. The optional crown cap allows you to spray hairlines while resting the nozzle on the surface of the illustration, something only the most precision-controlled tool could even hope to execute. All of the internal parts are chrome-plated, so there is no risk of binding. Probably the best all-around airbrush.

The Iwata HP-SB is a siphon-feed airbrush with a side-mounted cup that can be altered for right- or left-handed use. When fitted with the 0.2-millimeter fluid nozzle, the HP-SB can spray lines fine enough to contend with the Paasche AB Turbo, and the HP-SB has the midrange capabilities that the Paasche model lacks—it can lay down a $^{3}/_{4}$-inch-wide spray. Although the HP-SB is slender, it is not fragile; its cups are carefully machined, so

The Badger 100 XF airbrush.

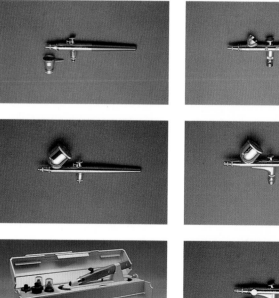

The Toricon-Hohmi Y-2 Dash airbrush.

The Badger 100 LGIL airbrush.

The Iwata HP-C airbrush.

The Aztek 3000S system—an excellent value, and a distinct departure from competing models.

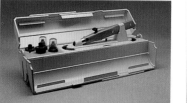

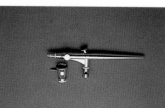

The Iwata HP-SB airbrush.

they won't fall out (a common complaint with the Paasche V). The HP-SB's action is silky, and the gradually tapered needle ensures a smooth flow of paint.

By removing both the nozzle and the needle cap, Iwata airbrushes can be made to stipple. The size of the stipple pattern can be varied by adjusting the air-flow regulator. Lower pressure and/or thicker paint produces a larger dot size.

THE AIR SUPPLY

As its name implies, an airbrush must have an air supply. The occasional user can get by with a can of compressed air. Both Frisk and Badger market compressed air, at about 70 pounds of pressure per square inch, or 70 PSI. Badger also offers an inexpensive air regulator, which allows you to adjust the pressure from 10 to 50 PSI.

The Whisper Jet III—a quiet, powerful compressor.

The Whisper Jet's desk-mounted remote air station includes a filter, regulator, and airbrush holder.

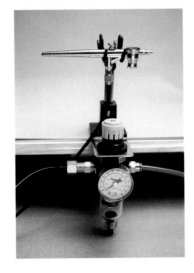

Even for frequent airbrush users, compressed air canisters are useful when you need a portable air supply, but they would be prohibitively expensive for day-to-day use in the studio. Instead, most illustrators prefer a *compressor.* I started with the small Paasche D-1/4, a diaphragm-type compressor that delivers a relatively constant pressure of 30 PSI. Diaphragm-type compressors generate a pulsating air flow, however, which results in a varying air–paint mixture. Moreover, diaphragm models offer no pressure variation—you're stuck with a preselected pressure. On the other hand, diaphragm compressors are the least expensive option. Solid models include the Badger 180-11, the Thomas compressor, and the Gast compressor. Another inexpensive choice is the Airmaster, which has a small piston, a storage cylinder (which eliminates the pulsation problem), and a built-in regulator.

The following compressors are among the most commonly available. They are considerably more expensive than the diaphragm devices just described, but not all have enough power for the most demanding work. When shopping for a compressor, the most important feature is the volume of air it can pump, as measured in cubic feet per minute (CFM). Greater volume means more spraying power and less strain on the compressor. High-volume compressors can operate several airbrushes at once—a must for a busy studio.

- The Jun-Air is a quiet, nicely made compressor that comes complete with its own regulator and an impressive warranty. It cannot handle high output guns like the Iwata RG-2, however.
- The AMI 20A is an attractively priced 1/4-horsepower compressor with its own regulator. It produces 90 PSI of pressure, but at a volume—0.8 CFM—that is insufficient to operate anything but one airbrush.
- The Badger Silent 1 has a 1/3-horsepower motor, a 1-gallon storage tank and a built-in regulator. It produces 70 PSI of pressure with a maximum air flow of 1.0 CFM. Operating a high-output spray gun might be beyond its capabilities and cause it to overheat.

- The Badger Silent II has a $1/2$-horsepower motor and a 1.3-gallon storage tank. It will produce a maximum air flow of 1.75 CFM and a maximum pressure of 100 PSI—enough to run five airbrushes simultaneously. It has an air regulator and a line/tank pressure gauge.

It's worth noting that all of these compressors use oil-lubricated refrigerator pumps. The last thing that I want to have in my air supply is oil.

On the brighter side, Medea has designed two compressors specifically for airbrush illustrators. Their Whisper Jet II has a $1/7$-horsepower motor that generates a 1.25-CFM air flow at 70 PSI. It can safely power two airbrushes at once. Aside from the motor and output, it's identical to its bigger brother, the Whisper Jet III, which has a $1/3$-horsepower motor that produces a whopping 2.3-CFM air flow at 70 PSI. That's enough for intermittent use of a large gun like the Iwata RG-2, or four airbrushes at the same time. The Medea compressors feature 1-gallon tanks and oilless motors and pumps, and are very quiet. And instead of mounting the regulator on the compressor, Medea designed a remote air station that mounts to your drawing table and gives you a secure place to rest two airbrushes. In short, these are the best-designed air supply systems on the market.

HEALTH CONCERNS

Most artists' skills improve as they get older. But in order to grow older in the first place, you must protect your health—airbrushing microscopic particles of paint into a closed environment can create serious health problems. Happily, more and more products are being designed with the illustrator's health in mind. Paints formulated with hydrocarbon resin, for example, rather than acrylic resin, are a real advance. Still, the best advice is to avoid breathing anything but clean air. And that brings us back to something we've covered before but bears repeating here: *Get an air-purification system.* Don't waste your money on air purifiers designed to remove household smoke and odors—they aren't made to handle the airborne contaminants in a studio. Studio-specific systems, like the Artograph Model 836 Spray System (which I favor) and the Frisk Airbrush Spray-Away, have a series of replaceable mechanical and chemical filters. Once you see how much paint the filters accumulate, you'll understand the risk posed by working in an unfiltered environment.

Filter masks, if you don't mind wearing them, provide an inexpensive alternative to an air-purification system. The excellent masks used for auto-body painting are available at auto-body supply stores. But even the best mask cannot prevent airborne paint particles from settling on every exposed surface in your studio. Ultimately, masks are best as a complement to a filtration system, not as a replacement for it.

Airbrushes must be cleaned and flushed with solvent between color changes, leading to more airborne contaminants. The initial

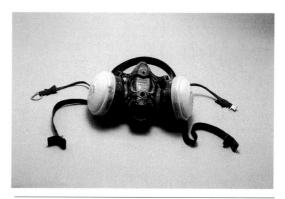

A filter mask with activated charcoal filters.

The Medea overspray eliminator (background) attaches to the inside of your wastebasket and really works. Dr. Martin's No Mist does just as well, but has a shorter effective life.

cleaning usually involves rinsing the cup with water and blowing some water through the brush. I position my water container next to my air purifier, which catches the overspray. To completely clean all color from my airbrush, I put a few drops of solvent into the brush and spit it into an *overspray eliminator* made by Medea, which is made of rugged steel and hooks onto the side of a trash can. A less expensive overspray eliminator is the No Mist, from Dr. Ph. Martin, which is nothing more than a can stuffed with filter material, with a hole in the top where you can insert your airbrush. It's good for about 200 cleanings.

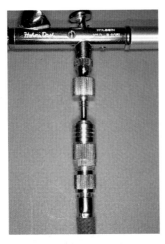

A crown cap on an Iwata HP-C. The two prongs serve as a bridge, keeping the airbrush steady on the surface of the paper.

Quick-disconnect fittings on a Toricon-Hohmi Y-2 Dash.

The sturdy Toricon airbrush holder.

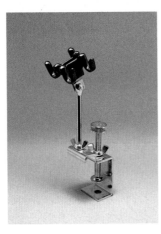

ACCESSORIES

Have you noticed how many fields have become hyper-accessorized? I remember when the only thing you needed to ride a bicycle was the bicycle itself. Today, no self-respecting cyclist will be seen without the appropriate accessories: helmet, gloves, special shorts, shirts, shoes, sunglasses, and water bottles. If you're the type who wonders whether all those accessories really help, you'll be glad to learn that airbrush accessories really *can* add a level of efficiency to your work. Not every add-on accessory is available from all makers for all models, but a general knowledge of what's available should help you sort out what will be most useful to you.

- *Crown caps* replace the airbrush's standard nozzle and allow you to produce fine lines by resting the airbrush on the surface of the illustration.
- *Quick-disconnect fittings* allow you to switch between airbrushes with a simple pull on the coupler.
- *Cobra hoses* are coiled hoses that eliminate the tangled hose maze that so often clutters the airbrush artist's studio floor.
- *Airbrush holders* allow you to "holster" your airbrushes in a safe spot when they're not in use. Badger, Toricon/Holbein, and Iwata/Medea offer sturdily machined, desk-mounted models that hold and protect two airbrushes. The Iwata/Medea version has a bracket to hold a filter and regulator. And Paasche offers a stamped metal hook that attaches to your desk, wall, or other vertical surface with a thumbtack.

PAINTS FOR THE AIRBRUSH

Watercolor is an obvious choice to use in an airbrush. It has the advantage of a thin consistency, which enables it to flow easily.

Mixing tube watercolors to the desired consistency can be a bit tedious. In the interest of efficiency, most illustrators opt to use Luma Concentrated Water Colors or Dr. Ph. Martin's Radiant Water Colors, both of which are usually referred to as dyes. These products offer exceptionally luminous, transparent premixed colors. Most of the colors, however, are very fugitive, and will fade in sunlight—sometimes in a matter of hours. Every illustrator has horror stories to tell about illustrations that have literally disappeared over the years. Although these dyes are easy to use and very attractive, *don't use them*. Dr. Martin's produces another range of colors, the Synchromatic line, which is more permanent.

Similar in intensity to dyes are *colored inks*, which dry waterproof and can be diluted with water. The 17 colors offered by Design/Higgins are relatively lightfast. Heavy coats tend to dry to a disagreeable shine, but this can be subdued with Myston or Krylon Matte Spray. One equipment-maintenance item of note here: When airbrushing with waterproof inks, be sure to clean your airbrush with denatured alcohol.

Similar to Luma dyes are Graphic Markers, which are alcohol-based dyes. These dyes are the "marker juice" used in felt-tipped markers, and are a poor choice—marker juice was designed for use in comprehensive sketches, not serious illustration, and spraying that much alcohol into the air will make you wacky.

Oil paints are seldom used with an airbrush, but they *can* be thinned for this purpose. I've never understood why anyone would do it, however, because oils' slow drying time allows any painter to render as smoothly as an airbrush using traditional tools.

Gouache is a traditional favorite with airbrush illustrators, although today's acrylics have pretty much supplanted it. Gouache is readily thinned with water, flows evenly, and is noted for brilliant, lightfast colors that dry to a pleasing matte finish. Heavy gouache layers tend to crack when the support is flexed, but it's unlikely that you will spray such heavy coats. Gouache is very opaque and has exceptional covering ability, but the wet paint has the disconcerting quality of turning to a very different tone when it dries. Do some tests before you start on a finished piece, so you can get a feel for these color changes.

Both tube and jar *acrylics* can be made to flow through an airbrush as well. Jar acrylics, because of their higher pigment content, are better for diluting. The dilute acrylic medium discussed in Chapter 10 is ideal for thinning and diluting purposes: In a 1-quart jar, mix $\frac{1}{4}$ cup of gloss or matte medium, add 10 drops of water tension breaker, and fill with water.

It's difficult to keep the diluted colors for long—after a day, the medium settles out and hardens into a lump. So after your colors are properly diluted, they must be strained through a fine mesh—I use two thicknesses of nylon stockings.

Diluted acrylics tend to clog the airbrush. The best cleaning solvent is lacquer thinner, which should be used sparingly and with caution.

Design/Higgins colored inks work well in the airbrush.

Gouache is a traditional favorite with airbrush illustrators.

Graphic marker dyes are used by some airbrush artists, but they're really too hazardous to bother with.

Acrylics can be thinned to produce very effective airbrush paints.

NEW PAINT PRODUCTS

While mixing, diluting, and straining your own colors is a useful skill, the rising popularity of the airbrush has sparked the development of new paints that are far superior to anything you might make. In fact, the world's top color manufacturers are in fierce competition to produce the perfect airbrush paint. I've tested many of these products, and all are very good. While they each have their distinct traits, they do share certain characteristics: They are all premixed, ready-to-use free-flowing paints that use permanent pigments, and with the exception of Com-Art colors, they are acrylic resins.

Holbein Aeroflash offers 50 colors in squeeze bottles. The Holbein people pride themselves on grinding their pigments finer than anyone else, and are fanatical about uniformity of their products. Thus, if you like their viridian, you'll probably like all of their colors, which are divided into a full range of transparent and opaque choices. Aeroflash can be manipulated and cut back with an eraser, a technique we'll examine in the demonstration section.

Winsor & Newton Designer's Liquid Acrylic Colours are available in 36 colors. They are marketed in glass bottles with dropper caps. The acrylic binder is fairly strong, which allows you to dilute the colors with water, yet it responds well to manipulation with an eraser.

Badger Air-Opaque has a range of 35 colors, sold in squeeze bottles with dispenser caps. Despite the name, these colors are not as opaque as gouache, but they are the most opaque (as well as the fastest drying and least water-resistant) of the new products I've tried. The pigments are ground in an acrylic copolymer, which helps them dry to a matte finish.

Dr. Ph. Martin's Spectralite Airbrush Colors come in 48 colors, packaged in plastic bottles with dropper tops. These colors are almost as opaque as Badger Air-Opaque, but have a strong binder that makes them the most water-resistant of these paints. They are difficult to manipulate with an eraser.

Holbein Aeroflash, made especially for airbrush.

Winsor & Newton Liquid Acrylic Colours.

Badger Air-Opaque is the most opaque of the new airbrush-specific paints.

Spectralite is the most water-resistant of the new generation of airbrush paints.

Schmincke Aerocolor markets 36 colors in glass bottles with the best designed dropper cap I've ever seen. Aerocolor is transparent, dries to a matte finish, and is easy to manipulate with an eraser. Schmincke also offers a color chart which shows formulae for various color mixtures. The fine-tuned mixture recipes are made possible by Schmincke's precision dropper. Paynes grey, for example, is mixed from 1 drop of Carmine Red and 1 drop of Cinnabar Green—simple, yet precise.

Com-Art colors are made by Medea in 27 opaque and 18 transparent colors. Unlike the other products just discussed, Com-Art colors are made from a hydrocarbon resin, which presents even less of a health hazard than the negligible threat posed by acrylic resin. They are packaged in plastic squeeze bottles with dispenser tops. The Com-Art transparents are the most transparent colors available—they respond superbly to manipulation and reduction with an eraser, and dry to a matte finish. Com-Art opaques are not as opaque a Badger Air-Opaque. Golden Acrylics produce a full range of colors formulated for the airbrush. In addition, Golden will custom-mix any color, with any characteristics (gloss or matte, fast- or slow-drying, etc.).

PRO'S TIP: OPACITY

Despite the continued references in this chapter to opacity, the truth is that the acrylic colors designed for airbrush use are *not* opaque—at least not when compared to gouache or gesso. Simply put, airbrush colors don't have much hiding power. If you require very opaque color, use gouache. For the advantages of gouache combined with those of acrylics, use Holbein's Acryla Designer's Gouache—it's a major advance over gum-based gouache.

Schmincke Aerocolor, a superbly made line of matte-finish paints.

Com-Art in opaque (right) and transparent. These paints are perfect for use with an eraser.

Golden's specially formulated airbrush paints.

What with all of the friskets, changes of colors, and cleaning, airbrushing can become very time-consuming. Time is always in short supply for the illustrator, so efficiency is a must. Compounding this problem is the fact that there are more ways to go wrong while airbrushing than in any other form of illustration—hands can smudge the surface, cups of paint can spill onto the illustration, dust particles can become embedded in the paint, and so on. A simple way to avoid most of those problems is by using a *table easel*, an inexpensive device that keeps the illustration vertical so dripping paint and dust won't land on its surface. If you're reducing color with an eraser, the table easel allows the eraser crumbs to fall or be brushed more easily from the surface.

When you first work with a table easel, you'll probably find it a bit awkward—there will be a transition period if you're used to resting your hand on a solid horizontal table. Stick with it, though—it won't take long to adjust, and in the end you'll develop a lighter touch.

A table easel is a great aid in keeping your artwork clean and free of spatters.

PRO'S TIP: GLOVES

Animators must be very careful to avoid touching the surface of their cels with their hands. Airbrush art is delicate, and should be treated with similar care.

The animators' solution works just as well for the illustrator: Wear a thin cotton glove, the kind made for photographers. Kodak sells them in boxes of 20. I cut off all of the fingers, with the exception of the pinkie, which rests on the artwork.

There is a huge difference between an airbrush illustration that has been executed without gloves while the board was lying horizontal and one done on an easel with gloves. And don't kid yourself—art directors can see the difference.

Cut-down cotton gloves will keep the oil in your hands from contaminating the surface of your illustration.

Basic airbrush technique should be second nature to any working illustrator reading this book. Instead of rehashing the fundamentals, let's examine an advanced technique: *eraser reduction.*

Among the tools you'll need are an electric eraser (the lightweight Sakura model works well), a vinyl pencil eraser (the kind used for erasing drafting film), transparent airbrush colors (either Com-Art, Schminke, or Winsor & Newton), a dusting brush or feather, and an X-Acto knife.

Once you get to the point where you're ready to airbrush, start laying in your colors and then reduce the lights with the erasers. Working with a traditional portrait palette of ochres, yellows, reds, and grays, with violet for the shadows, quickly fill in and do a bit of modeling. Then build the form using friskets, acetates, and freehand work. Small spots of gray can be sprayed in areas that will show skin texture, or you might also try stippling. Use the vinyl eraser to lighten broad areas; the electric eraser is more aggressive and can be used to open up smaller areas. Skipping the electric eraser across the surface helps build the areas of skin texture.

This technique offers a lot of layering possibilities: Because we are using transparent colors, layers can be built up; because we are using erasers, layers can be lightened or removed. This method of building and then lightening produces astonishing detail and texture, all in a fraction of the time required for traditional methods. It also gives the illustration a flawless surface. Finer details can be scraped out with your X-Acto knife. Except for details at the very end of the illustration, always lighten and remove the color with the erasers or the knife, *not* with white paint, which will just create a muddy mess.

The tools you'll need to use the eraser reduction technique. Included with the boards are a table easel, dusting brushes, transparent colors, erasers, an electric eraser, and X-Acto knives.

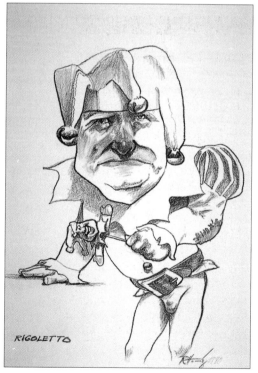

The project starts with this pencil sketch of Rigoletto.

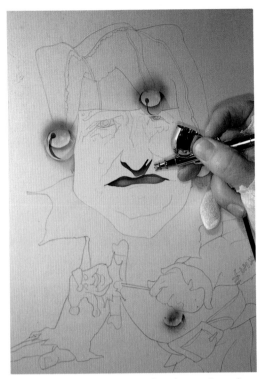

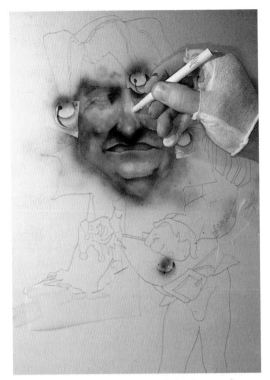

After the sketch is projected and transferred onto a piece of Crescent Scanner board, a frisket is cut and the bells, mouth, and nose shadow are sprayed.

The friskets are removed and the face is then sprayed, using a combination of acetates and freehand work. Areas of color are lightened gently with a vinyl eraser, creating subtle gradations. Color is slowly built up, erased, and built up again, creating a vibrant texture.

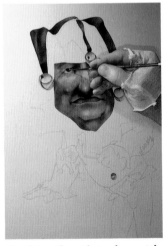

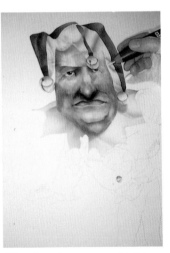

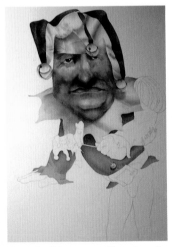

Applying Com-Art colors with a brush.

The electric eraser, which is more aggressive and precise than the pencil eraser, is also skipped across sections of the face to help create a gnarled skin texture.

The doublet, initially painted a rather horrid green, needs to be revised, so it is painted out with an opaque color—much simpler than erasing the whole thing.

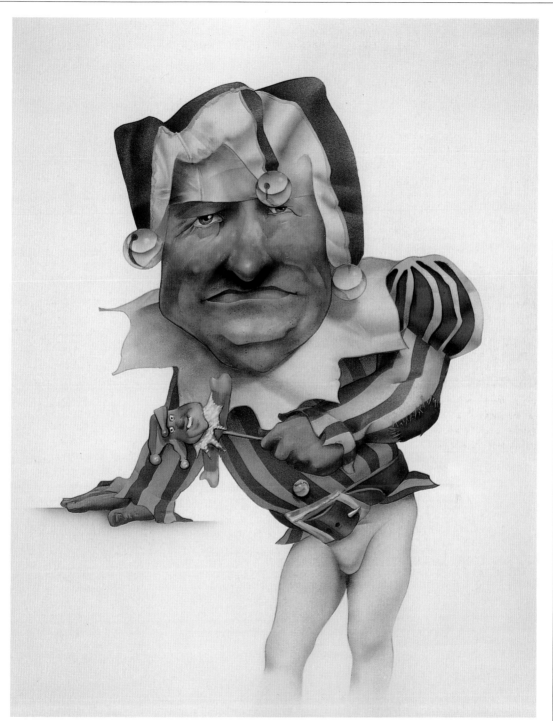

The finished piece. The transparent purple stripes in the doublet were applied after the opaque color over the green had dried. Some of the final detail was done with Spectracolor pencil. Other details, like the eyes, were done with Acryla gouache. The effect on the collar was achieved with the electric eraser. Total working time: 8 hours.

THE BUSINESS OF ILLUSTRATING

The notion of the starving artist may have some romantic appeal as a theatrical vehicle, but it has no place in the modern illustrator's life. One does not become an illustrator to suffer for art, and poverty most assuredly does not ennoble the soul. Conversely, there are very few cases of great talent being ruined by great success. Illustration, after all, is a *commercial art*, so the better you understand the business side of it—where to find clients, how to approach them, and how much to charge—the better off you'll be.

Fortunately, there are few fields that show greater kindness to beginners than the two in which illustrators ply their trade: advertising and publishing. Although most art directors don't have an abundance of time to spend looking at portfolios, they realize that an important part of their job is locating and using new talent. If your illustrations show a fresh look that will help set their projects apart from the others, they'll work with you to bring out your best. This is simple enlightened self-interest.

So how do you find these art directors? Start with the phone book. Just call an advertising agency or publishing house and ask for a list of the art directors. Then contact them and ask for an appointment to show your portfolio. Don't get discouraged if some of them have no time for you—eventually, you'll get your foot in someone's door. And even if you can't get an art director to sit down with you to review your work, you may have better luck if you offer to just drop off your portfolio and then pick it up later after the art director has seen it. Don't get discouraged if you don't meet with immediate success—if your portfolio is genuinely good, one art director will recommend you to another. And above all, remember the big cliche that still bears repeating: Persistence pays off.

Although the quality of your work is obviously important, the way you present and package it can be just as crucial. You should begin to think in terms of self-marketing. Here are a few common questions that might occur to you along the way:

Q: How many samples should I have in my portfolio?
A: Most illustrators show too many pieces. Beginners make the common mistake of laying out a smorgasbord of every piece they've done since the cradle. Be selective— show only your very best work. If you work in a highly detailed style that requires the viewer to spend a great deal of time drinking in all of the intricate work, show just a few— half a dozen well-selected pieces will give the average art director a good idea of your range. If your work is more conceptual, a dozen pieces should be enough to demonstrate that the ideas shown in your work are not flukes

and that the art director can expect you to come up with lots of bright ideas. A dozen pieces is also a good number for children's book art, caricature and cartooning, and poster art. If you're still unsure of how many pieces to include, remember that it's always better to err on the side of too few—you want to leave them hungry to see more.

Q: Should I show original art?
A: In most cases, no. Your original pieces are irreplaceable, and should not be exposed to possible damage when you drop off your portfolio at various locations. More than one reputation has been ruined by loud arguments over damaged or missing original art. Instead, show reproductions—if a slide or transparency is damaged or missing, you can take it in stride and just make another. In addition, reproductions allow you create several portfolios and show them all in one day. The greater the number of people who see your work, the greater the chance of having your work used.

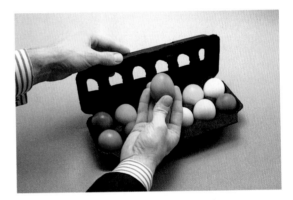

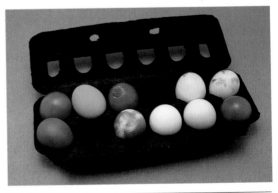

If you take the chance of sending out a portfolio of originals, be prepared to find damaged or missing pieces when it is returned to you.

Q: Should I show color prints in my portfolio?
A: Until recently, I would have said no, but today's color print films and printing papers are a vast improvement over those of just a few years ago. Of course, you should still have such shots photographed by a commercial photographer and processed in a professional lab—if you're planning to save money by photographing your artwork with your trusty 35mm camera and having the prints made at the local same-day processor, forget it! Have it done professionally or not at all.

Q: How about 35mm slides?
A: This you *can* do yourself. There are a number of books on the market devoted to showing you the proper way to make 35mm slides of your art. Given the cost savings, 35mm slides are an excellent way to document your illustration. But follow through with a proper presentation in your portfolio—many beginners actually appear at an art director's door with a slide projector and then start looking for the nearest electrical outlet, usually leading to a comedy of errors (the room is too bright, there's no room for the projector, etc.). If you must bring slides, have them in professional mounts. Most art directors will have a lightbox. Although they will usually have a loupe as well, you should bring your own. Instead of getting one of those cheap plastic ones, invest in a high-quality loupe from Edmund Scientific. If the art director ends up having to borrow it from you, you'll look like a pro. Meanwhile, get yourself some well-designed

and printed shipping labels and high-quality shipping envelopes—armed with these materials and your attractively mounted slides, you can present your work anywhere in the world, all from the comfort of your studio.

Q: Are there any other good presentation formats?
A: Yes: Large transparencies, which require professional photography but offer all the other advantages of both 35mm slides and originals. The most common sizes are 4 by 5 inches and 8 by 10 inches. The colors and detail look almost as good as in the original art, and the large size obviates the need for a loupe. And when mounted in a black mat, large transparencies viewed on a lightbox take on a jewellike quality. I've seldom seen a piece that wasn't improved by such a treatment. This is the most impressive way to show your work.

ARTIST'S REPRESENTATIVES

Another way to have your work seen by art buyers is through an artist's representative. The best reps know everybody, usually on a personal basis, and have a reputation for scrupulous honesty, both to the buyer and to the illustrator. There are some advantages to working with someone who knows your work and knows your prospective clients' needs—a good rep will never recommend that the art director use an illustrator who might be ill-suited to the project.

A rep will take a 25-percent commission from the sale of each piece. If that sounds a

If you plan to present your work in the form of slides, arrange them in professional mounts.

bit steep, bear in mind that the rep will always fight to get the top price for your illustration, and will usually be in a better position to negotiate for it than you are, since the rep will almost always know the marketplace better than you will. Above all, being associated with a good rep frees you to do what you do best—illustrate.

Some reps service a broad market—advertising, collateral, publishing, and so on. Others are highly specialized. Obviously, you should look for a rep who fits your needs. Are you a generalist or a specialist? If you're a children's book illustrator, for example, there are reps who specialize in that area. Also, when considering a rep, examine the type and quality of the illustrators who are currently in his or her stable. Do they work in the same general area or style? Is their work significantly better or worse than yours? And consider the size of the stable—will you get lost in a crowd of too many other illustrators? Are there so few illustrators in the stable that you wonder if the rep is competent?

Even if all these questions have been answered to your satisfaction, it's not yet time to commit to a rep. Call a few of the illustrators in the stable. Ask other illustrators for their advice. Ask art directors who they'd recommend. When you feel confident that you're with the right person, go ahead and make the deal.

SELF-PROMOTION

One way to have your work seen by a broad audience is to enter it in shows. Not long ago, there weren't many shows for illustrators to enter, but today's rapidly mounting number of shows has become an industry unto itself. Entering these shows can be expensive, and their use to the illustrator is doubtful. Having your work exhibited at The Society of Illustrators's annual exhibit, on the other hand, is an honor—enter that competition, but be choosy about the others.

You can also run your work in annuals and directories, like *American Showcase* and its various clones. These books, like the shows, have grown into a small industry of their own. Publishing your work in these directories can be expensive, but it's usually worth it—

advertising *always* sells. Remember, however, that it can sell for *and* against you—be very careful when considering which pieces to show. Because these ads will be seen by top-flight art directors and designers, have your ad designed by the best designer you can afford. In addition, look at the quality of the work in the different directories, since you'll be known by the company you keep. Among these various directories, *American Showcase* offers by far the biggest bang for the buck. It has a large format and the widest distribution of the major directories. don't pin all of your hopes on one directory, however—you have to follow up with other forms of client contact.

DIRECT MAIL

The post office can be a valuable marketing tool, but how can you avoid sending out thousands of mailers that will end up stuffed in the wastebaskets of people with no interest in buying illustration? A small mailing list can be made from the names garnered in your phone calls to advertising agencies and publishers, and this can be supplemented by your past, present, and potential clients. Your personal computer will be a big help in maintaining your in-house mailing list, and can also print the list onto labels. Because people tend to move from company to company, try to update the list periodically. The trade papers can be very helpful in keeping track of address changes, and are also the best way to learn about the new faces at the agencies and publishing houses.

Leasing a mailing list from one or more of the various companies who compile them is another good investment. The cost varies—the more targeted the list, the higher the cost. To find such a firm, look in the Yellow Pages under "Mailing Lists," or contact your local Small Business Administration office. When you have the names of several list brokers, ask for their list catalogs. You'll find that some brokers, like Creative Access in Chicago, specialize in the graphic arts. Whichever company you use, remember that you are only leasing the list—it is unethical to transcribe a leased mailing list to your permanent list. (Once a client from a leased

list contacts you, however, the client becomes part of your permanent list.)

The most focused list for an illustrator is Labels To Go, a service of American Showcase. They lists 20,000 art buyers, all categorized by their type of business—ad agencies, design studios, magazines, record companies, and so on. You can further break down the buyers by the region of the country, state, city and even by zip code. Once you select the list you want, it arrives on pressure-sensitive labels.

Now that you have your mailing list, what do you mail? For a nominal fee, all of the directories offer reprints of your ad. These are fine to send to potential clients. Several firms produce small-quantity runs of photographic postcards, which are more than adequate. to use as follow-up mailings. Full-color printing can be expensive, but you can get a good job for an astonishingly low price from McGrew Color Graphics, in Kansas City, Missouri.

Your rep, if you have one, should bear a percentage of your mailing and production costs. What goes around comes around: A rep who gets a 25-percent commission on your work should likewise pay 25 percent of your printing and mailing costs.

PRICES AND OWNERSHIP

How do you know what to charge for an illustration? Are your prices too low or too high? Until recently, the only prices the illustrator, graphic designer, or cartoonist knew about were those circulating through the grapevine or those dictated by the client. In addition, illustrators were often forced to sell all their rights to a given piece to their clients. But that changed forever in 1973 with the founding of the Graphic Artists Guild, which has labored ceaselessly on the behalf of illustrators. Under the Guild's standards, which are accepted throughout most of the industry, the illustrator sells the *reproduction* rights to a piece but keeps the future rights and the original illustration. When Congress wanted to enact a crippling tax bill that would have made it virtually impossible for artists to itemize their deductions properly, the Guild successfully lobbied against the legislation. And when artists and their clients are locked in seemingly unresolvable disputes, the Guild will assign arbitrators to help arrive at a reasonable and businesslike resolution to the problem.

The Guild's best-known service is its *Handbook of Pricing and Ethical Guidelines*, which contains virtually everything you'll need to know about trade customs, ethical guidelines, who owns what and, best of all, how much to charge. Want to know how much to charge for a book jacket illustration? The *Handbook* has it broken down by "wrap-around cover" and "front cover only" prices, with further subdivisions for hardcover or paperback books, mass market or trade, major publishers with major distribution, and so forth. And that's just one small category of work. You name it, the *Handbook* covers it.

Given all of these benefits, you owe it to yourself and your fellow artists to become a Guild member. Because of the Guild, illustrators and graphic artists are no longer isolated and pitted against each other. We're now part of a larger community.

The Graphic Artists Guild publishes the Handbook of Pricing and Ethical Guidelines. *Guild membership confers numerous other benefits.*

If you have trouble locating any of the products described in this volume, the following list of manufacturers and the tools and materials they produce should help you find what you need.

Air Noveau
P.O. Box 73
Lakewood, NJ 08701
Stencil burners.

American Showcase
915 Broadway
New York, NY 10010
Illustration directory and a good source for mailing lists.

Artograph
13205 16th Avenue North
Minneapolis, MN 554441
Opaque projectors, air-purification systems.

Arjomari
1-3 Impasse Reille
75014 Paris
France
Arches papers.

Aztek Inc.
620 Buckbee Street
Rockford, IL 61104
The Aztek 3000S airbrush.

Badger Airbrush Co.
9128 West Belmont Avenue
Franklin Park, IL 60131
Airbrushes, laser-cut friskets, AirOpaque paint, bristol board.

Binney & Smith Inc.
1100 Church Lane
Easton, PA 18044
Liquitex acrylics, oils, watercolors, and gesso.

Crescent Cardboard
100 West Willow Road
Wheeling, IL 60090
Illustration boards, scanner board, and mat board.

Daler-Rowney
1085 Cranbury South River Road
Jamesburg, NJ 08831
Gouache, oils, pastels, acrylics, and Luma dyes.

DeVilbiss Co. Ltd.
Ringwood Road
Bournemouth BH11 9LH
England
Airbrushes.

Faber-Castell
551 Spring Place Road
Lewisburg, TN 37091
NuPastels, Spectracolor pencils, Higgins ink, and UHU stick glue.

Fluorographic Services , Inc.
622 Olive Street
Santa Barbara, CA 93101
Guide-Line sensitizer and developer, Coltec repro markers.

Golden Artist Colors, Inc.
Bell Road
New Berlin, NY 13411
Custom-made acrylics.

The Graphic Artists Guild
11 West 20th Street
New York, NY 10011
Publishes the Handbook of Pricing and Ethical Guidelines.

Jerry Griffith Art Products
10833 Farragut Hills Boulevard
Knoxville, TN 37922
The Incredible Nib, White Mask.

M. Grumbacher, Inc.
30 Englehard Drive
Cranbury, NJ 08512
Oils, Myston fixative, and pastels.

HK Holbein Inc.
20 Commerce Street
Williston, VT 05495
Oils, acrylics, airbrush paints, gouache, Acrla gouache, watercolors, gesso, pastels, Toricon-Homi airbrushes, and camera lucidas.

Hunt Manufacturing Co.
P.O. Box 5830
Statesville, NC 28677
Conte crayons and pastels, Speedball pens and inks.

McGrew Color Graphics
1615 Grand Avenue
Kansas City, MO 6414
Economical full-color printing, postcards, mailers, etc.

Medea Co.
13585 Northeast Whitaker Way
Portland, OR 97230
Iwata and Olympus airbrushes, Com-Art colors, and Whisper Jet compressors.

Mitchell Press Ltd.
P.O. Box 6000
Vancouver, British Columbia
Canada
The Fairburn System of Visual Reference.

3M
St. Paul, MN 55101
Krylon fixatives, spray adhesives.

Nielsen & Bainbridge
A Division of Esselte Pendaflex
 Corporation
Cranbury, NJ 08512
Bainbridge and LetraMax illustration boards, strippable scanner boards, coquille board, and mat board.

Paasche Airbrush Co.
7440 West Lawrence Avenue
Harwood Heights, IL 60656
Airbrushes, compressors.

Salis International, Inc.
4093 North 28th Way
Hollywood, FL 33020
Dr. Martin's dyes, Spectralite airbrush paints, and accessories.

H. Schmincke & Co.
Postfach 32 42
4006 Erkrath 1
Germany
Gouache, Aerocolor airbrush paints, resin-oils, watercolors, and pastels.

Daniel Smith
4130 First Avenue South
Seattle, WA 98134
World's Best Acrylic Gesso, unusual color mixtures of oil paints.

Winsor & Newton
11 Constitution Avenue
Piscataway, NJ 08855
Oils, alkyds, acrylics, gouache, watercolor, airbrush paints, and accessories

INDEX

Abitibi, 46, 106
Acetate, 55, 64, 131
Acrylics, 125–33
 on acetate, 131
 airbrush, 161, 162, 163
 color mixing, 126–27
 froth technique, 130
 gesso, 128, 132–33
 mediums/varnishes, 128–29
 tube colors *vs.* jar colors, 128
Adhesive, 15
Airbrush, 45, 51, 52, 153–67
 accessories, 160
 air supply, 158–59
 eraser reduction technique, 165–67
 health concerns, 159–60
 paints for, 160–63
 with table easel, 164
 types of, 154–58
Aldus Gallery Effects software, 147
Alkyd painting mediums, 105–6
 paint brands, 108
 pros and cons of, 104–5
 supports, 106–7
Amberlith, 63
American Showcase, 172
Art directors, 170
Artist's representatives, 171–72

Ballpoint pens, 61
Beeswax, 104
Black scratchboard, 77
Bleach, 149
Blueline print, 86
Blueline transfer, 38
Bowl-pointed pen, 76
Brushes, cleaning, 108

Camera lucida, 21–22
Canvas, 47, 106
 alkyds on, 123
 oil on, 120–22
 preparing, 109
Casein 80–82, 142–45
Chevreul, M. E., 127
Chromacolor, 56
Color mixing, 126–27
Color theory, 127
Colored ink, 161

Colored pencil and pastel, 97–99
 water-soluble *vs.* wax-based, 96
Combo technique, 88
Copy transparency, 14–15
Coquille board, 70
Costumes, 31
Curves, 25–26

Denril, 42, 106
 oil wash on, 118–19
 pencil on, 64–69
Direct mail, 172–73
Drawing. *See* Line techniques
Drawing tools, 60–63
Dyes, 149, 161

Easel
 opaque projector and, 20
 table, 164
Eraser, electric eraser reduction technique, 165–67
Etching, illusion of, 73

Fairburn system, 32–33
Film positive, 89
Fixative
 on drawings, 38–39
 on gouache, 138
 on pastel paintings, 94–95
Flexible pens, 61
Friskets, 84
 acetate, 55
 film, 51–53
 laser-cut, 56
 lettering and, 112
 liquid, 149
 photochemical, 56–57

Gel medium, 128–29
Gelatin, 45
Gesso
 applying, 45
 over drawing, 39
 over masonite, 46
 pencil on, 72–73
Gloss medium, 128
Gloves, 10
Gouache, 135–41
 airbrush, 161, 163
 brands of, 136–38
 gelatin fixative, 138
 ox gall in, 137

Graphic Artists Guild, 173
Graphite transfer, 37
Gray scale, 24
Grisailles, 143

Hair dryer, 26, 55
Hand positions and movements, 9–11
Handbook of Pricing and Ethical Guidelines, 173

Illustration board, 15, 37, 44
Incredible Nib, 51, 149
India ink, 62, 74, 86, 148
Ink, 62, 74, 78, 86, 148, 161
Ink drawing–paint resist, 74–75
 on rice paper, 76

Knife, 64

Laser-cut friskets, 56
Lenses, 28–29
Letraset type, 56
Lettering, Gerber method of, 112–13
Lightbox, 22, 24, 36, 171
Lighting, 29–30
Line techniques
 cardboard cut, 86–87
 casein on mat board, 80–82
 etching, illusion of, 73
 film positive, 89
 halftone combo, 88
 ink on rice paper, 76
 ink–paint resist, 74–75
 monoprint, 78–79
 pastel and colored pencil, 97–99
 pencil on Denril, 64–69
 pencil on gesso, 72–73
 rubber cement resist, 84–85
 scratchboard, 77
 with tape, 83
 on textured paper, 70
Linen, raw, 47
Liquitex color mixing system, 126–27
Lucy, 19

Magnifying lens, 24–25
Mailing list, 172–73
Markers, 63
Masking film, 54–55, 63

Masking fluid, 50–51
Masking tape, 50
Masonite fiberboard, 46
Mat board, 46
 bleached, 94
 casein on, 80–82
Matte medium, 129
Matte varnish, 129
Mediums
 acrylic, 128–29
 alkyd, 105–6
 oil, 104
Meglip, 104
Models, 31
Modular color system, 126
Monochrome painting,
 116–17
Monoprint drawing, 78–79
Morgue, 31–32
Mortise, 45
Mounting, 15
Mylar, 42

Non-repro colors, 60

Oil painting, 103–23
 airbrush, 161
 alkyds mixed in, 105
 paint brands, 108–9
 pros and cons of, 104, 105
 supports, 106–7
Opaque paper, 43–44
Opaque projectors, 19–21
Overhead projectors, 21

Painting techniques
 drawing, laying in, 109–11
 group project, 118–19
 humorous illustration, 123
 lettering, 112–13
 monochrome, 116–17
 patching, 114
 research and preparation,
 120–21
 washes, 109
Palette, 24
PANTONE paper, 54

Papers
 opaque, 43–44
 pastel, 93–94
 rice, 76
 textured, 70–71
 transparent, 42
Pastel painting, 91–96
 blending tools, 94
 and colored pencil, 97–99
 fixatives on, 94–95
 hard pastels, 92
 soft pastels, 92–93
 steamed, 95–96
 supports, 93–94
Pastel pencils, 93
Patches, invisible, 45, 114
Pen holder, 61
Pencil drawing
 colored pencil and pastel,
 97–99
 on Denril, 64–69
 on gesso, 72–73
Pencil sharpener, electric, 22, 23
 pastel pencils and, 93
Pencils, 62
 colored, 96
 pastel, 93
Pens
 breaking in, 62
 types of, 60–61
Perspective charts, 26
Perspective drawings, 26
Photochemical friskets, 56, 57
Photocopy transfer, 37
Photographs/photography
 copy transparencies, 14–15
 projected, 36
 reference, 26–33
Polaroid camera, 27
Portfolio, 170–71
Pose, 31
Poster paint, 74
Prereleasing technique, 56
Pricing, 173
Props, 31

Quills, 61

Repro colors, 60
Reproduction process, 13–15
Reproduction rights, 173
Resist, ink–paint, 74
 rubber cement, 84–85
Retarder, 129
Rice paper, 76
Rights, 173
Rockwell, Norman, 31, 36,
 110

Saran wrap, 129
Scratchboard, 64, 77
Self-promotion, 172
Shellac, 110
Slide projectors, 18–19
Spray fixative, 38–39, 94–95
Steel-etch conversion, 73
Stencil burner, 55
Stipple drawing, 70
Stock houses, 33
Studio equipment, 17–33
Suede effect, 105
Supports, 41–47

Table easel, 164
Tape, flexible, 83
Technical pens, 61
Templates, 24
Textured papers, 70–71
Transfer papers, 37
Transferring methods, 35–39
Transparent tracing paper, 42

Varnish, 129
Vellum, 42
Video camera, 33
Video cassette recorder, 33
Visualizing devices, 18–22

Washes ink, 148
 oil/alkyd, 109
Water tension breaker, 129
Watercolor, 147
 airbrush, 160–61
 rubout, 150–51
Wide-angle distortion, 28